PIONEERS OF PREFABRICATION

The Johns Hopkins Studies
in Nineteenth-Century Architecture

PIONEERS OF PREFABRICATION

THE JOHNS HOPKINS UNIVERSITY PRESS

THE BRITISH CONTRIBUTION IN THE NINETEENTH CENTURY

GILBERT HERBERT

BALTIMORE AND LONDON

This book has been brought to publication with the generous
assistance of the Andrew W. Mellon Foundation.

Manufactured in the United States of America

The Johns Hopkins University Press, Baltimore, Maryland 21218
The Johns Hopkins Press Ltd., London

Library of Congress Catalog Card Number 76–47372
ISBN 0–8018–1852–4

Library of Congress Cataloging in Publication Data

Herbert, Gilbert.
 Pioneers of prefabrication.

 Bibliography: p. 213
 1. Buildings, Prefabricated—Great Britain—History.
I. Title.
TH1098.H47 693.9'7'0941 76–47372
ISBN 0–8018–1852–4

This book is dedicated to my wife, Valerie, an unfailing source of strength, a discerning critic, and my most resourceful—albeit unpaid—research associate; to my daughter Margaret, who has done so much to help; and to Barry, whom we all loved.

CONTENTS

ACKNOWLEDGMENTS

The research upon which this book is based was initiated while I was at the University of Adelaide. However, in more recent years, it has been carried out within the framework of the Faculty of Architecture and Town Planning and the Centre for Urban and Regional Studies, at the Technion, Israel Institute of Technology. I am grateful for the research funds and facilities extended to me by the Technion. I investigated South African aspects of the study during 1975, while I was Visiting Professor at the University of the Witwatersrand, Johannesburg. Much of the investigation had of necessity to be carried out in England, some of it from afar. My thanks go to Sutherland Lyall and Noemi Maas, who searched for material on my behalf so intelligently and efficiently, and to Michael Lazenby, for his assistance with the illustrations, as well as to Kate Diamond and Sarah Prager, who helped me organize the information into manageable form. I would also like to thank Rachel Lipschitz, who typed the manuscript, and Jacqueline Wehmueller, who helped with its preparation. Throughout Great Britain, the United States, Australia, South Africa, in such remote corners of the globe as Hong Kong or Tierra del Fuego, I have received the ready assistance of innumerable individuals, libraries, institutions, universities. To list every name would be impossible, to mention some, invidous perhaps; nevertheless, I am compelled to draw attention to two colleagues who have been unsparing in their help and encouragement over a long period of time. My especial thanks go to Professor J. M. Freeland, of the University of New South Wales, a pillar of strength in all matters Australian, and to Professor Charles E. Peterson, whose American studies are landmarks in the history of prefabrication and who has been so generous in sharing his unrivaled fund of knowledge. Finally, I am grateful to Sir Nikolaus Pevsner, who somehow found the time to read many of these chapters in draft form

and encouraged me to believe that they contained within them the potentiality of a book.

Chapter 2 of this book first appeared as "The Portable Colonial Cottage" in the *Journal of the Society of Architectural Historians,* XXXI:4 (December 1972), pp. 261–75; and portions of chapters 6 and 8 derive from "A Cast-iron Solution," published in *Architectural Review,* CLIII:916 (June 1973), pp. 367–73.

CHAPTER 1

DEFINITIONS AND LIMITATIONS

During the nineteenth century, for the first time in the long history of "man the builder," serious and sustained attempts were made to devise systems whereby most of the component parts of a building could be fabricated in a builder's yard or workshop prior to their assembly on the actual building site. In other words, men sought to devise construction processes that would shift the major component of labor from the crude area of field operations to the controlled, and increasingly mechanized, conditions of the factory. This transfer from ad hoc building to planned, multiple production is one of the fascinating break points in the curve of architectural evolution.

Fascinating, but not necessarily dramatic—for the story of nineteenth-century prefabrication is an unfolding account of progressive achievements, each perhaps unspectacular in itself, rather than of a single momentous breakthrough. In order to illustrate this evolution in concept and in practice, I have turned specifically to the pioneers of the Victorian era. Limiting the study to the British contribution in no way suggests that this constituted the sum total of nineteenth-century prefabrication. There was, as is well known, the highly significant American experience ranging from the innovative role of Bogardus and the industrialized production of Badger in the 1850s to the "mail-order" house at the turn of the century. And there were the contributions of European countries: Belgium, France, and Germany. But the British story is a self-contained case study of the origins and subsequent development of industrial prefabrication, of remarkable consistency and wholeness.

Paradigmatic of early industrialized building is the spectacular Crystal Palace built for the London Great Exhibition of 1851 (fig. 1.1). Joseph Paxton's great work was a symbol of Victorian daring, ingenuity, and technological skill. But there is much more to nineteenth-century

1

prefabrication than a single bravura display. There is a chapter of pioneer experimentation, often modest in scale but significant in concept, which is the prehistory of this mid-century monument; and there is a period of continuous development, at first of technical innovation, and later of expanding areas of application, right up to the end of the century. This extended story of invention and evolution is our proper field of study.

There is, moreover, the web of circumstances surrounding the creation of these buildings. To this we must pay some attention, for the history of prefabrication is inextricably involved in the social and economic history of Victorian Britain and its empire, in the history of its industrialization, urbanization, and colonial expansion. We must consider the question of motivation, when local demand, generated by unusual circumstances—the settlement of a new colony, the finding of gold or diamonds, the waging of a far-off campaign—exceeded the local capacity to supply the houses, hospitals, churches, warehouses, schools, and shops so urgently needed. In a sense, the history of prefabrication in the early days is the record of a successful response to the challenge of recurring crises. The ability to respond in adequate measure is a function of that growing technological competence and industrial capability that characterized Victorian Britain and that ultimately enabled its manufacturers to produce, market, package, and dispatch extremely large quantities of "portable buildings" to all corners of the earth.

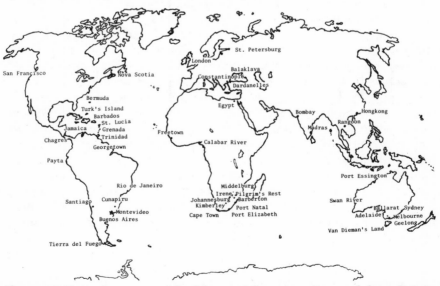

Figure 1.1. Some Locations of Prefabricated Structures Exported from Britain during the Nineteenth Century

The nature of this output of industrially produced buildings was diverse, and its architectural character was variable. Much of it was pretentious, reflecting in sheet and cast iron the stylistic vagaries of the era. Much of it was brutally utilitarian: harsh, shedlike structures of galvanized iron, at best decked out in the irrelevant frippery of machine-made ornament. But many examples, in their simple, disciplined modularity, in their honest response to functional and climatic problems, and in their reflection of the nature of the new materials and the new technological processes used, have a directness, a naïve appeal that is not entirely innocent of architectural merit. And, whatever the quality, quantitatively they could not be ignored, for in many a burgeoning new town, from San Francisco in 1849 to Johannesburg nearly half a century later, prefabricated structures dominated the urban scene and determined its architectural character.

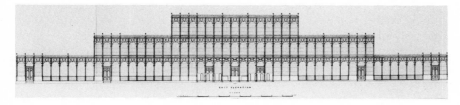

Figure 1.2. Joseph Paxton, Fox and Henderson. Crystal Palace, London, 1851. Downes, *The Building Erected in Hyde Park*, Pl. 5. (Courtesy Victoria and Albert Museum.)

This study, then, is selective in its themes and does not attempt to be an all-embracing history of nineteenth-century prefabrication. It eschews the standard monuments and looks instead to the lesser buildings that constituted the fabric of Victorian prefabrication. It directs its attention to those British pioneers whose inventive minds conceived the principles of the industrialized prefabrication of buildings, and whose courageous common sense and technical skill enabled them to put it into effective practice.

CHAPTER 2

THE PORTABLE COLONIAL COTTAGE

Between 1827 and 1829 a small group of settlers came from Britain to make a new home on the banks of the Swan River in West Australia. The early pioneering days were hard, and the hastily improvised shelter provided by tents and flimsy huts was woefully inadequate. In about 1830, soon after the founding of the settlement, an advertising pamphlet was directed toward prospective migrants:

> Gentlemen emigrating to the New Settlement, Swan River, on the Western Coast of Australia, will find a great advantage in having a comfortable Dwelling that can be erected in a few hours after landing, with windows, glazed doors, and locks, bolts, and the whole painted in a good and secure manner, carefully packed and delivered at the Docks, consisting of two, three, four, or more roomed Houses, made to any plan that may be proposed; likewise Houses of a cheaper description for labouring men, mechanics, &c. &c.[1]

Several such houses, it was claimed, had already been built and shipped to this new settlement and also to New South Wales and Van Diemen's Land (Tasmania). These were well-made wooden houses, built in sections in England and packed especially for export. Their designer, the father of one of the emigrants, was a carpenter and builder of London by the name of John Manning.

"These cottages were found to be of the greatest service to settlers, both in protecting their families from the weather, and their property from theft," claimed Manning. "Many persons who took out only tents, suffered severely in both respects; their tents being frequently blown down in the middle of a stormy night, and their goods being thus not only exposed to the weather, but to pilfering. Provided with a cottage of this description, an emigrant might land from a ship in a new country in the morning, and sleep in his own house on shore at night."[2]

4

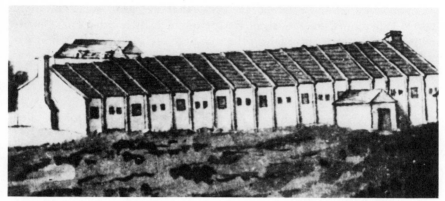

Figure 2.1. Samuel Wyatt. Hospital, Sydney, Australia, 1787. Detail from watercolor attributed to G. W. Evans, c. 1787. (Courtesy Allport Library.)

Young Manning was not the first migrant to bring a house with him from overseas. The first real building in Australia was the home brought from England by Captain Arthur Phillip in 1788. Recent research indicates that this was probably a compact four-room structure, about 50' X 22', which took about a week to erect.[3] A contemporary reference describes it as "the Governor's Portable House which is framed and the sides etc. of painted canvas."[4] Unfortunately, the house proved "not perfectly impervious to either wind or weather."[5]

The earliest settlement of New South Wales had involved several instances of prefabrication, including a timber-framed hospital (fig. 2.1), probably one of twelve "moveable Hospitals each 83 ft. long & 12 ft. wide . . . so contrived as not to require artificers of any kind to fix them up or take them down—not even a hammer will be necessary," that Samuel Wyatt built in 1787 "for his Majesty's distant possessions."[6] Less than a year later, Wyatt reported to his friend Matthew Boulton—to whom he had earlier turned to provide the copper covering, presumably for the roofing—on the final outcome of the venture: "I exhibited the moveable Hospitals to the King &c &c by taking down one of the buildings & putting it up again . . . in one hour, which gave general satisfaction."[7]

This hospital, together with a prefabricated storehouse and some rudimentary cottages, was sent out from England to Sydney, arriving in 1790.[8] A recent reconstruction of the hospital, based upon incomplete information, suggests that it was a frame structure of alternating modules, wide and narrow, filled in with premade wall, floor, and roof panels.[9] Of the dwellings we know little; they may also have been of canvas or, alternatively, of precut timber studs faced externally with weatherboarding, possibly after erection of the framing. Wyatt, we know, used an

5

analogous system for a temporary shop that he made for Boulton in 1788.[10] When, in 1804, Governor P. G. King of New South Wales "made architectural history by ordering the manufacture of Australia's first exportable prefabricated buildings, which were shipped to Newcastle and Tasmania,"[11] the buildings probably followed this same elementary pattern.

About the same time that the prefabs were arriving in Sydney, an order was placed in England by the Sierra Leone Company for an even more ambitious range of prefabricated buildings. These buildings—a church, a warehouse, a range of shops, two hospitals, several dwellings, and four canvas houses[12]—were unloaded and erected in Freetown in 1792. It is conceivable that the same source supplied both these and the Sydney portable buildings.

These isolated pioneer examples were followed by others in the British colonization of South Africa. An early proposal is recounted by Ronald Lewcock: "In 1801 the Government received a report from the Resident in Simonstown suggesting that cheap houses might be erected of timber, imported ready for assembly from the United States. The originator of the suggestion was the Superintendent of Fisheries at Kalk Bay —an American. . . ."[13] It must be understood that this was not prefabrication in its fullest sense, but the manufacture of building components and elements—posts, studs, boarding, and shingles—which could be put together simply, thus reducing the amount of site work needed. This early instance of exportation of American premade components to a British colony is an interesting commentary on the emerging international character of the new building industry. There was, of course, a long tradition of American timber construction; and later there was to be some important experience in prefabrication proper, which Charles Peterson and others have documented.[14]

In 1820, when the British sent out about 5,000 settlers to the Eastern Cape Province as a relief measure for the acute unemployment and economic depression in the home country, they were eager to make this colonial venture a success. The government therefore provided a subsidy of £50,000 for the costs of the journey, offered the migrant "a good tent for 2 guineas,"[15] and, on the initiative of the Colonial Office—according to Lewcock[16]—sent out several demountable three-room wooden cottages of weatherboard construction. These houses were intended for the farm settlements in the Albany district, but because of the high cost of transportation and the difficulty of erection most of them were used in Port Elizabeth and other established centers of population.[17]

Little has been published about the technical specification of these prefabricated houses brought out by the settlers of the Eastern Cape Province (fig. 2.2). However, it seems reasonable to assume—and this

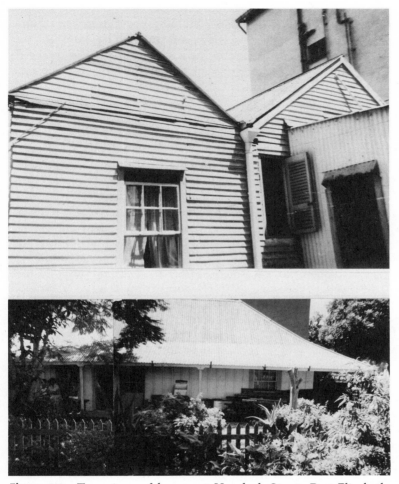

Figure 2.2. Two views of houses at Havelock Street, Port Elizabeth, South Africa, c. 1840.

assumption is borne out by the fragmentary evidence that remains[18]—that these houses, like their early Australian counterparts of the pre-Manning era, were little more than simple shedlike structures, with precut timber frames, clad either with weatherboarding, trimmed and fixed on the site, or with board-and-batten siding. Doors and window sashes were probably premade as complete components. Such wood-framed, boarded sheds and cottages, although technically prefabricated, involved a fair amount of site work after assembly—in the putting to-gether of the framework and particularly in the fixing of the sheathing.[19]

7

It was an elementary form of prefabrication, close in construction method to the traditional on-site timber building but differing, perhaps, in the greater emphasis on precutting and preplaning, and in the avoidance of complicated techniques for the joinery of the framework.

Up to the time of the Manning cottage this was, with certain isolated exceptions, the rudimentary nature of colonial prefabrication. The exceptions were unique cases of "one-off" houses, sometimes specially designed by architects and constructed by builders and carpenters especially recruited for the task. While technologically they may not have been more advanced than the simple demountable cottages we have been discussing, they were more ambitious. They were more substantial structurally, they were more complex in plan form, and, in an architectural sense, they attempted more. Because they were unique undertakings for a specific purpose, they tended to be better documented than the anonymous wooden huts of the early settlers.

One such example from early in the history of prefabrication is the frame house built in 1772 by Clarke and Hodgdon of Portsmouth, New Hampshire, for shipment to the Island of Grenada.[20] This house, 50 feet long and 18 feet wide, consisted of three rooms fronted by a continuous gallery 12 feet deep, and was capped by a pavilion roof. Doors, glazed windows, shutters, veranda posts, and planed and beaded sheathing were included in the inventory of components. Such a complex house obviously demanded much site work, and it is not surprising to learn that, presumably for this reason, two carpenters and a smith were engaged to go to Grenada. Even more complex, but less far-traveled, was the large, two-story eighteenth-century prefabricated house that still stands at Emsworth, in Hampshire, England (fig. 2.3). This white-painted, weatherboarded, frame house was, according to a recent account,[21] built by John King, a local shipbuilder, who first assembled the complete structure in his shipyard and then, in 16 hours, reerected it upon its destined building site. In the Antipodes, to point to yet another example, we learn of a large, complex, but, according to Morton Herman,[22] poorly planned house for a Mr. Busby of New Zealand, designed in 1832 by architect John Verge and framed in timber in Sydney, Australia.

Up to the time of the Manning cottage, prefabrication for colonial needs came in two forms: elementary timber-framed and sheathed huts and sheds, similar, perhaps, to rudimentary farm buildings at home; and isolated examples of more ambitious, specially conceived, fabricated, and erected houses for presumably wealthy clients—the Busby house was more than seven times the area and perhaps twenty times the cost of a colonial cottage.[23] However, whether hut or mansion, whether flimsy and temporary or substantial and relatively permanent, all these examples are mutations of established building techniques evoked by the

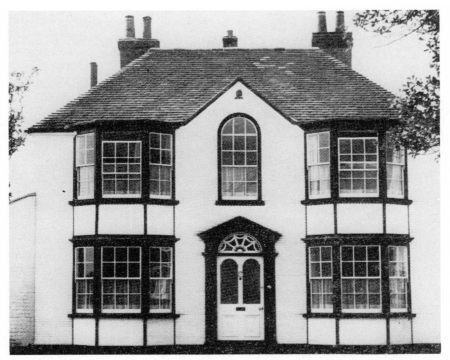

Figure 2.3. John King. House at Emsworth, Hampshire, England, eighteenth-century. *Country Life*, 6 August 1970.

emergent needs of colonialism. With Manning, however, these needs stimulated a far more radical change from the points of view of design, construction, and marketing. With the production of the Manning cottage, prefabrication became an industry.

The Manning Portable Colonial Cottage for Emigrants (fig. 2.4), as described by John Loudon,[24] consisted essentially of grooved posts housed into, and bolted to, a continuous floor plate carried on bearers, the posts in turn carrying a "wall" plate supporting simple triangulated trusses. Between the grooved posts, very much in the manner of the infilling of traditional plank-wall construction,[25] were fitted various interchangeable panels of standard size.

The essential novelty of the cottage lay in a unique synthesis of several factors. First, it was conceived, as the name implies, as a unit specifically designed for mobility and ease of transportation. It was designed "to pack in a small compass" for shipping; and on eventual arrival at its colonial destination, Manning claimed, "as none of the pieces are heavier than a man or a boy could easily carry for several miles, it might

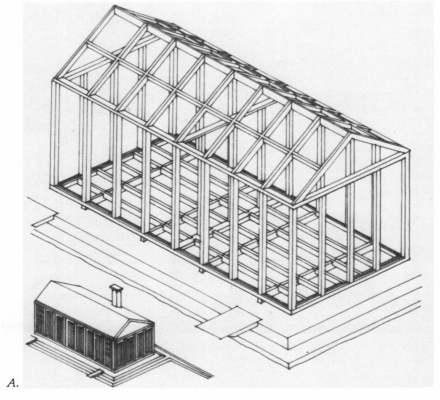

A.

Figure 2.4. John Manning. Portable colonial cottage, c. 1833. *A.* Frame; *B.* Plan; *C.* Detail of wall panels; *D.* Detail of framing. Diagrams after Loudon, *Encyclopaedia; E.* Advertisement. The *South Australian Record*, 27 November 1837. (Courtesy British Library Board.)

be taken even to a distance, without the aid of any beast of burthern." The point of this argument becomes clear when one remembers the critical lack of transportation in the colonies (Colonel Light, the famous surveyor of South Australia, carried out his survey of much of that vast area on foot) and when one recalls the two basic problems that the 1820 settlers in South Africa had with their prefabricated houses—they were costly to transport and difficult to erect. This leads us to the second significant characteristic of the Manning cottage: it was designed for ease of erection. It was completely fabricated in the carpenter's shop and required little or no site work other than the building of foundations and the assembly of components. The structure required no fashioning of

10

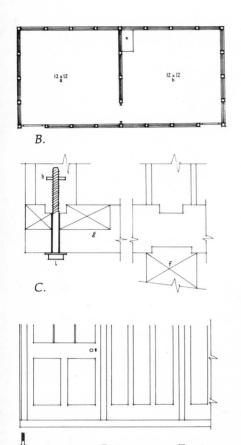

B.

C.

D.

E.

joints, no cutting of timber, no nailing—"whoever can use a common bed-wrench can put this cottage up." The design was tailored to the limited resources of skill and tools available to the emigrant.

Finally, the Manning system foreshadowed the essential concepts of prefabrication, the concepts of dimensional coordination and standardization—"every part of it being made of exactly the same dimensions; that is, all the panels, posts, and plates, being respectively of the same length, breadth and thickness, no mistake or loss of time can occur in putting them together." The standard panels of the Manning system consisted of a wall unit comprising outer frame, muntins, and infill panels; a glazed door; a solid internal door; and a window and spandrel unit, all based upon a panel module of 3 feet.

Conceptually, Manning's cottage derived from the emigrant's need

11

for "instant" temporary housing. Technologically, although it depended upon the traditional British skills of the shipwright and the carpenter, it was adapted to the techniques of large-scale manufacture. It came into being, through personal circumstances, when the needs of the emigrant were being defined; its techniques were evolved in the early 1830s when the demand was still small; it was exploited commercially when the flood tide of emigration to Australia dramatically expanded the market; and it set an example for emulation that was followed by other manufacturers, not only in Britain, but also in the United States.[26] The Manning cottage was the start of a prefabrication industry in which many firms were to participate. In the early phases of this industry its major product was the portable colonial cottage, although, as we shall see, other buildings, notably churches, were also produced; its principal markets were the new colonies developing in the Antipodes.

In the early 1830s emigration from Britain had been largely to the settled areas of British North America and the United States. In the second half of the decade, however a significant movement began to the south. In 1834 settlers from Tasmania moved across to the Australian mainland to found Port Phillip, which became later the city of Melbourne and a nodal point of growth. In December 1836 Captain Hindmarsh proclaimed the establishment of the colony of South Australia, idealistically envisaged as a demonstration of the Wakefield colonial theory.

Increasing numbers of immigrants came to both new settlements— and some of them brought their houses with them. Amid fragiles shacks, unstable pisé cottages, and flimsy tents, these were looked upon with admiration. Describing the many improvised forms of shelter (mostly disreputable) a report in the *Colonist* of July 1837 commented, "Some of them, however, are more sightly, being composed of wooden frames neatly covered with canvas,[27] or of panels screwed together; these last description are the most convenient, from four to six roomy apartments in them. The parsonage, Mr. Osmond Gilles' and Mr. Hack's, are of this construction."[28]

Gilles, the colonial treasurer of South Australia, had a house built by Peter Thompson, a new manufacturer and a somewhat aggressive promoter of prefabricated buildings of whom we shall have more to say later. The other houses referred to, the parsonage for the Reverend C. B. Howard and the house for J. B. Hack, were Manning cottages. Let us look at Hack and his cottage as something of a case study, illuminating generally the motivation and experience of the pioneer users of prefabricated houses.

John Barton Hack, a well-connected member of the Society of Friends, took passage, together with his brother Stephen, on the *Isabella*, arriving at Holdfast Bay, South Australia, in mid-February 1837. "Fearful

of depending upon canvas in a country where everything had to be extemporised," his biographer wrote, "he brought with him two Manning cottages."[29]

His brother Stephen reported the circumstances of their first days in the new colony. "For the first fortnight I was on shore, I lived under one of the carts for want of a better house, my brother and his family stayed on board till we got the wooden house up, which we had brought from England; they turn out the most convenient places possible, and taking the climate into consideration are quite as comfortable as any brick house in England."[30] John Barton Hack endorsed his brother's overemphatic commendation, obviously pleased that his foresight was bearing dividends. "If you were to see the miserable shifts our good friends and neighbours are put to, you would think us well off: we are almost the only people in the colony who possess wooden houses, all the others living in rush-huts and tents. The other day, in a gale of wind, we saw some people running after their house that had blown away: let no one come to a new colony without one of Mr. Manning's nice portable wooden houses."[31]

Those without Hack's foresight had to improvise as best as they could. To supplement the tents, reed huts, and mud bricks, building components began to arrive at Holdfast Bay. There were shipments during the first year of the colony of bricks, timber, shingles, and hardware. Special items of equipment were also sent out. For instance, thirty-three packages of doors and windows and two packages of water closets were delivered on the *William Hutt* in March 1837.[32]

These materials and components, and perhaps even complete houses in component form, became available to the emigrants who wished to build their own homes. This is indicated in stories sent back to England. One such report concerns a Mr. Wyatt, who, having tried without success to construct a house for himself out of local materials, eventually abandoned the attempt and sought instead the resources to be found on board one of the vessels in the Bay. "Man and self being both laid up with festered fingers, from splinters, returned to the ship, and having purchased all the wood of the fittings of emigrants' cabins on board, including fifty doors with jalousee upper pannels, for £14, was engaged with my assistant . . . in laying up the wood in bundles for the advantage of taking them on shore."[33] It was probably from such components and materials as these that Captain Hindmarsh, the governor, built his viceregal residence, a timber house[34] put up by the sailors of his ship. During the construction of the governor's house it was discovered that windows consigned to Charles Mann, the advocate general, and John Morphett, the land agent, had mysteriously been incorporated into it.[35]

Certainly by 1838, consignments of complete houses were sent out,

not only for specific consignees, but presumably for general sale as well. Richard Smith, a carpenter, emigrated on board a vessel carrying such a cargo and was engaged, prior to arrival (probably by the South Australia Company), to arrange for the erection of the houses. He disembarked at Holdfast Bay and, after an illness that frustrated his attempts to erect the prefabricated cottages, wrote to his son of the transaction. "I there landed and informed Mr. Stevens, the Governor of the Bank,[36] of my arrival, and that I had engaged twenty men on board the Renwick to put up the houses, and was ready to do so; but although the houses had been landed at Port Adelaide ever since, they had not been brought up to the city of Adelaide until within these ten days, and the Head Commissioner is putting them up himself, as it was impossible for me to do it if I had been ever so well, for he gives 10s a-day for carpenters, and cannot get them for that money. . . ."[37]

The shortage of labor referred to in this letter was chronic in the early days of South Australia. More than the difficulty of acquiring suitable building material, it was this shortage that acted as a brake on local building. Contractors were inundated with offers of work but could not accept because of the lack of a suitable labor force.[38] But if the non-availability of building workers created an inescapable bottleneck for local building, it also created the right conditions for importing relatively easy-to-erect cottages from England.

Manning capitalized on this demand. Late in 1837 he began advertising in the *South Australian Record*, a newspaper published in London for prospective emigrants. "PORTABLE COLONIAL COTTAGES. H. Manning, 251, High-Holborn, London, manufacturer on the most simple and approved principles, to pack in a small compass, may be erected with windows, doors and locks, painted inside and outside, floors, &c. complete for habitation in a few hours after landing. Price £15 and upwards. They may be taken to pieces and removed as often as the convenience of the settler may require."[39]

In this first advertisement Manning referred to testimonials from his satisfied customers Reverend Howard and Mr. Hack. By January 1840 this list had expanded to include eight prominent citizens of South Australia;[40] the late governor of West Australia; Dr. Evans, the chairman of the New Zealand Association, and the surveyor general of New Zealand, together with several members of his staff; and La Trobe, the lieutenant governor of Port Phillip. La Trobe arrived in Melbourne in 1839 and erected his Manning cottage in Joli Mont, Victoria. This house was later moved to the Domain, Melbourne, and reconstructed in 1964 (fig. 2.5). As it now stands, the house maintains the basic modular construction but shows some deviation in detail from the original prototype: the roof is shingled, horizontal boarding replaces the framed panels, and

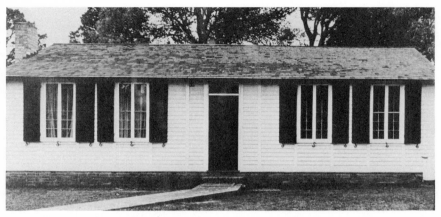

Figure 2.5. John Manning. La Trobe's cottage, Joli Mont, Victoria, Australia, 1839; later moved to the Domain, Melbourne, Australia. Freeland, *Rude Timber Buildings*. (Copyright © Wesley Stacey.)

the windows are shuttered. I do not know whether these changes date from the reconstruction or are original.[41]

The concept of the prefabricated cottage and the name "Manning" were by now well established—so much so that, more than 15 years later, one could refer to a "Manning cottage" without need for further explanation.[42] Yet Manning was by no means alone in the field, as he was forced to concede, and he began to frame his advertisements accordingly: "The well-known superiority of these Cottages over any others hitherto introduced to the Colonies renders it unnecessary to add more. . . ."[43]

From the earliest days of the South Australian settlement, Manning had competitors; of these, the most important was Peter Thompson, an ambitious, and not altogether scrupulous, carpenter and builder from London.[44] As mentioned earlier, his house for Osmond Gilles, the colonial treasurer, was contemporaneous with the pioneer Manning cottages for Hack and Howard. According to a full-page advertisement that Thompson ran in the *South Australian Record* beginning in 1838, this house was a large villa, of H plan, 80′ X 32′ in size (fig. 2.6). Also illustrated was a sumptuous sixteen-room prefabricated residence for J. H. Fisher, the colonial commissioner, as well as more modest three- and four-room cottages. In their design, these houses by Thompson showed little trace of their prefabricated origin. They were complex in plan outline and roof form and far from austere, with elaborate finials to the roof, ornately carved bargeboards, and neoclassical touches in the pedimented windows and doors. There is an unreal air about these houses compared to the workmanlike character of the Manning cottages; and there has

15

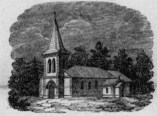
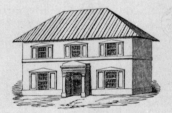

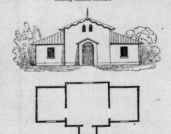
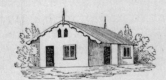
Figure 2.6. Peter Thompson. Emigrants' houses, 1838. Advertisement, the *South Australian Record*, 13 January 1838. (Courtesy British Library Board.)

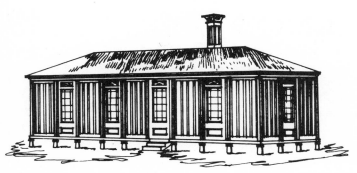

Figure 2.7. John Manning. House for Captain Hall, Wargrave, near Henley-upon-Thames, England, c. 1833. After Loudon, *Encyclopaedia*.

been some speculation whether they were ever built.[45] Toward the end of 1838[46] new four- and eight-room plan types appeared—with full-length shuttered windows and lean-to verandas—which seemed to be not only more practical but patently more suited to the Australian climate in form and character. The construction was of studwork framing, sheathed internally and externally with boarding, and had a boarded ceiling. The roof, in the sketches, also appeared to be boarded, but it was described as being covered with patent felt.[47] The stud-and-sheathing construction followed the older traditions of timber building and compared unfavorably with the technically advanced system of erection of the Manning cottage, with its bolted frame and infill panel; but it gained immeasurably in thermal insulation, the construction rendering the houses "impervious to heat and cold, and excluding all sounds and draughts," as Thompson somewhat overemphatically claimed.

Manning was less alert to the problems of heat, the consequences of which will be examined later. He was, however, aware of the problems of cold and suggested installing heating—in Captain Hall's house (fig. 2.7), one of his first experiments in England, he had fitted a ship's cabin stove and a ship's galley stove with a horizontal flue controlled by a bypass valve to heat the whole house in winter. His and Thompson's Australian cottages lacked these elaborate installations, for obvious reasons, but they were nevertheless well equipped. Manning provided dressers, safes, tables, and other furniture made to be packed one item within the other, saving space in shipping; Thompson included closets, washstands, dressers, and chiffoniers.

By 1838 other firms had entered the prefabrication market. Joseph Harvey of London advertised his "portable colonial houses" in the *Record* for use in Australia and New Zealand. He claimed that those ordering

17

one of his houses would "be able to see the actual house they are likely to reside in, and not when they arrive have to manufacture at least one-third of their house at [their own] expense"[48]—the latter perhaps being an allusion to some unhappy experiences by emigrants due to incomplete sets of components. In 1839 L. R. Peacock advertised "portable colonial cottages" both in the *Record* and in the *Colonial Gazette* and claimed[49] to have supplied many such homes to South Australia. In the *Record* in 1839 and in the *Commercial Gazette* in 1840,[50] James Matthews of Bishopgate stressed that his houses were properly marked and easily erected—and he, too, gave the names of satisfied customers, now a traditional form of advertising.

For all these firms, the portable colonial cottage (a name stereotyped after Manning's lead) was the principal, if not the only, item for export. Thompson, however, was more ambitious. In his first advertisement he showed a design for a banking house for the directors of the South Australia Company, an imposing two-story structure with a classical portico. He also illustrated a church for Adelaide. While there is no evidence that the bank was delivered, the church might well have been the short-lived predecessor of Holy Trinity, Adelaide's first parish church, whose permanent structure was commenced in 1838. In the preceding year the place of worship had a checkered career. "When the Reverend C. B. Howard, South Australia's first Colonial Chaplain, arrived in Adelaide at the end of 1836, he was a preacher with a flock but no church. With the help of the Colonial Treasurer, Osmond Gilles, he dragged a ship's sail from Holdfast Bay in a handcart for his first services."[51] Obviously a more substantial shelter was needed, and it was soon on the way from England—a prefabricated church. By July 1837 it had arrived but was not yet erected, for, as a contemporary report explained, "the church, a frame building, sent from England, per "Coromandel," is not yet put into commission, in consequence of the want of bullocks to transport it from Glenelg to the site intended for it."[52] Eventually the transportation problem was solved, and it was brought to its place of assembly and erected, a wooden church made in sections and big enough to house 350 people—"but it was found inadequate even before the walls had been stood up."[53]

In 1839 another prefabricated building for a religious congregation was sent to Adelaide, a meeting house for the Society of Friends (fig. 2.8). This proved to be a much more durable structure, a much-cherished, elegant little building; and it makes an interesting case study in the history of prefabrication, in the era of the portable colonial cottage.[54]

John Barton Hack, one of the first customers for a Manning cottage, was a Quaker. In his home in Adelaide the first meetings of those professing with the Friends took place. The accommodation was apparently

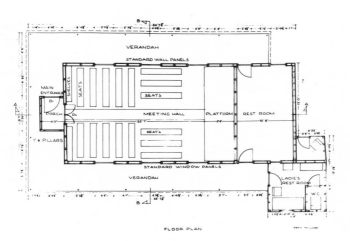

VERANDAH

STANDARD WALL PANELS

MAIN ENTRANCE

SHELVES

SEATS

PORCH

SEATS

MEETING HALL

PLATFORM

REST ROOM

1" ♦ PILLARS

SEATS

STANDARD WINDOW PANELS

VERANDAH

LADIE'S REST ROOM

W.C.

FLOOR PLAN

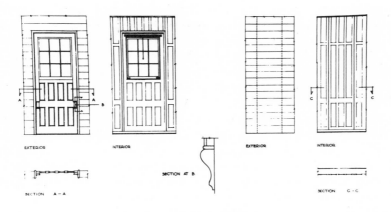

EXTERIOR

INTERIOR

SECTION AT B

EXTERIOR

INTERIOR

SECTION A - A

SECTION C - C

TYPICAL WINDOW & PANEL DETAILS

Figure 2.8. Meeting house, Society of Friends, Adelaide, Australia, 1839. *Top*, general view; *Middle*, plan; *Bottom*, window details. Laikve, "Report on the Meeting House of the Society of Friends." (School of Architecture, University of Adelaide.)

inadequate, and Hack must have written to the Society of Friends in London. At the yearly meeting of 1839, voluntary contributions of approximately £400 were collected, and out of these funds (but not the official funds of the National Stock) a prefabricated meeting house was purchased and dispatched to Adelaide.[55] It is not known whether the suggestion for a prefabricated building came from London or from Hack. The latter's experience and obvious satisfaction with the Manning cottage suggest that the initiative was his. However, the London Friends were not entirely unfamiliar with the idea of prefabrication. As early as 1825 they had planned to send "a framed Dwelling house &c" to Sierra Leone but were forced to abandon the scheme when it was discovered that it "would have exceeded their present pecuniary means."[56] The idea of temporary accommodation was also well known to the Friends. The Melbourne Friends, for instance, met in an iron store which, they reported in 1837, they had "converted into a Meeting House for temporary use at a cost of about £50."[57] Moreover, an entire section of the basic handbook of that time on the design of meeting houses was devoted to the improvisation of temporary accommodation.[58] This remarkable book is suffused with concern for proper environmental control and represents a pioneer pragmatic work in the field of lighting, ventilation, heating, and acoustics. One of its concerns is the design of movable partitions—and the system it suggested, with grooved frame and sliding shutters, strangely foreshadows the window details of the Adelaide meeting house.

"I have to advise you," wrote the Friends to Hack in 1839, "of our having shipped aboard the Rajasthan, Capn. Richie, a Wooden framework Meeting House with Verandah and Iron Pillars complete, packed & numbered with contents of each package as per annexed list of particulars. A plan & elevation of the building will also accompany this for your guidance in erecting it."[59] There were two postscripts: the first to notify Hack of the separate shipment of 3,300 slates for the roof, on the ship *John*; and the second to note that "any particulars of its use will be acceptable." About a year after its receipt, Hack duly reported, "The building has proved very convenient, and is quite a handsome erection."[60]

The packaged meeting house arrived in Adelaide in February 1840 and was erected, probably in June, on land belonging to Hack.[61] The contract price for the erection was £120 and, for painting, an additional £70.[62] It was a frame structure of wooden posts, 4" X 2", and a trussed roof, the framing being covered, externally, with weatherboard panels extending horizontally across two units of structure and, internally, with framed modular panels. The preglazed window modules were also structural and contained a vertically sliding sash moving down in front of the spandrel panel. The slate-covered roof had that combination of hip and

gable which provides ventilation at the apex, typical of the Australian homestead. It implies a knowledge of local tradition and conditions on the part of the designer, as does the shading veranda roof.

It is not known who was responsible for the design and manufacture of the meeting house. It is a likely supposition that Manning was the designer: his connection with Hack and the modular nature of the construction and the detailing of the internal panels seem to support this. Moreover, the abortive history of Thompson's church would tend to eliminate him as a likely alternative. Yet, it is strange that, in such a highly competitive era of advertising, neither Manning nor any other known supplier of prefabricated buildings to the colonies claimed responsibility for this most successful of structures. Some years ago, when I last had an opportunity to inspect it, the meeting house still stood, altered but fundamentally intact, in a good state of preservation after nearly 130 years of use.

One other event remains to be recorded before we round off our discussion of the wooden prefabs of the era of the portable colonial cottage. The event is paradigmatic of the period because its essence is an adventure in colonization almost entirely dependent upon prefabrication. In November 1838 an expedition set out from Sydney for the purposes of establishing a military colony, to be manned by the Royal Marines, on the north coast of Australia. The site for the new colony was to be Port Essington, about 140 miles northeast of Darwin. An account of the expedition was given by W. Earle in a letter referred to in the *Colonial Gazette*. Earle, who was on board the *Alligator*, waiting to sail on the 2,400-mile journey to the north, reported "that a brig and a schooner had previously sailed, the latter containing a great many wooden houses for the settlers, and also a wooden church complete, for the construction of which 300l. had been granted by the Bishop of Australia."[63]

These houses, the church, and many other prefabricated buildings, including the hospital, the quartermaster's store, and another large store, were duly erected, generally being placed upon foundations of local sandstone.[64] During the first year, a hurricane ravaged the site, destroying many of the buildings, including the church, which was never rebuilt. Nature was unkind to the new settlement: what the hurricane left of the timber buildings soon fell prey to the savage depredations of termites. After 10 years of endless struggle against a hostile climate and an unbearable isolation, the outpost was abandoned.

As a military, commercial, or political venture, the colony at Port Essington must be considered a failure. Nevertheless, it is not without historical significance. It is a pioneer instance of colonialism being given an up-to-date technical base, an example of what has been aptly called "the technology of colonial expansion."[65] In the Port Essington experi-

ment one can see how the concept of prefabrication had become linked in official thought and imagination with the idea of colonization and emigration. Doubtless, the success of the portable colonial cottage, as exported from Britain to the new settlements in Australia and New Zealand, did much to establish that link.

The advertisements for portable colonial cottages, the prefabricated cottages for emigrants, continued regularly until 1841 and then began to diminish in intensity. It is difficult to estimate the total quantity of business conducted by such firms as Manning's or Thompson's over this period, but it must have been considerable. For years they kept themselves constantly in the public eye through the colonial press. After 1841, however, the volume of advertising and, presumably, the volume of business transacted, began to decline, following the sharp drop in emigration to Australia and New Zealand.[66] The year 1841 had established a peak, with nearly 33,000 migrants to Australia; by 1842 the figure showed a sharp decline, to about 8,500; and by 1845, when the migration had come almost to a complete standstill, with only 830 migrants, the end of an era was obviously near.

By 1845 the advertisements for emigrants' cottages had ceased to appear. The Australian colonies were going through a period of depression, and the attractiveness of migration to the affluent west was pulling enormous numbers to the North American continent. With depression, the availability of labor—always the controlling factor of local production of houses and the inverse key to prefabrication—increased; and the need for prefabricated dwellings inevitably decreased as the strength and capacity of the local industries developed. In 1846 a report of building in Adelaide could confirm "a superabundance of talent both for design and execution."[67]

Moreover, with the change from crisis conditions to a more settled state of development, the euphoria engendered by the "instant" shelter of the prefabricated cottage was gradually replaced by a more critical attitude. As a contemporary observer remarked, "few of the wooden houses sent out from Britain answered the expectations of the importers or fulfilled the promises of the builders." The double-lined houses provided "complete and convenient repositories for many of the noxious and innocuous tribes" of vermin.[68] The single-paneled Manning cottage engendered complaints regarding its inadequate thermal insulation. Here the roof was a greater problem than the walls. Even after 1850, when the specification became far more elaborate than the original tarpaulin—two comments refer to boarding covered with metal tiles[69]—on hot days the rooms below were unbearable. The 8-foot ceiling, moreover, so cozy in England, created intolerable conditions when the external temperature

soared to 100°F. or more. The timber construction was considered a fire hazard, and this problem was compounded by high insurance rates.

Manning must have sensed the chill wind of changing conditions long before these complaints appeared in the press, for he began to diversify his business interests. Perhaps his inventive nature was attracted to the new technological challenges of the day; as early as 1836 he had described himself as a "metal sash and fanlight maker"[70] and, toward the end of 1840, in addition to his continuing business as a builder, he set up an iron and wire works and offered for sale to the colonists "brass and iron bedsteads, iron hurdles, fences, gates, garden-chairs . . . every kind of useful and ornamental wire and iron works."[71] His advertisements for colonial cottages ceased in the middle 1840s, and it would be reasonable to assume that his production ceased, too. Certainly he is not included in the lists of "builders of portable houses for exportation" that appeared in the London directories from 1842 onward. However, two 1850s correspondents from Melbourne, in letters to the *Builder*,[72] talk of their Manning cottages as if they were fairly recent acquisitions, so the final date of Manning's production must be left an open question. With the boom days of the gold rush in Australia there was an Indian summer for the wooden cottage, and perhaps Manning shared in its late fruits. Henry Manning's orthodox business as a London builder continued at least until 1872; and as late as 1895 the firm of Blott, Walt and Manning, Builders, was still listed at the old address at 251 High Holborn.

There is continuing news of Thompson's activities during the 1840s, and as late as 1851 he is recorded in the census as a "colonial architect." According to some reports, he was operating vigorously in 1843. The *Builder*'s attention, for instance, was drawn "to a manufacture which is carried on in this metropolis on a large scale, in preparing wooden houses for the colonies, suited to the necessities of emigrants."[73] The *Builder* illustrated, as an example of this enterprise, a small, two-family cottage (fig. 2.9), and then went on to add, "we regret that the information did not reach us earlier, so as to have enabled us to visit Mr. Thompson's manufactory in the Commercial Road, and to have seen, before it was dismantled for packing a two-storey house of twelve rooms, intended for Madras." In 1844 there are further accounts of Thompson's activities, but these, as with the Madras house of the previous year, are for markets other than Australia. We know, for instance, of a temporary wooden church in Kentish Town, London,[74] and another, an iron church, for Jamaica.[75] However, the Australian market was undoubtedly declining, and with it, Thompson's trade there. It is not with surprise, therefore, that we learn of a falling off of demand in Australia for such houses and that one of Thompson's was ignominiously offered for sale in 1844 at the

Front View.

End Elevation.

Ground Plan.

Figure 2.9. Peter Thompson. Two-family cottage, 1843. The *Builder*, 1843, p. 70. (Courtesy Royal Institute of British Architects.)

wharf at Melbourne "for Building Materials . . . to which the attention of Carpenters and Builders is particularly invited. . . . The dimensions are 62 by 18, and if suitable as a whole will be put up, if started, at one third of its value."[76]

When emigration began to wane in 1844, Thompson, like Manning, recognized the implications and sought viable alternatives. It appears that he turned his attention more and more to the home market, building temporary churches in London at Finchley Road and Maida Vale (1845); Camden Town (1846); Agar Town and South Lambeth (1847); and Westminster and St. Pancras (1848).[77] Outside of London, at Eyot, Eton College, sometime before 1847, he erected a large church capable of seating 900 people. Some of Thompson's temporary churches, surprisingly enough, were of brick, but many were timber structures. The doughty editor of the *Ecclesiologist*[78] approved of this use of timber instead of brick for temporary structures, but—apropos of a church by Thompson for the West Indies—wondered about their suitability as permanent structures in the tropics. From a ritualistic point of view the full-sized chancel drew praise, and there was commendation for the austere interiors, whose religious affect could not be denied. However, there was harsh criticism for the ugly roof line caused by the lack of alignment between the aisle rafters and the spandrel brace of the main truss. These churches were technically advanced, if his original Kentish Town example is at all typical (fig. 2.10): modular in nature, frankly expressing the structure, and exploring new materials such as asphalt sheeting, marine glue, and translucent "vitreous cloth" for glazing. According to Darlington, these innovative buildings were not at all well received by the conservative Metropolitan Building Office. However, no matter how advanced, wood construction was no longer the progressive field; and with his church for Jamaica, Thompson attempted to move into the new, fashionable, and technologically far more challenging era of iron.

The political and economic basis of Britain's industrial revolution was the colonial empire, at once the provider of raw materials and the consumer of manufactured products. The prefabricated house was an early manifestation of the industrialization of the building process; here, too, the reciprocal relationship of the mother country to the colonies was to prevail. Looking at the large-scale production of the portable colonial cottage, the *Builder* drew attention to this phenomenon. "It is quite amusing, and in truth we may say, refreshing, to see this species of manufacture in operation for the benefit of the industries of our own country. The raw material is conveyed hither from the distant foreign tributaries, and operated on by English artisans, to be forwarded in the complete state, ready for setting up, for the comfort and advantage of

PERSPECTIVE VIEW.

SECTIONAL INTERNAL VIEW.

SCALE. _____ FEET.

GROUND PLAN.

SCALE. _____ FEET.

Figure 2.10. Peter Thompson. Temporary church, Kentish Town, London, 1844. The *Illustrated London News*, 7 September 1844, p. 156.

our emigrating fellow-countrymen."[79] The benefits of home production for the colonial market were clearly understood in Britain—so were the responsibilities. Peter Thompson's firm, for instance—and we have no reason to think he was favored with a unique privilege—received a special treasury grant "allowing him to manufacture, free of duty, framed churches, chapels, schools, and dwellings, to export to her Majesty's various colonies."[80]

In 1843, before the flood of emigration temporarily subsided, the *Builder* once more drew the attention of its readers to the conjoined concepts of prefabrication and emigration. An editorial entitled "Emigration" stressed Britain's responsibility to its departing sons and then went on to add, "To us is reserved that especial function of accompanying the emigrant to his adopted home, and catering for his wants as to houseing [*sic*] and shelter. We gave a few weeks ago a draft of Mr. Thompson's wooden houses, and we this week subscribe to the same fund an ornamental cottage, applicable alike to colony or continent. In last week's number also, the iron house of Mr. Laycock would suggest many points of fertile application to emigrants' dwellings. . . ."[81]

At the time of the writing of this editorial, the golden age of the British-made prefabricated wooden cottage was nearly over. From the mid-forties on, the center of gravity of this industry began to shift from England to the United States, where, as early as 1840, the example of Manning had been noted and emulated.[82] In America, the congruence of a native tradition of building in wood and abundant supplies of local timber was reinforced by new demands for easily transportable houses. Deriving its strength from the economics of large-scale production and an expanding market, the American wooden prefabrication industry grew rapidly, first in response to the needs of the California gold rush[83] and then, in the 1860s, to cope with the settlement of the prairie states.[84] This is a chapter in the history of prefabrication that has already been recorded and need not be recapitulated here. But it is of interest to expand the field and draw attention to one example of American timber prefabrication in South Africa, a market traditionally regarded as British in the mid-forties.

According to family tradition, "Martin Beresford who emigrated to the Eastern Province with his family on board the 'Warrior' in 1844, brought with him from England 'four American wooden houses, which he erected on the farms Rietkuil and Brak River near Uitenhage. . . .' "[85] Two of Beresford's wooden houses, joined together, still stand—although much altered—at Nocton Farm, in the Eastern Cape Province. Because their era coincided with the end of the epoch of the Manning colonial cottage, a comparison between the two is instructive.

Superficially, the houses appear to be remarkably similar. The basic

27

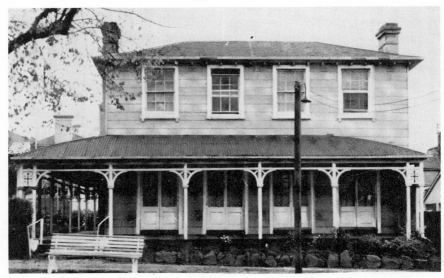

Figure 2.11. Timber house, Jolimont Square, Melbourne, Australia, before 1859. Saunders, *Historic Buildings of Victoria.*

Beresford house is two-roomed, 24' X 12' overall and 8 feet high to the springing of the roof; so, too, is the Manning cottage, as described by Loudon. The Beresford house has a tiled roof (a late-nineteenth-century replacement); Manning proposed a tarpaulin for the roof of his cottages but suggested that "when a permanent situation is fixed upon, the cottages may be covered with shingles, or thatched. . . ."[86] Both houses employ full-length glazed panels, alternating with the solid walls; and the proportions of openings are similar.

However, despite these similarities, the evidence of the construction would appear to confirm a difference in concept and in origin. The Beresford house, according to Bismark van Niekerk, a former owner, is "built like a ship . . . [with] a long beam running under the floors along the whole length of the house"; it is timber-framed and is sheathed with tongue-and-groove boarding.[87] Manning's cottage, on the other hand, represents a much more sophisticated concept, with its modular frame of bolted, interlocking elements and its system of interchangeable infill panels.

In its technical sophistication and its potential for large-scale production the pioneer Manning cottage had special significance. But quantitatively it was overtaken by the American wooden house, for the reasons discussed above. Despite the revival of British interest in the wooden house (fig. 2.11), in the British sphere of influence, in the frenzied era of

the Australian gold rush of the early 1850s,[88] and despite the importance of wooden construction during the Crimean War, the dominance of the British-made wooden cottages receded. Even in Melbourne, the origin of many of the wooden houses was not the mother country.[89] But if international competition was a negative factor in the decline of the portable colonial cottage, the positive and forward-looking factor was Britain's growing preoccupation with the new techniques of building—not in wood, but in iron. The *Builder*, in its leading article on emigration earlier referred to, spoke more prophetically than it knew when, as the first act of the drama of emigration and prefabrication came to an end, it drew attention to the potentialities of the iron house.

The portable colonial cottage had firmly established the feasibility of prefabrication as a technical means to facilitate colonial settlement in the first half of the nineteenth century. Now, in the British colonies at least, its central role had declined. The immediate future lay in another direction, for in emigrants' prefabricated housing, as in so many other aspects of industrial production, the watchword of the Victorian era was to be "nothing like iron."

CHAPTER 3

CORRUGATED IRON AND PREFABRICATION

In its best form, the prefabricated wooden cottage embraced advanced concepts of flexibility, ease of erection, mobility, standardization, interchangeability of components, and dimensional coordination. However, these forward-looking design concepts were linked to a traditional material, timber, and derived from the time-honored crafts of the carpenter and the shipwright. The more progressive manufacturer of prefabricated buildings in the mid-nineteenth century was not restricted to these conventional materials and techniques. He could turn toward a new technology, the technology of iron construction, which had by then been brought to an advanced level of development.

Iron construction, by its very nature, leads to the concept of prefabrication. Iron components of buildings—lintels, windows, balustrading, rainwater goods, columns, beams, arches, trusses—are essentially products of the foundry and the workshop, later incorporated into structures on the actual building site. In the first half of the nineteenth century such products were well known and widely used throughout Britain. This was prefabrication in a partial sense only. However, there were early-nineteenth-century precedents of a much more important kind, precedents for the prefabrication of entire systems, and not merely the incorporation of premade iron elements into otherwise traditional structures.

Bridgebuilding is a notable example of such total prefabrication. As early as 1807 the Coalbrookdale Company (famous for the manufacture of the first iron bridge over the Severn) shipped the components of an iron bridge weighing over 50 tons down to the Bristol docks, and from there to Jamaica.[1] In the years that followed, this became more commonplace: iron bridges were manufactured in British foundries, premarked for later assembly, and shipped great distances to their ultimate

destination. Before 1830, for instance, the Butterley Company of Derby had not only erected the Vauxhall Bridge over the Thames in this fashion but had also sent a cast-iron bridge to Lucknow, for the Nabob of Oude.[2] J. C. Groucott, discussing the elegant cast-iron side bridges over the Oxford Canal, argues that several bridges, identical structures using standard components, were "put together in the works yard, marked, dismantled and put into canal boats for direct shipment to their final site. They could then have been re-erected without the necessity of employing large numbers of skilled operators." The "matchmarks" that ensured correct fitting and jointing can still be seen.[3]

It is suggested that the Oxford Canal bridges were made at the Horseley Iron Works, at Tipton, Staffordshire. According to John Grantham, it was at these works that the first iron steam vessel to put to sea, the *Aaron Manby*, was constructed in 1821. It, too, was made in sections, sent down to London in parts, and finally assembled there in the Surrey Canal docks.[4] Several similar vessels were shipped in sectional form from Horseley to Charenton, near Paris, where they were put together for service on the Seine. In 1833 William Fairbairn built the *Minerva*, a 108-ton vessel about 100 feet long, for the Lake of Zurich. It was "sent in parts from Manchester to Hull, and there reconstructed, and made the voyage from Yarmouth to Rotterdam in 33 hours; steamed up the Rhine to the falls, and then taken to pieces, and carried overland; and again reconstructed on the banks of the Lake." In 1836 Fairbairn shifted his shipbuilding operation to his new yards at Millwall, London. During the next four years, he sent out, in sections, no fewer than 12 iron vessels, many as large as 334 tons, to be variously assembled on Lake Constance, on the Upper Rhine, in Bombay, and in Calcutta.[5] Four of these vessels, built for the East India Company, were "accommodation boats," prefabricated water-borne buildings 125 feet long. It is not surprising that when Fairbairn manufactured his first real prefabricated building, the celebrated iron mill for Turkey, he did so at his Millwall shipyards and not at his foundry and works in Manchester.

Such prefabricated sectional ships were often made of heavy plates, ¼ inch or even ⅜ inch thick, riveted together to form subunits. The firm of Laird and Woodside, of Liverpool, which had been making iron ships since the 1820s, shipped components for three such vessels, fabricated so "that the whole may be with facility put together on arrival at the port of their destination, Monte Video, South America."[6]

Even lighthouses were constructed in this fashion.[7] Perhaps the most famous was Alexander Gordon's 130-foot-high tower for Gibb's Hill, in the Bermudas. This prominent structure of cast-iron plates bolted together first rose, incongruously perhaps, on the grounds of the engineering premises of Cottam and Hallen, near London's Waterloo Bridge, in

31

1844 (fig. 3.1). After this trial erection it was dismantled and shipped in sections to its final destination in the West Indies. From the time of his first project, the iron lighthouse at Morant Point in 1841, Gordon was responsible for many such lighthouses, from the West Indies to Ceylon. Others built these iron towers in Spain and Russia.[8] Prominent constructors of these iron lighthouses were H. Grissell, J. H. Porter, and the firm of Cottam and Hallen—names also associated with the prefabrication of everyday, less romantic structures. Their buildings were sturdy— Gordon's lighthouse at Barbados stood for 112 years, until it was demolished in 1964;[9] and his Cape Point lighthouse in South Africa, manufactured in 1857 by the Victoria Foundry Company of Greenwich, still stands.

By the middle of the nineteenth century, a British designer or manufacturer of prefabricated iron buildings could turn to half a century's experience of iron technology. He could use the materials developed and exploited by the engineers for a wide range of structures. He could learn the techniques of manufacture and assembly from the builders of bridges, iron-framed mills, and railway stations, the makers of pressure boilers and gasholders, the manufacturers of iron and glass hothouses, and from the shipbuilding industry. And now, in addition to the familiar castings of building components from staircases to spires, in addition to the repertoire of cast- and wrought-iron structural elements, in addition to the new techniques of iron roof construction, he had readily available, for the first time, a large-scale, relatively lightweight building element suitable for roofing and wall-cladding: the galvanized, corrugated iron sheet. There are two materials that predominate in the making of the iron house of the nineteenth century. One of these, cast iron, will be discussed in a later chapter; the other, corrugated iron, must now come under scrutiny. When considering the development of prefabrication in the 1840s and '50s, one can hardly overstate the importance of corrugated iron. While the iron frame was a structural system especially important for large-scale buildings of many stories, and the iron truss was related to the problem of the wide span, the development of corrugated iron resulted in a system of construction, a quick and inexpensive means of enclosure that was relevant to all buildings, both large and small. Corrugated iron was considered a material whose strength, portability, impermeability to water, invulnerability to termites, and presumed resistance to fire, gave promise of a sheathing and roofing system infinitely superior to wood. It was a material, moreover, entirely consonant with the spirit of the times, for if it lacked the fruity richness of cast iron, it nevertheless reflected that other attribute of the Victorian era, the quality of stern utility.

The principle of enhancing the rigidity of a sheet of iron by fluting,

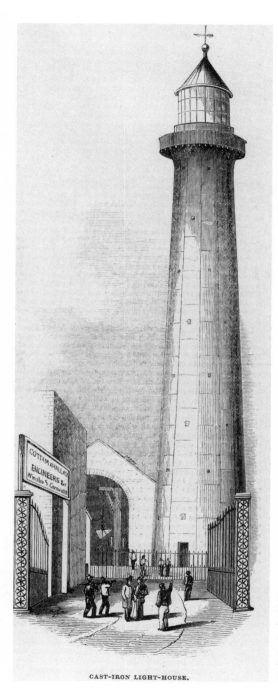

CAST-IRON LIGHT-HOUSE.

Figure 3.1. Alexander Gordon. Lighthouse, Gibb's Hill, Bermuda; erected in the yard of Cottam and Hallen, London, 1844. The *Illustrated London News*, 20 April 1844. (Courtesy British Library Board.)

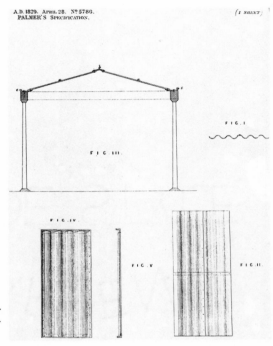

A.D. 1829. APRIL. 28. N° 5786.
PALMER'S SPECIFICATION.

(1 SHEET)

FIG.I

FIG.III.

FIG.IV.

FIG.V

FIG.II

Figure 3.2. Henry R. Palmer's specification, 1829. (Patent no. 5786/1829)

grooving, or corrugating, had long been known;[10] practical problems of manufacture, however, inhibited its development. Sheets could not be produced in a commercially usable size, and were either cast or stamped out laboriously by a machine capable of making only one groove at a time. Corrugated iron proper, fabricated from wrought or puddled iron and corrugated in the black, was first produced on a commercial basis at the end of the 1820s by passing the iron sheet "through fluted rollers when in a red hot state."[11] The first patent concerned with corrugated iron (fig. 3.2) and, in fact, using the term "corrugation," was granted to Henry R. Palmer, a London civil engineer, in 1829. Palmer claimed no priority in the invention of corrugated iron, "the means of producing such forms being well known"; however, he did claim originality for the "application of fluted, indented or corrugated metallic sheets or plates to the roofs and other parts of buildings," these latter referring to walls, doors, shutters, and partitions.[12] In the same year that Palmer's patent was granted, the firm of "Richard Walker, Carpenter and Builder and Manufacturer of the Patent Corrugated Iron," was founded.[13] It is usually assumed that Richard Walker was the inventor of corrugated iron and the patentee of the process of its manufacture.[14] The truth of the matter is that he had acquired the patent, by purchase, from Henry Palmer.[15]

34

However, even if Richard Walker was not the actual originator of corrugated iron, there is no contesting his pioneering role in the practical application of the material to building. By 1832 sufficient progress had been made by Walker to allow him to advertise impressively in Robson's London Directory. The full-page advertisement is headed by the royal crest and the legend "By the King's Royal Letters Patent." An engraving illustrates both straight and curved sheets of corrugated iron and shows a large warehouse consisting of a one and a half barrel vault of this material, supported on U-shaped beams forming continuous gutters and carried on cast-iron columns (fig. 3.3). As the text explains, the curved sheets, riveted together, form a self-sustaining structure, with tie rods for lateral stability. "A new property is given to Sheet Iron by its being Corrugated, or formed, by means of powerful Machinery . . . ," Walker claimed. "A sheet of iron so thin that it will not sustain its own weight, will, after this process, bear 700 lbs."[16]

On the evidence of this advertisement we may assume that by 1832 Richard Walker had acquired considerable experience in the manufacture of the new material and in its practical application. Not only had he "applied it in ways which may serve for the purposes of inspection" at his own factory in Grange Road (fig. 3.4), but he could also point to its use "on an extensive scale" in the London docks—including sheds in the entrance basin, the eastern or new dock, and Hambro's wharf. It is intriguing to note that the engineer in charge of the principal works at the eastern docks was Henry R. Palmer.[17] This use of corrugated iron by Walker was entirely consonant with Palmer's original vision, for in his specification for the patent Palmer had stressed its application "in the construction of warehouses, sheds and other buildings for the protection of property."

Corrugated iron used for roofing constituted an important application of the material at this stage. Since the roof had proved to be one of

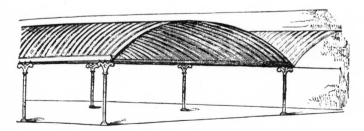

Figure 3.3. Richard Walker. Warehouse, 1832. Engraving from advertisement in Robson's London Directory, 1832; also in Loudon's *Encyclopaedia.*

Figure 3.4. Richard Walker. Corrugated iron factory, Grange Road, Bermondsey, London, 1829. Ordnance Survey map, 5 feet, London, 1st ed., Sheet XI-7. British Museum. (Courtesy British Library Board.)

the intractable problems, not amenable to satisfactory solution using conventional materials, this was a factor of the greatest potential value in the field of prefabrication. The contemporary Manning cottage—the pioneer portable cottage of 1833—although most ingenious in its use of a bolted timber structure and modular timber panels, could suggest nothing more sophisticated for roofing than canvas. Later alternatives included zinc-faced boarding and "patent asphalted felt."[18] The advantages of corrugated iron for roofing over these systems were apparent. However, in the early 1830s there was still a major drawback: unless the iron was painted regularly[19] it was highly vulnerable to corrosion.

It was not until the development of the process of hot-dip galvanizing—Craufurd took out the first British patent in 1837 and Sorel a patent in France in the same year[20]—that a protective surface added durability to the impressive list of qualities already claimed for corrugated iron. Firms other than Walker's were first prominent in the early use of the new galvanizing process. Edmund Morewood had taken out a patent for "preserving iron and other metals from oxidation and rust" in 1841;[21] and there were several patents in the name of the firm of Morewood and Rogers from 1843[22] onward. The partners of this firm advertised themselves as "patentees of galvanized iron" and jealously guarded their rights to the "galvanized" material.[23] One of their products was a 3′ X 2′ sheet of metal, fluted at both edges, known as the "Morewood tile." It was regarded as particularly suited for exportation, since it did not require any skill in laying.[24] Morewood, of course, did not manufacture the original iron sheets; he obtained them from one of the big foundries, and his task was to shape and then galvanize them. Richard Walker probably derived his "black" iron from the same source as Morewood.[25] The first application of iron, both corrugated and galvanized, to roofing in Britain was claimed to have been made by John Porter of Southwark in 1843;[26] corrugated iron covered by zinc was described in a patent application by Morewood and Rogers two years later.[27] Walker, however, whose original product predated galvanizing, continued to lay stress on the "corrugated" nature of his product and offered it, in later years, in either painted or galvanized form.

Walker's process of manufacturing the corrugated iron was cumbersome and expensive. In 1844 John Spencer, an agent for Thomas Edington and Sons of the Phoenix Iron Works, Glasgow, was granted a patent for producing corrugated iron, using either a hot or cold process, by passing it between rollers (fig. 3.5). This process affected the production of corrugated iron significantly, making it available in much greater quantities and at a reduced cost.[28]

In his use of corrugated iron for building purposes, Richard Walker anticipated most of his competitors by at least a decade. Moreover, right

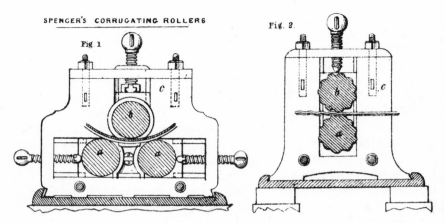

Figure 3.5. Thomas Edington. Machinery for making corrugated iron, 1844. The *Civil Engineer and Architect's Journal*, 1845, opp. p. 264. (Courtesy Royal Institute of British Architects.)

from the beginning, he foresaw the potential of corrugated iron as a material for prefabrication—or for "portable buildings," to use the parlance of the day. He foresaw its use, moreover, not only for roofs, but also for doors, shutters, partitions, and external walls. "It is particularly recommended for PORTABLE BUILDINGS FOR EXPORTATION," he claimed in his advertisement of 1832, "the small space occupied in stowing them, when the respective parts are separated, rendering their conveyance cheap and easy. For New Settlements, the facility with which they may be erected, or removed from place to place is a desideratum of great consideration."[29]

These advantages of prefabrication—use of components, ease of assembly and erection, flexibility, portability—are linked to the idea of providing housing for exportation, especially to the new settlements overseas. From this point of view, Walker's advertisement is a historic document. The substance of the advertisement was included in the first edition of Loudon's *Encyclopaedia*, which was prepared in 1832 for publication the following year.[30] It must share pride of place, in the *Encyclopaedia*, with the classic description of the Manning cottage. Manning's designs were more thoroughly worked out in terms of a conceptually advanced vision of standardization and prefabrication. He had actually built many such cottages before the publication of Loudon's account. Walker theorized in a more general way, limited, perhaps, by the slow acceptance of the more novel material and by the vulnerability of his black iron to corrosion. Manning, at this stage, had a firmer grasp of the concept of prefabrication, while Walker had the courage to embrace a

new technology. Each in his way was a significant pioneer in the history of prefabrication. It is interesting to speculate whether these two men, both carpenters and contractors of London, had knowledge of each other's work prior to its publication in Loudon's book.

Uncorrugated iron roofs had been sent out to the colonies long before Manning's or Walker's time. One of the 1820 settlers to Algoa Bay reported, in a letter to the *Times*, that "one gentleman, who brought out an iron roof, was housed with all his family, in three days and nights, by lodging his roof on stumps of trees, plastering up the sides, and giving it a good white-washing. . . ."[31] Walker's concept of buildings for exportation, although technologically above comparison with this primitive antecedent, sought to exploit the same need for speed of erection in a colonial situation. He, too, looked overseas for his market and began to establish connections with the new British colonies in Australia.

CHAPTER 4

THE PIONEER MANUFACTURERS

From 1837 on, Richard Walker, "Manufacturer of Patent Corrugated Iron," advertised in the *South Australian Record*.[1] In these advertisements he listed a wide range of products and drew special attention to his "Portable Buildings for Exportation," which were made of corrugated iron, a material notable for its "economy, durability, lightness and strength." Possibly it was one of his buildings that served as the first Friends Meeting House in Melbourne;[2] presumably it was Walker's portable buildings that figured prominently in accounts of the first year of the South Australian colony. We know from these accounts that shipments of complete iron storehouses were sent to the new settlement in 1837. Four such buildings arrived at Adelaide in one shipment alone, aboard the *Africaine* from London.[3] In the rough early days of the colony such storehouses were valued as much for their security against theft as for the protection they offered against the weather. Thomas Gilbert, the storekeeper of the South Australian Company, was most pleased with them and reported early in 1837, with evident satisfaction, "At the harbour we have large quantities of stores, where we have put up two of our iron storehouses, which made an impressive appearance each being 40 feet long, 30 wide and 20 high; two more are erecting at Adelaide. . . ."[4]

Walker's work was known in America from an early date. Charles Peterson, for instance, cites a detailed account of Walker's work that appeared in the *Journal of the Franklin Institute* of Philadelphia in July 1833, and infers that William Strickland, a member of the institute, may have been influenced by this publication when he proposed an iron roof for the High Street Market House of Philadelphia in 1834.[5] Although it is possible that Walker was influential in America at this date, it is not known whether he actually exported his products there in the 1830s or '40s. After this promising early start by Walker, we do not hear much

Figure 4.1. William Fairbairn. Corn mill for Turkey, 1840. Fairbairn, *Mills and Millwork*, vol. 2, p. 121. (Courtesy Royal Institute of British Architects.)

about his buildings for export for some years. At home he was busy with such structures as the large iron shed that he erected in 1839 or 1840 for the London terminus of the Eastern Counties Railway. This building was 230 feet long and 77 feet wide; the span was divided into three bays, each covered by barrel-vaulted, corrugated iron roof of elliptical shape.[6] At about the same time, William Fairbairn, Sons, & Co. produced, at their Millwall iron ship-building works, a three-story corn mill intended for Turkey, made entirely of iron (fig. 4.1): cast-iron columns and beams, hollow, square-section cast-iron pilasters filled in with cast-iron plates for the first story, wrought-iron plates riveted to the flanges of the pilasters for the two floors above, the whole roofed with a corrugated iron segmental barrel vault, in typical Walker fashion.[7] Fairbairn had first visited Turkey in 1839, at the request of the Sultan, and he sent out many buildings, including an iron house for the Seraskier Hallil

Figure 4.2. Laycock. Iron palace for King Eyambo, Calabar River, Nigeria, 1843. The *Builder*, 1843, p. 10. (Courtesy Royal Institute of British Architects.)

Pasha.[8] Fairbairn later claimed that the corn mill was, to the best of his belief, "the first iron house" built in England, and that it began a trend: "from that time to the present [1861] a large trade in the construction of iron houses, churches, warehouses, & c., has been carried on between this country and the Colonies, India and America."[9]

One such building for export, the celebrated Iron Palace for King Eyambo, built by Laycock of Liverpool in 1843—"a composite structure of plate and panels of iron upon a wooden skeleton merely," as the *Liverpool Times* described it[10]—is an early example of the use of corrugated iron, if we can judge from the illustration (fig. 4.2); but there is no clear description of the wall covering, and it is possible that it consisted only of flat plates of iron. These panels, according to another contemporary account,[11] were separated into an outer and inner plate between which passed, for insulation purposes, a controllable current of air. Laycock used a similar system in a house that he built for two maiden ladies at St. Lucia in the following year.[12] Not only was the cavity wall com-

posed of iron plates, but the wrought-iron roof was covered by "galvanized plates of iron." There is no mention of an iron or wooden frame here, and it is possible that the wall plating was self-supporting, very much in the way that the upper floors of the Gibbs Hill lighthouse were.

One of the early suggestions that specifically related to corrugated iron in this period came from S. W. Brooke in the *Builder* of 1843.[13] Brooke proposed a timber-framed portable cottage, the external panels of which could be lead, zinc, marine metal, or corrugated iron. His detailed drawings show the application of corrugated iron (fig. 4.3) with alternate details for zinc-faced boards. The internal panel is of prepared canvas or oil cloth. Corrugated iron was also used in 1844 for the roof of an iron-framed church for Jamaica by Peter Thompson,[14] one of the pioneer builders of prefabricated timber houses and churches of that time.

Examination of trade literature expands the limited information we derive from the published sources. It is from a trade catalogue or pamphlet, for instance, that we can learn of perhaps the most significant development in corrugated iron in the 1840s; this came from John Porter of Southwark,[15] whose pioneering use of galvanized corrugated iron we have already noted. The work illustrated in the catalogue dates from about 1844, which is a key date in the history of corrugated iron: Palmer's

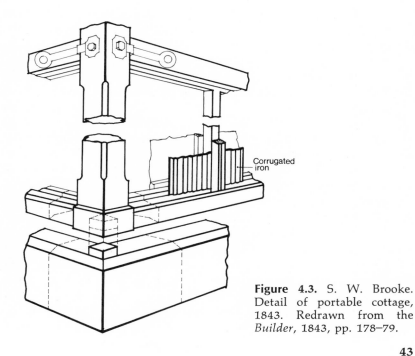

Corrugated
iron

Figure 4.3. S. W. Brooke. Detail of portable cottage, 1843. Redrawn from the *Builder*, 1843, pp. 178–79.

43

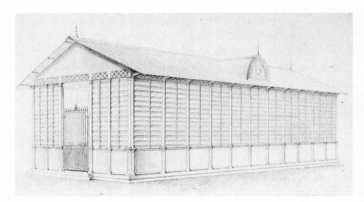

Figure 4.4. John Porter. Market house, San Fernando, Trinidad, 1848. Porter, *Iron Building and Roofing*. (Courtesy Royal Institute of British Architects.)

patent, owned by Richard Walker, had expired the previous year,[16] and then John Spencer developed his new, more efficient process of production in 1844. The result of these two developments was that corrugated iron became much more readily available, and much more economical—according to one source, the cost of manufacturing iron roofs was halved in 1844.[17]

Much of the work of Porter's firm was for industrial purposes in England. The railways, with their increasing demand for stations and carriagesheds, were particularly good customers;[18] so were the gas companies, whose stores and retort houses generated some novel roof forms.[19] The farmers of Britain, too, despite their traditional conservatism, provided a ready market for the experimental products of the new technology.[20]

In addition to producing for the home market, Porter was engaged significantly in the export trade. As early as 1844, a corrugated iron dwelling and warehouse was sent out to a merchant in Hong Kong, and in the same year, iron roofs were exported to the West Indies and Ceylon. Also at this time, following Czar Nicholas I's visit to the British court, one of Porter's galvanized corrugated iron roofs was ordered and dispatched to St. Petersburg. Apart from an iron cottage and a warehouse sent out for a merchant emigrating to the Cape of Good Hope in 1846, most of Porter's subsequent exports were to the West Indies. The flexibility and strength of iron were assets in this earthquake- and typhoon-prone area, as Laycock had previously discovered.

From 1846–49 a series of stores, warehouses and churches were exported to the Caribbean.[21] One of the most interesting of these buildings is a market house for San Fernando, Trinidad (fig. 4.4), built in

1848. It is an immaculately detailed, beautifully engineered structure of a strictly modular nature. The columns are cast iron, of I section; between the columns are standard panels consisting of a corrugated iron spandrel with an infilling of galvanized sheet-iron louvers. A lightweight, lattice-work beam connects the heads of the columns on the outer periphery. There are light roof trusses of wrought iron covered by galvanized corrugated iron roofing. The 22-ton building, delivered to the London docks, cost £550. With an anticipated erection cost of only a further £100, the total expenditure seemed well worthwhile, especially since, in Trinidad as "in many of the colonies, building materials [had] to be imported at a great expense, and the high price of skilled labour [acted] as a powerful preventive"[22] to the substantial constructions necessary to withstand the hurricanes and earthquakes of the region.

In general principle but not in detailed construction, the louvered walls of the market house foreshadow those of the Crystal Palace, which followed a couple of years later. The latter were manufactured by Tupper and Carr, whose Galvanized (Patent) Iron Co. had offices adjoining those of Porter in 1850, at Mansion House Place.[23] One may speculate that there was some association between these firms, at least at the time of the building of the Crystal Palace. Both firms continued in business for some time; the firm of John H. Porter continued in existence, in London and Birmingham, at least until 1864,[24] and Tupper and Carr had an important place in the history of prefabrication during the next 40 years.[25]

It is interesting to note that a large iron market house, similarly ventilated by louvers or "jalousie blades," had been manufactured by the Phoenix Iron Works earlier, and sent out to Honduras in 1846. The *Builder* admired this all-iron structure "where due attention [had] been paid to ornament and architectural beauty, whilst at the same time lightness, combined with great strength, [had] been studied," and was moved to comment, "Iron steam-vessels are rapidly superseding all others, and we make no doubt that iron houses will, in the course of time, become common."[26]

The extent and range of production of iron buildings in the years that followed certainly bore out this prophecy. For instance, Morewood and Rogers, in their catalogue of 1850, illustrated many examples of prefabricated iron cottages, houses, and warehouses that were available for export. The destination of these iron buildings is not indicated, but since the firm maintained an agency in Melbourne,[27] it is reasonable to assume that some, at least, found their way to Victoria. It is known that at least 26 iron houses were imported in that colony between the years 1842 and 1847.[28]

But in all this there is no news of Walker of London. The factory stayed in existence, and, from advertisements and entries in the London

directories, we can begin to put forward a tentative history of the firm. If we look more closely at Walker than at some of his contemporaries, it is perhaps for the reason that in the story of Richard Walker the father, who pioneered the production and application of corrugated iron, and of his sons Richard and John, who played an important role in the subsequent exportation of prefabricated iron buildings, we have a historical vignette that encapsulates in one generation the pioneer phase of industrial prefabrication in corrugated iron, from its initial inception to its maturity.

For more than a decade, from 1829 to 1842, the firm of "Richard Walker Patent Corrugated Iron Factory" had operated in Bermondsey, generally at Grange Road. In 1843 Walker was listed merely as "Carpenter and Undertaker"—that is, contractor. In 1845 a significant change occurred—the name appeared as "Richard Walker and Son." This son, presumably, was Richard Jr.,[29] although one report indicates that two sons of the pioneer were then active in the firm.[30] The following year Richard Walker, the father, either died or retired from business, and from 1846 to 1849 the firm is listed as "Walker, Richard and John," and is referred to either as "Carpenters and Undertakers," or as "Manufacturers of Portable Houses." From 1848, the term "Patent Corrugated Iron Factory" is once more added to the description.

The partnership appears to have broken up in the middle of the century. The entries in the various directories from 1850 onward show two separate names: "Walker, Richard, son of original patentee, Grange Road," and "Walker, John, son of original patentee, Ferry Road, Millwall, Poplar; Arthur Street West, 32 King William Street, City." It seems that the two sons of Richard Walker went separate ways; whether in fact the brothers maintained some form of business connection or relationship is not known to me.[31] The original firm of Richard Walker continued, under various proprietors,[32] but always with the appellation: "Late Richard Walker, Son and Successor to the Patentee"—or at least until 1887. Of John Walker the son, in whom our interest now principally focuses, there was no news after 1862, when the last entry bearing his name appeared in the directory.

In 1849 there is the sudden flowering of the California trade in iron prefabs. The gold rush of that year and the massive exodus to the West precipitated an urgent demand for housing that the manufacturers of prefabricated structures in both Britain and America hastened to satisfy. As Charles Peterson has so adequately documented, not only were timber structures sent to California from all over the world, but iron houses were also supplied in vast quantities.[33] Our present interest is not in reiterating this story but, rather, in examining the British connection.

In the early 1850s America imported more iron than it produced;

half of the large British output of iron was being sent across the Atlantic.[34] How much of this was corrugated iron we do not know, but at least one British manufacturer, Morewood and Rogers (who claimed sole rights to the North American market), certainly exported galvanized iron to the United States in the 1840s. They supplied many large American buildings with their iron roofs,[35] and they sold galvanized iron to Peter Naylor of New York,[36] who, during the California gold rush, was perhaps the largest American manufacturer of prefabricated iron houses, shipping more than 500 houses to the West in one year. But in addition to supplying the material, British manufacturers participated more directly: they found it profitable to export complete iron buildings—in component form for reassembly—to California. Presumably (on the basis of the long British experience), they could be competitive with the New York product built out of imported British iron sheets.

During this frenetic spurt of new construction there is further mention of the production of iron buildings for export by a Walker of London. We refer now to John Walker, who for many years had been associated with his father and his brother, had shared their experience, and had benefited from their accumulated technical knowledge. In July 1849, we learn, John Walker had at least eight prefabricated iron houses under construction and had shipped to San Francisco a corrugated iron storehouse (fig. 4.5) two stories in height, 75 feet long and 40 feet

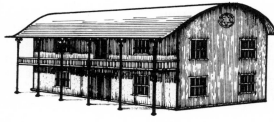

Figure 4.5. John Walker. Iron storehouse for San Francisco, 1849. Redrawn from the *Illustrated London News*, 14 July 1849.

wide.[37] The debt this large building owes to the original Richard Walker precedent is immediately apparent: we see the same arched roof form and the same cast-iron columns with foliated capitals that had been illustrated in the original advertisement 17 years earlier. There are other parallels. The report on John Walker's California building notes that corrugated iron "is peculiarly adapted for portable dwellings and storehouses, being very light, and packing so close, that the expense of freight is comparatively small." This is merely a paraphrase of Richard Walker's 1832 statement on the advantage of corrugated iron for prefabricated portable buildings. In form, structure, and principle of portability, there

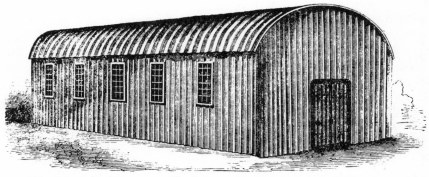

MOREWOOD AND ROGERS'S **No. 5.** PATENT CORRUGATED GALVANIZED TINNED IRON.

FIRE-PROOF STORE, with arched roof, 100 feet by 40 feet, entirely of corrugated Galvanized Tinned Iron. This form of roof requires no framework of any kind, the metal being arched supports itself, the edges only resting on a wall-plate, a stout Iron gutter is generally so placed that it serves both as a gutter and a wall-plate, the bottom edge of the roof being rivetted flange on the back of it. The sides are supported by iron columns and a skeleton frame, and from side to side are Iron tie-rods which counteract the outward thrust of the roof.

Figure 4.6. Morewood and Rogers. Fireproof store, c. 1850. Morewood and Rogers, *Catalogue, Galvanized Tinned Iron.*

is a direct line of evolution from 1832 to 1849; it is apt that the news-paper reporting the achievement of John Walker should note that he was "the son of Richard Walker, the original manufacturer and patentee."

The arched roof form that Richard Walker specified in detail in 1832 became a generic type. The corrugated iron sheets, curved to form a self-supporting skin, required no roof truss, only the restraint of an iron tie rod. This simple structure, now used by John Walker, may be seen in a wide range of examples from many sources. It was used in the coal depot of the London gas works at Vauxhall in about 1837;[38] it was used by Fairbairn for the iron mill that he designed and sent to Constantinople in about 1840; John Porter made extensive use of the form in many of his buildings in Britain and the colonies in the 1840s;[39] Morewood and Rogers illustrate its application both in open shed and closed warehouse form (fig. 4.6). In the 1850s we find many examples in the illustrated work of Charles D. Young & Co. that were being sent to America and Australia;[40] it was used by Badger, the pioneer manufacturer of iron buildings in New York, for a large sugar shed in Havana;[41] it was used in British army camps at home, and, as early photographs reveal,[42] it was employed extensively in the field during the Crimean War. Tupper & Co. illustrated it in their advertisements at least until 1865; we find it in the 1873 catalogue of Francis Morton & Co., where it was used to roof an entire range of structures from cottages to factories (fig. 4.7); it appeared in Walker advertisements as late as 1887; Braby & Co., in 1889, called it "the cheapest form of roof that can be supplied". By 1890 two hotels, three stores, and the fire station on the Johannesburg market square

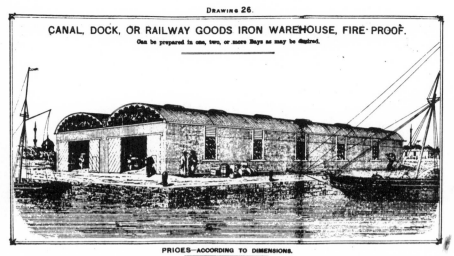

DRAWING 26.

ÇANAL, DOCK, OR RAILWAY GOODS IRON WAREHOUSE, FIRE·PROOF.

Can be prepared in one, two, or more Bays as may be desired.

PRICES—ACCORDING TO DIMENSIONS.

NOTE.—For Export all the parts are carefully marked and fitted ready for putting up; when this is done, and with the Drawings furnished by Francis Morton & Co. for the guidance of the workmen, the erection is readily accomplished.

OUR ONLY CORRECT ADDRESS IS—**FRANCIS MORTON & COMPANY, LIMITED, NAYLOR ST., LIVERPOOL.** London Branch—36, Parliament Street, Westminste
ESTABLISHED OVER QUARTER OF A CENTURY. Glasgow Branch—Bank of Scotland Buildings, George Square.

Figure 4.7. Francis Morton. Iron warehouse, 1873. *Catalogue, 8/b.*

were covered with it;[43] in our own time, it is still found in many unpretentious sheds and warehouses.[44]

This arched roof of corrugated iron appears in several contemporary views of San Francisco at the time of the gold rush. Other British manufacturers besides John Walker contributed to the increasing number of iron buildings of various forms. John Grantham, a noted Liverpool engineer, designed a large iron shed—corrugated iron sheathing and roofing on a wooden frame—which was built in the engineering works of Vernon and Son, the iron shipbuilders.[45] This building, when it was assembled on the banks of the Mersey prior to being dismantled, packed into crates, and shipped to California, evoked much public interest because of its sheer size (110′ X 30′ X 20′ high), the unfamiliar dazzling brightness of its galvanized finish, and the speed of its manufacture and erection: only 23 working days. Grantham was also patronized by the American army; War Department records of 1849[46] show a large, bow-roofed iron barracks, and a vast corrugated iron warehousing system, comparable in scale with the warehousing that, by then, had been erected at many British dockyards.[47]

This activity of Grantham in the field of prefabrication is especially interesting because it was peripheral to his central concern, which was the design of iron ships. He had written a well-known study, *Iron as a Material for Ship-building*,[48] and at the Great Exhibition of 1851 he

49

chose to exhibit a model of an iron ship. We have already commented on some of the links between shipbuilding and prefabrication. It is perhaps relevant, therefore, to note that galvanized iron also had its application in ship construction. F. & H. J. Morton, of Liverpool, advertised their galvanized tinned iron, not only for building purposes—they made roofing and iron buildings for export—but also advised shipbuilders of the material's suitability for sheathing, claiming that "vessels have arrived in New South Wales sheathed with this Metal, and, after three years constant service, required no repairs;"[49] and both the Galvanizing and Corrugating Iron Company—which galvanized John Walker's black corrugated iron for him—and Tupper and Carr advertised in their trade pamphlets that they had supplied large quantities of galvanized sheathing for shipbuilding purposes.[50] There are also structural analogies to be drawn between iron houses and ships. For instance, an enormous iron house—so large that a banquet was served to 200 guests in one of the rooms—made by M'Kean and Perkes of the Victoria Works, Birkenhead, and shipped to California, utilized a system of T-iron framing "not unlike that used for ordinary deck-beam purposes."[51] In the search for light but rigid construction there were, as William Fairbairn had demonstrated 10 years previously, some technological gains made in linking the shipbuilding and prefabrication industries.

A former apprentice of Fairbairn's, Edward T. Bellhouse, eventually entered the field as a competitor for the Californian iron prefab market. After his apprenticeship, Bellhouse became a partner in his father's firm of iron founders and constructional engineers at the Eagle Foundry, in Manchester. This great engineering establishment had many diversified interests—ironfounders, millwrights, hydraulic and screw press manufacturers, boilermakers, general contractors—and it continued, under the style of E. T. Bellhouse & Co., for about 50 years.[52] In light of their wide-ranging output and because they were listed in the trade directories only under the general category of iron founders and not the specific categories of portable or iron building manufacturers, we have to assume that the production of iron buildings was a secondary and, perhaps, short-term, interest, rather than a central activity of the firm. It is almost certain that they themselves were not direct producers of corrugated iron, but purchased this material from other manufacturers, probably Morewood and Rogers.[53] For a few years the involvement with portable buildings was intense, and for Bellhouse there was always the technological challenge that provoked his inventive engineer's mind. But after about a decade of producing some fascinating buildings, Bellhouse's activity in this field apparently ceased.

At the time of the California gold rush Bellhouse's work was well reported in the British press.[54] His small and large houses and his large

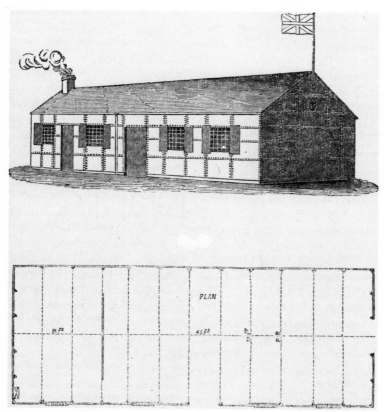

Figure 4.8. Edward T. Bellhouse. Iron warehouse for California, 1849. The *Mechanics' Magazine*, 1849, p. 441. (Courtesy British Library Board.)

warehouses, all of which used a T-iron framing system covered with iron sheets, drew much attention. At first, it would seem from the descriptions, Bellhouse used flat, wrought-iron plates, ⅛″ in thickness, bolted to the frames; an early illustration (fig. 4.8) seems to confirm this.[55] But soon he replaced the heavier flat plates—which he retained only for internal partitions—with sheets of corrugated iron that measured 6′ X 2′. In his more elaborate houses the interior is lined with boarding and battens. For further information on his corrugated iron buildings we must turn to a somewhat surprising source, the *Algemeine Bauzeitung* of Vienna,[56] which reported on two types: a large, two-story warehouse and residence, complete with hipped roof, and what appears to be a rooming house, with 12 rooms either as separate or linking units. These were

51

relatively expensive buildings, as were some of Bellhouse's larger and more elaborately equipped houses, costing from £500 to £1,000. In addition, Bellhouse produced a range of small cottages for workmen, hardly larger than one- or two-room cabins, which cost £40 to £80 each. According to Peterson, several hundred of these houses were exported to San Francisco.

These cottages and larger buildings manufactured by Bellhouse present us with a problem. Charles D. Young & Co., a large firm of Scottish ironfounders, were the manufacturers of some interesting cast-iron prefabricated structures, the significance of which we will consider in a later chapter. But in addition to these "more costly massive and elaborate designs"—which were obviously to Young's taste—he produced a more utilitarian product, a range of simple corrugated iron structures for export, which he described as "the commoner class of Iron Structures largely in demand for various quarters of the world, from their convenience, strength and utility." Young illustrated these utilitarian structures in his catalogue of the mid-1850s:[57] they are cottages and houses identical in form and dimension to those produced by Bellhouse for the California trade in 1849. Only in one respect do they differ: the external walls of Bellhouse's buildings of this early period are of corrugated iron, the corrugations running vertically; in Young's example, the corrugated iron is used horizontally, as infill panels between exposed iron columns. This latter system is, in fact, the method described by Bellhouse in 1853, when, as we shall see, he patented his prefabricated building system. The similarities are too great to be merely coincidental. Because of the obvious dependence of Young's buildings upon those of Bellhouse, and because there is no evidence of a business relationship, we have an enigma here. Was Young copying these buildings with Bellhouse's consent, or is this an early example of industrial plagiarism?

While gold fever raged in California, Britain prepared to astonish the world with the Great Exhibition of All Nations. Within the glass walls of the Crystal Palace—itself the great exemplar of nineteenth-century prefabrication—we find the pioneers of prefabrication demonstrating the potentialities of the new materials and techniques.[58] Morewood and Rogers displayed a wide range of galvanized corrugated iron sheets, rainwater goods, and other building products, as did Tupper and Carr (who also, as we have seen, made the louvers of the building itself). In addition, Morewood and Rogers showed a model of a farmyard whose buildings were constructed chiefly of patented galvanized iron. Cottam and Hallen demonstrated some of their cast-iron building elements, such as staircases and railings—their manufacture later became an important industry. And Bellhouse, together with a series of hydraulic presses, brickmaking machines, and mechanical hoists, displayed a model of an

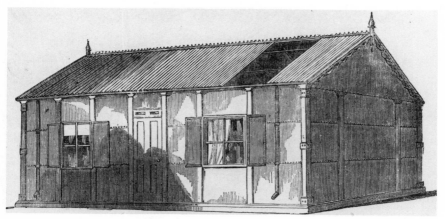

Figure 4.9. Edward T. Bellhouse. Iron cottage for emigrants, 1851. *The Illustrated London News*, 20 September 1851. (Courtesy British Library Board.)

iron cottage (fig. 4.9), with cast-iron columns and corrugated iron sheathing, for emigrants.[59]

The designation "for emigrants" indicates that this cottage is not for the California miner. Indeed, by this time, the intense but short-lived San Francisco boom was over; however, the expanding colonial and financial empire presented continuing opportunities to British firms. British industry in 1851 stood at the height of its power, and the reputation of its engineers and its manufacturers was at its apogee. Recognition at home and profitable orders from abroad: this was the pattern of the day. Bellhouse himself received the highest accolade, an order for an iron building from no less a patron than the Prince Consort; his iron ballroom for Balmoral Castle—inspired by Prince Albert's admiration for the technical ingenuity of his emigrants cottage and based upon a similar system of construction—was widely reported[60] and greatly admired. In this building the corrugated iron sheathing ran horizontally between cast-iron columns: the horizontal ribs enabled the iron to span the 8 feet between supports without intermediate framing, but caused complication at the junction of the corrugated iron sheet and the pilaster. Bellhouse, ever the inventor, responded to this technical challenge and, to solve the problem, produced a special column, which he patented[61] and used in most of his later buildings, designed in the post-California period (fig. 4.10).

The capacity of British industry had been expanded and developed by the American interlude. Now it turned once again to its traditional links and markets: to Africa, Australia, India, Ceylon, the West Indies, and to those Republics of Latin America whose economies were strongly oriented toward Britain. John Walker was one of the many manufactur-

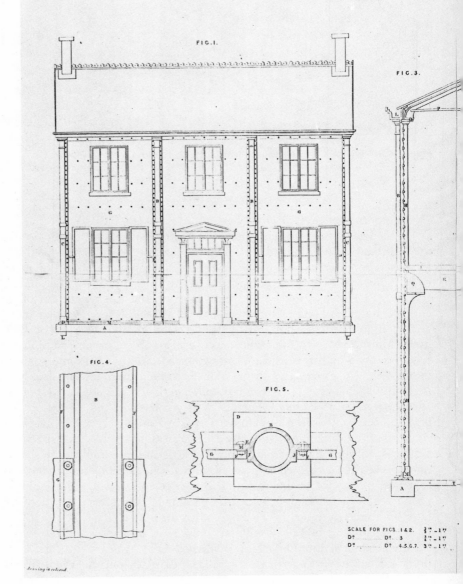

FIG.1.

FIG.3.

FIG.4.

FIG.5.

SCALE FOR FIGS. 1 & 2.

D.º D.º 3.

D.º D.º 4.5.6.7.

Drawing is colored.

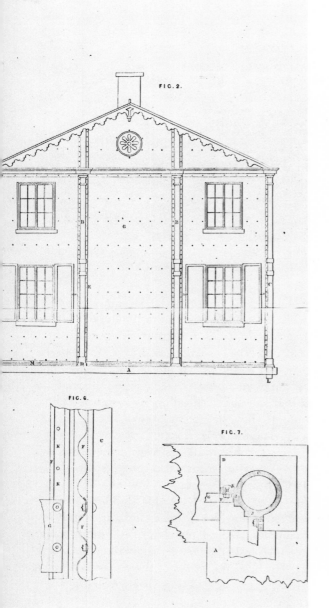

Figure 4.10. Edward T. Bell-house. Patented iron house, 1853. Front and side elevations; structural details. (Patent no. 609/1853)

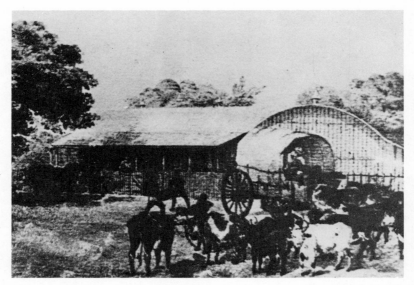

Figure 4.11. John Walker. Hotel converted to store, Port Natal, South Africa, 1850. (Courtesy Durban Museum and Art Gallery.)

ers of iron prefabs who capitalized on the experience gained in California; they turned their newly developed production potential to these areas of settlement and expansion. In 1850, for instance, we learn of a Walker contract to ship a spacious hotel of corrugated iron, "one of the largest structures yet made of this material," to Port Natal.[62] The hotel had a frontage of 78 feet, a depth of about 60 feet, and contained 20 large rooms. It was intended that the floor and ceiling be installed at Port Natal. The building was put on show for some weeks before it was shipped out on the *Globe* by emigration agent J. C. Byrne.[63] An old painting[64] shows a building unmistakably Walker's, with arched roof and a veranda on the long side that is carried on cast-iron columns (fig. 4.11), a single-story version of his California warehouse. However, Byrne ran into financial and other difficulties, and in 1854 this building was included in his insolvent estate, suffering the ultimate indignity of being offered for sale by E. C. Lamport, a Natal merchant, as building material.[65] It was advertised in the *Natal Mercury* in February and March 1854, in the following terms: "For Sale: the whole of the materials known as BYRNE'S IRON HOTEL, consisting of corrugated iron sheets, roofing, angle iron, doors, window frames, gutters and piping, rivets & c. Part is in good condition, and can be readily and economically applied to the construction of any sized sheds and buildings, from a pigstye to a sugarhouse."

The versatility of the iron prefab could not be more graphically demonstrated.

This was one of several iron buildings sent out at that time to Port Natal. There were occasional advertisements in the *Natal Mercury* offering to sell or rent "commodious" or "well-finished" iron houses. In 1856 Lamport once again offered for sale "a large Corrugated Iron shed, 40 feet by 20 feet . . . in good condition, forming a large amount of building material, which could readily be re-erected at small expense, in any other convenient form."[66] This was obviously one of those "warehouses of corrugated iron, having usually a circular roof," that, according to Hattersley , replaced wattle and daub for mercantile establishments in the early years of the 1850s. "The Exhibition of 1851," Hattersley goes on to explain, "caused iron to be greatly admired as a building material, and a sugar store, later erected in Commercial Road (Durban) was actually a portion of Paxton's Hyde Park Edifice."[67]

By 1857 small quantities of imported galvanized corrugated iron sheets in 6- and 8-foot lengths, together with guttering and ridge caps, were being offered by the Durban merchants. In 1859, however, after the customs duties were altered, large quantities of galvanized iron sheets, fittings, and rainwater goods were imported, and, with the ready availability of the building material in Natal, interest in the imported prefabricated iron building declined.[68]

Port Natal was a British colony; Chagres was a port on the Isthmus of Panama partly developed by British initiative. Walker built a large two-story house of galvanized corrugated iron there in 1853, complete with surrounding veranda, a typical colonial feature (fig. 4.12). This house was for the Royal Mail Steam Packet Company and was to serve as the headquarters of the superintendent and port officers. The correspondent of the *Builder* who inspected the house as it stood, erected on the site of the Walker factory, was greatly impressed, saying, "Although it is, of course, to be taken to pieces in order to be embarked, and will weigh about 40 tons, yet when erected . . . it will present to the eye the appearance of a perfect, permanently built private residence, within and without, in all the details of paper, paint, & c."[69]

The importance of Chagres hinged on the California gold rush. It had grown with the exodus of the fortune seekers, and its decline dated from 1855, with the completion of the Panama railway. On the opposite side of the world, another gold strike, this time in Victoria, Australia, in 1851, was creating similar boom conditions, and generating equally urgent demands for housing. Walker, now an experienced manufacturer and exporter, turned his attention to the Antipodes, where the young town of Melbourne, close to the Ballarat gold fields, experienced unprecedented growth and suffered the inevitable shortage of housing. "The

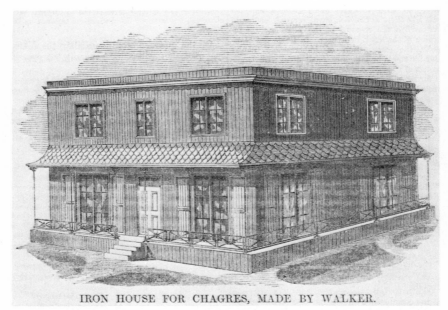

IRON HOUSE FOR CHAGRES, MADE BY WALKER.

Figure 4.12. John Walker. House, Chagres, Isthmus of Panama, 1853. Redrawn from the *Builder*, 2 July 1853. (Courtesy Royal Institute of British Architects.)

population is swelled by the arrival of thousands of immigrants weekly from England and the neighbouring colonies," a correspondent complained, "while there is no corresponding increase in house accommodation."[70] With the high price of labor, disproportionate land rents, and scarcity of materials, conventional building was costly and difficult. The conditions were right, however, for the exporters of prefabricated buildings—like Walker.

Seeking to exploit these new opportunities, John Walker advertised in the Australian press[71] during 1853, as his father had done 15 years previously; his business prospered. His range of houses spanned from modest two-room cottages that he sold for £40, to large mansions costing £5,000.[72] So far my researches have failed to uncover any information as to the design and construction of these houses. Literature searches have not been productive of detailed information about his basic product, the iron house. We have discovered no pamphlet or catalogue of Walker's such as those we have of his competitors Porter, Morewood and Rogers, Hemming, or Young (fig. 4.13); we have no Walker drawings submitted to the patent office, as we do in the case of Bellhouse. So, while we know something of the nature of his rivals' houses, we know nothing of Walk-

er's. Moreover, despite the excellent quality of the corrugated iron of the 1850s,[73] not many iron houses of that period appear to have survived to the present day (fig. 4.14).[74] Among the few that did, one well-preserved example is known to have been manufactured by Walker. This is the iron house at 388 Coventry Street, South Melbourne, which has been described by its present owner, the National Trust of Australia, as "the most complete example of John Walker's prefabricated houses."[75] Notwithstanding the paucity of extant examples, Walker's original produc-

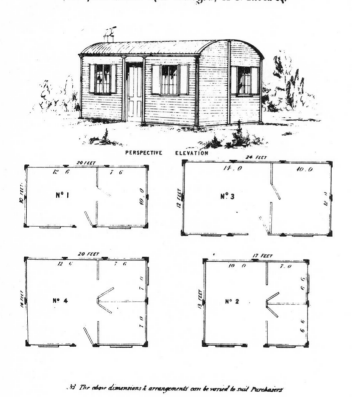

Figure 4.13. Charles D. Young. Iron cottages, c. 1855. C. D. Young & Co., *Illustrations of Iron Structures for Home and Abroad.* (Courtesy Royal Institute of British Architects.)

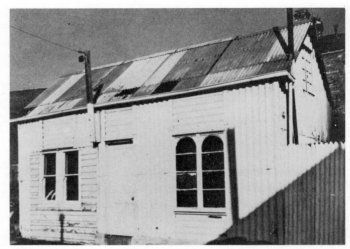

Figure 4.14. Iron cottage, South Melbourne, Australia, c. 1853. (Copyright © John M. Freeland, *Architecture In Australia*, p. 113.)

tion must have been on a large scale. By May 1853 he could claim to have erected "many hundreds of houses;"[76] in July the *Builder* noted that Walker had "in course of construction thirty-six iron houses for the residences of emigrants sent out by Government to Australia."[77]

These figures suggest an undertaking of some considerable size. Here was no modest workshop, but a modern industrial process; it is significant that contemporary accounts referred to Walker's "factory." In 1853, which was probably a peak year, this factory occupied over three acres of ground, employed upwards of 400 men, and had a weekly wage bill of £800.[78] By 1855, corrugating by steam power, John Walker was capable of producing 100 tons per day[79] and was supplying the trade as well as his own needs. Besides manufacturing corrugated iron and running an iron foundry, he acted as a builder and contractor, and now even had his own saw mills; in addition to his works, he had, at London Bridge, a design office "where experienced draughtsmen [were] kept to furnish designs and estimates."[80]

When it is realized that John Walker was only one of a large number of manufacturers of galvanized iron buildings and components, the scale of mid-nineteenth-century prefabrication for home and abroad assumes significant dimensions. At the original site at Grange Road where old Richard Walker had started manufacturing, Walker's Corrugated Iron Works, first under the direction of John's brother Richard, and then under new proprietors, continued in production at least until 1889. They

remained contractors for iron structures, as they had been for over 50 years; in the directories they were listed throughout the years as manufacturers of iron houses and churches; and they produced the material—the sheets of corrugated iron—that they offered for use in "workshops, stores, dwelling-houses, churches and schools."[81] We have already noted something of the scale of activities of Morewood and Rogers, who maintained links with the United States, a dealer in Jamaica, and an agency in Melbourne. Then there were firms in Scotland such as Robertson and Lister of Glasgow, whose production of churches and warehouses was so extensive that, it was reported, "fifteen of the giant structures in corrugated iron occupied the grounds" of their factory at one time.[82] And C. D. Young & Co., to whom we have already referred, had branches in Glasgow, Liverpool, and London (the main works at Edinburgh were reputed to "cover several acres"),[83] and a peak labor force of over 1,000 workmen.

Many of these firms were diversified, producing a wide range of engineering products from machine castings to bridges, in addition to corrugated iron buildings for export. But one significant firm specialized in these portable buildings: the Iron Building Manufactory of Samuel Hemming, of Bristol and Bow.[84]

The entry "Samuel Hemming, civil engineer and railway contractor, of Merrywood Hall, Bedminster," appears in the Bristol directories from 1841 to 1856. In addition, from 1854, a Samuel C. Hemming is listed at Coronation Road; presumably this is the same person, but it might be a son of the engineer.[85]

Coronation Road was the location of Clift House, on the banks of the Avon, at Bristol. Here stood the extensive factory of Acramans, Morgan & Co., which was taken over by Samuel Hemming in 1852 for the purpose of manufacturing "portable houses, simple in construction, perfect in arrangement, efficient in character, and easy and inexpensive of carriage." This factory (fig. 4.15), variously referred to as Hemming's Patent Improved Portable Building Manufactory, the Clift House Factory, or the Avon Clift Iron Works, with a board of directors both British and Australian, was active at Bristol until 1854 or 1855, when Hemming transferred the firm to London and reestablished the Clift House Works at Bow. There they continued as builders of portable iron structures at least until 1870.[86]

Hemming's principal fame, perhaps, comes with his pioneering development of the portable or temporary church, both for home requirements and for exportation. We will deal with this aspect of his work in a later chapter; at this juncture we are concerned with Hemming's production of residential and commercial buildings. As with Manning, the pioneer of the portable timber cottage, Hemming's original motivation to

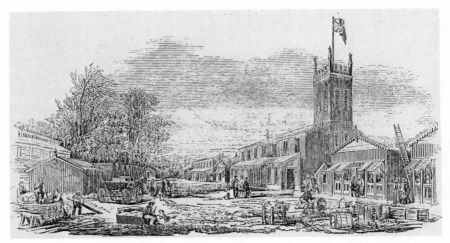

Figure 4.15. Avon Clift Iron Works, Bristol, England. The *Illustrated London News*, 1853.

develop a prefabricated dwelling came from his desire to provide his son, an emigrant to Australia, with some form of durable shelter. "Clift House Factory did not originate in the *counting-house*, but in the *Parlour*," a contemporary account tells us. "The proprietor has been himself under tropical suns and in tropical rains; and his inventive genius provided for his son a house which should comprise portability, security, and be put up without any difficulty or trouble, by the most inexperienced hands. Other parties who saw it wished for similar accommodation; but one required more room, another wanted a shop; Mr. Hemming saw at once the capability of this principle of construction for adaptation to almost every conceivable want and climate, and the Clift House Factory started with its hundreds of busy operatives."[87]

Hemming's factory flourished. He received the commendation and active support of that stalwart of the colonial movement, the formidable Mrs. Chisholm,[88] who visited his Bristol works at least on two occasions, and actively promoted the idea of the portable cottage as a means of assisting the settler in search of a dwelling. Thus motivated and thus encouraged, Hemming diversified and expanded his production of prefabricated buildings for export. A catalogue (fig. 4.16) of this date indicates the range of his production. There were simple cottages (fig. 4.17), medium houses, and large houses—he had built at least twelve of the latter, one for the Archbishop of Sydney. There were sumptuous villas with two reception rooms, six or seven bedrooms, even a butler's pantry and a library. Prices ranged from 50 to 850 guineas for these

dwellings. Then there were commercial buildings: small shops with simple dwellings attached, or a whole row of shops with six three-room apartments above them, destined for Melbourne. The *pièce de résistance* of the catalogue was a hotel for 80 persons, a handsome two-story structure, complete with veranda, costing 2,500 guineas (fig. 4.18). Our knowledge of Hemming's work is expanded by contemporary newspaper accounts.[89] Here we see further examples of ranges of shops and dwellings (fig. 4.19), and an ambitious three-story "iron bazaar" made for Miles and Kingston of Bristol, and shipped out by them, in about 1855, to Melbourne (fig. 4.20).

This wide variety of products is marked by an extraordinary uniformity of appearance. They all stem from one system of construction: a wooden or iron frame sheathed in corrugated iron externally and lined with ½" boarding. Windows come complete with spandrel, so wall and window units are rectangular elements that run cleanly from floor to ceiling, giving a remarkably modern appearance. There are full-glazed, half-glazed, louvered, and shuttered modular units, offering a wide range of alternative fenestration options. Roofs are narrow spanned and double pitched, with gable ends; they are kept low—large plans comprise multiples of smaller roofed units. Here we have a definite house style. Of all

EAST INDIA VILLA.

HEMMING'S PATENT IMPROVED PORTABLE HOUSES,

SOLE MANUFACTORY, CLIFT HOUSE, BEDMINSTER, BRISTOL.

Figure 4.16. Frontispiece to Samuel Hemming's catalogue, c. 1854. *Hemming's Patent Improved Portable Houses.* (Courtesy Baillieu Library, University of Melbourne.)

Figure 4.17. Samuel Hemming. Small portable cottages, c. 1854. *Hemming's Patent Improved Portable Houses.* (Courtesy Baillieu Library, University of Melbourne.)

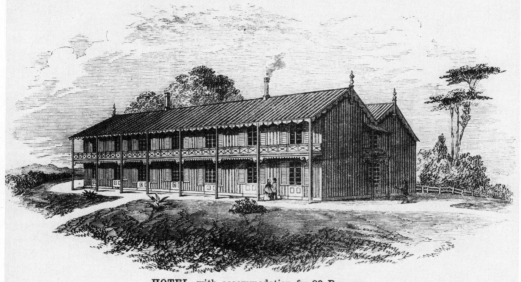

HEMMING'S PATENT IMPROVED PORTABLE HOUSES,
SOLE MANUFACTORY, CLIFT HOUSE, BEDMINSTER, BRISTOL.

HOTEL, with accommodation for 80 Persons.

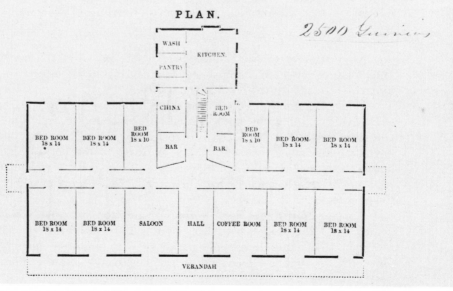

PLAN.

2500 Guineas

| | | | | WASH | KITCHEN | | | | |

PANTRY

| BED ROOM 18 x 14 | BED ROOM 18 x 14 | BED ROOM 18 x 10 | CHINA | BED ROOM | BED ROOM 18 x 10 | BED ROOM 18 x 14 | BED ROOM 18 x 14 |

BAR | BAR

| BED ROOM 18 x 14 | BED ROOM 18 x 14 | SALOON | HALL | COFFEE ROOM | BED ROOM 18 x 14 | BED ROOM 18 x 14 |

VERANDAH

Figure 4.18. Samuel Hemming. Hotel, c. 1854. *Hemmings's Patent Improved Portable Houses.* (Courtesy Baillieu Library, University of Melbourne.)

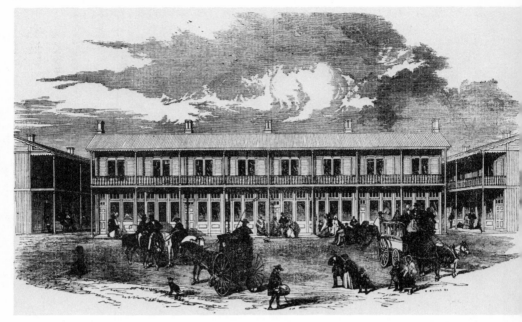

Figure 4.19. Samuel Hemming. Rows of shops and dwellings, Melbourne, Australia, c. 1854. (Braikenridge Collection, courtesy Bristol Library.)

the manufacturers of iron buildings, not one provides so consistent a range of products as Hemming, and few can match his design for functional quality and sense of handsome utility.

While Hemming produced for other markets—he designed an East Indian villa and he built prefabricated houses, churches, army buildings, and even a pub (the "Iron Duke," most aptly named, near Narberth) in England—his major field of activity, at least in the early 1850s, was undoubtedly in Australia, and especially in the gold fields of Victoria. By 1855 it was reported that he had forwarded "a vast number of houses to the gold regions."[90]

An idea of the considerable trade in prefabs for Australia may be gained from the statistics of iron houses imported into Victoria.[91] A report in 1853 notes that 6,369 packages were imported, mainly from Great Britain, with a total value of £111,380; by 1854 the figures had risen phenomenally, to 30,329 packages valued at £247,165. The extent of this trade may also be gauged from the advertisements in the Melbourne papers; the counting houses and auction rooms were inundated with iron sheds, storerooms, residences, shops—even a complete bank—

that were being offered for sale. In one issue of the daily Melbourne *Argus* alone, 43 houses were offered for sale by four dealers.[92]

After 1854, as we shall see, the demands of the Crimean War impinged upon the export trade. The flourishing commerce with Australia began to decline. The total value of iron houses imported into Victoria through the ports of Melbourne and Geelong in 1855 had dropped to £24,118, a mere 10 percent of the previous year.[93] When, in the middle of 1854, we have our last note of an exported building by John Walker of London—a large store, 120′ X 80′, which "by the manner of its construction [could] be made into one, two or three stores, or five three-roomed dwellings"[94]—it seemed that the market was beginning to be oversupplied. There was obvious difficulty in selling the merchandise, and, while new shipments were constantly advised, existing stocks remained unsold and advertisements began to be repeated, sometimes over several months.

The housing shortage diminished and offers of houses to rent appeared frequently in the newspapers. By 1855 building materials of all kinds were already in plentiful supply.[95] Vast quantities of corrugated

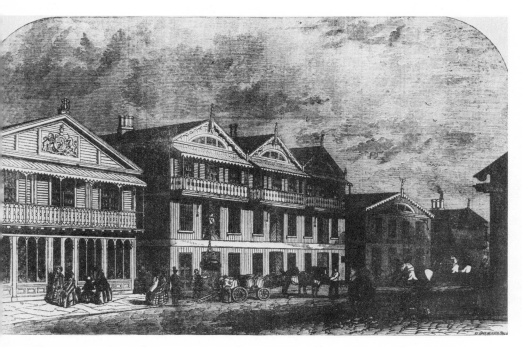

Figure 4.20. Samuel Hemming. Iron bazaar for Melbourne, Australia, c. 1854. (Braikenridge Collection, courtesy Bristol Library.)

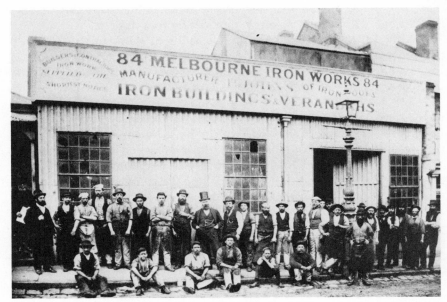

Figure 4.21. Peter Johns. Melbourne Iron Works, Melbourne, Australia, 1856. Blainey, *Johns and Waygood Ltd. 1856–1956.*

iron sheet, with all the necessary fittings, became readily available together with such ready-made components as cast-iron columns, roofing felt, wrought-iron windows, plate glass, and British, French, and American wooden doors and windows. Some dealers, such as Meyer & Co., "regularly advertised the sale of cheap iron houses, two stories high, 'of superior make and guaranteed complete,' " which they sold in component form, ready for erecting.[96] By 1856, Melbourne's first builder of iron houses, Peter Johns, set up business (fig. 4.21), purchasing his iron sheets and columns from Meyer. Moreover, Australia's own building capacity had increased. Sophisticated steam sawmills were imported to facilitate the handling of timber; by 1856 the Victoria Foundry at Ballarat was offering to "do casting in brass or iron to any weight or pattern."[97] With the collapse of the boom, Australia's building supply exceeded demand, and, by the end of 1857, there was critical unemployment in the building industry.[98] Moreover, after the crisis years of the early 1850s, when quantity rather than quality had generated the demand, a more selective approach to housing standards came about. Criticism of the iron buildings began to be voiced, for, despite valiant attempts to solve the insulation problem,[99] these buildings were never really adequate as protection against the fierce Australian sun. The Australian settler now turned to

more substantial building methods and materials, and the British manu-
facturer looked elsewhere for a market for his iron buildings.

Bellhouse, who, in addition to exporting iron houses to the southern
gold fields, had produced at least one major structure for Australia—the
well-known Coppin's Olympic Theatre for Melbourne in 1855[100]—was
one of those who now turned his attention to other markets. The heavy
British investment in South America and the high reputation of British
engineering opened the doors to a lucrative trade with the Latin Ameri-
can republics. After the Californian and Victorian experiences, Bellhouse
had developed an impressive capability to handle large undertakings.
Moreover, as a creative engineer, he was more interested in complex
buildings for export, each a unique challenge, than in the mass production
of small repetitive units. While he continued to produce houses—an 1860
publication[101] shows a two-story house almost identical to his patented
design of 1853—his significant prefabricated buildings are exciting "one-
off" examples, daring and varied permutations of his basic structural
theme.

The first of these undertakings is a project of 1854 comprising two
buildings for Payta, Peru—a customs house and a giant warehouse, "Al-
macénes del Estrado" (the "Stores of the State"). The warehouse, built
according to Bellhouse's patented principle, had cast-iron columns,
wrought-iron trusses, and corrugated iron sheathing, and occupied an
area of 120′ X 90′, with a covered cartway at its core, 60′ X 30′ X 30′ high.
This was utilitarian construction at its technical best. The customs house
that accompanied it, however, aspired to better things. "Metallic struc-
tures are gradually getting more ambitious," a journalist noted, with ref-
erence to this building. "From plain wooden sheds with corrugated iron
roofs, the ironhouse-builder has pushed his way forward until he has
produced long ranges of solid iron store-rooms and warehouses, com-
bined shops and dwelling-houses, and even palatial street residences,
churches with tall decorated spires, and custom-houses of elaborate dec-
oration and labyrinthic extent."[102]

The customs house is a large building 70 feet square and 45 feet high
to a platform on the roof, which carries a clock tower and flagpole (fig.
4.22). Architecturally speaking, this is one of the finest of all the iron
prefabs. It was designed by Manchester architect E. Salomons, and
exemplifies creative collaboration between architect and engineer, be-
tween designer and manufacturer. It is structurally logical, and it
expresses its structure and materials directly and with grace. Its propor-
tions are almost Palladian in their balance and restraint, and the simple
forms are set off by the elegant ironwork of the veranda. According to
one reputable source,[103] the customs house intended for Payta was actu-
ally set up in the neighboring town of Piura.

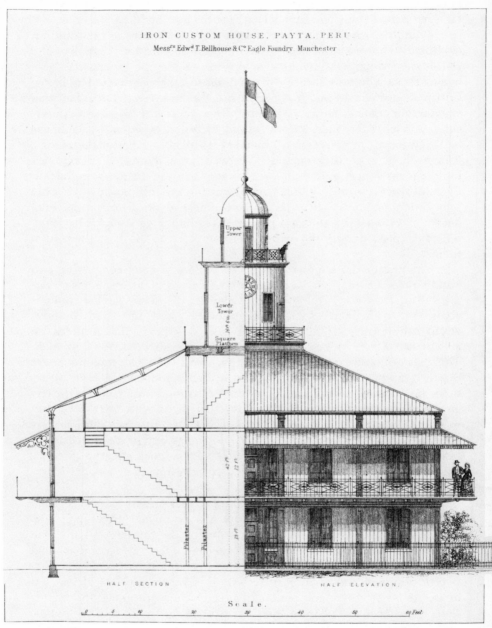

Figure 4.22. Edward T. Bellhouse. Iron customs house, Payta, Peru, 1854. The *Civil Engineer and Architect's Journal*, 1854, pl. 20. (Courtesy Royal Institute of British Architects.)

In the latter part of the nineteenth century Latin American states such as Chile and Peru turned increasingly to France for technical aid.[104] Gustave Eiffel & Co., for instance, manufactured the port facilities and customs house at Arica, then in Peru, in 1872; and, in the same town in 1875, erected the Church of San Marcos (one of a set of three similar iron churches and a synagogue that he put up in Paris, Arica, and Manila). This firm is also reported to have been responsible for the Palacio de la Exposición in Lima. The French engineering company of Schneider, Creusot, built bridges and viaducts in Chile in the 1890s, and, at the end of the century, shipped out the great iron roof of the Alameda railway station. But, in the earlier years, in the 1850s and, perhaps, in the 1860s, the probable source of many of the prefabricated buildings was Britain. The all-iron Mercado Central in (Santiago?) Chile, 1868–1872, for example, although designed by a local architect, Fermín Vivaceta, was actually fabricated in Britain. Bellhouse not only participated in this trade, but operated on an impressively grand scale throughout South America.[105]

He manufactured the entire gas works for Buenos Aires including the retort houses and purifying houses with their iron roofs, and, between December 1855 and March 1856, he shipped out the 2,000 tons of building elements required for them in 10 ships—a prodigious undertaking. For the Southern Railway Company of Chile, Bellhouse manufactured a 48-sided engine house, 171 feet across, with a cast-iron frame, a wrought-iron roof, and cladding of corrugated iron, which was erected in Manchester before being dismantled and shipped for eventual reerection in Santiago. For the same company he built a passenger station made completely of iron, that was 200 feet long and 80 feet wide, and for the Cantagello Railway, near Rio de Janeiro, all the stations were made of corrugated iron and were manufactured in the Eagle Foundry at Manchester.

Thus the output of the prefabrication industry directed toward the export market began to change. The frenetic production of emergency housing slowed down, and a greater diversity and sophistication of specialized building types appeared. In addition, and this is true particularly after the Crimean War, British manufacturers of iron portable or temporary buildings become increasingly engaged in catering for the needs at home. There was a growing demand for temporary churches (which we will consider at a later stage), and there were the large exhibition buildings, mostly inspired by the novelty and success of the Crystal Palace.

While most of the exhibition buildings are interesting because of their cast-iron structural systems, one is of particular relevance to our present theme because its cladding is of corrugated iron. This is a build-

71

ing manufactured by C. D. Young & Co., possibly from the design of Colonel Fowkes:[106] the Kensington Gore Museum (fig. 4.23), perhaps better known as the "Brompton Boilers," as it was derisively christened by the editor of the *Builder*. Contemporary criticism of this corrugated iron structure was harsh; to the Victorian taste this was indeed, as the *Builder* called it, a "melancholy construction."[107] Even latter-day critics like Hitchcock and Skempton[108] write of it in somewhat disparaging terms. And yet, in my view, the museum makes a considerable contribution. It is a modular building with cast-iron columns and bowstring trusses at 7-foot centers, with standardized infill panels of corrugated iron and louvers. The principle, Young said, was "somewhat similar to the Crystal Palace at Hyde Park"; and it is the recognition of this principle that gives significance to the museum. Whereas the other "progeny" of the Crystal Palace (to use Chadwick's term) borrow Paxton's forms and details, Young adopts the principle of prefabrication here, and translates it into other materials. The aesthetics of the museum are, no doubt, inelegant, but its ruthless, standardized façade is perhaps the most honest, clear-cut expression of modular construction of its day, and presages the aesthetics of system building of our own age.

This insight into new aesthetic forms that derived from the rationale of the modular structure and the assembly system is demonstrated in other prefabricated buildings manufactured by Young. There are the hospitals he designed for the War Office (probably to meet the needs generated by the Crimean War), and there are the prefabricated cottages and warehouses with cast-iron columns and corrugated iron walls and roofs that Young & Co. produced for the export trade, to which we have earlier referred. But the Kensington Gore Museum was a public building, and therefore was judged by standards beyond those of simplicity and utility. There is an irony that the harshest criticism of it should come from the *Builder*. Thirteen years previously, when discussing one of the earliest of iron prefabs—Laycock's Iron Palace for King Eyambo—the commentator in the *Builder* had taken a far more liberal and progressive view than had his contemporaries, of whom he complained, "Style comes first in most cases instead of last; it is regarded as the procreative instead of the emanative principle. Construction in its modes and material, climate, requirements, are the first considerations, and of these style is born, and by them fed and nourished; but, now-a-days, the first question is, what style shall we build in? and any answer is tolerable but—the rational style."[109] In 1856, however, the brutal rationality of the "Brompton Boilers" proved entirely unacceptable to the taste of the day, as adumbrated by the *Builder*.

The forms that were inadmissible for public buildings were, apparently, appropriate for the large Victorian industrial undertakings, and

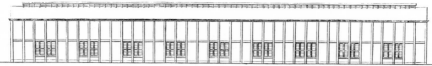

Elevation of Side.

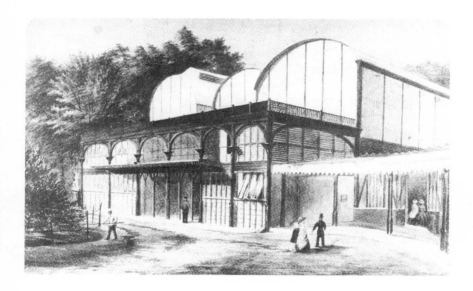

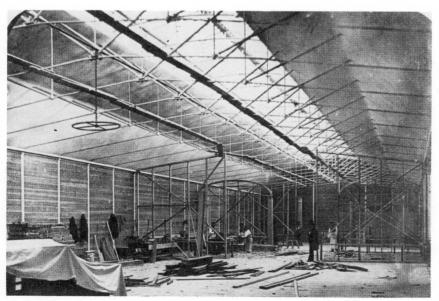

Figure 4.23. Charles D. Young. The Kensington Gore Museum, London, 1856–57. *Top,* Elevation. The *Builder,* 5 May 1856; *Middle,* Exterior shortly after construction; *Bottom,* Interior view. (Courtesy Victoria and Albert Museum.)

were invariably noted with approbation. In 1854 Richard Walker roofed the giant Metropolitan Cattle Market at Copenhagen Fields, London, according to the design of Bunning, while John Walker covered the 3¾ acres of Price's Candle Works at Bromborough Pool; both brothers used the now-standard vaulted corrugated iron roofs pioneered by their father.[110] And in 1857—the year of the last reference to his work that I have been able to trace—there is an announcement that the Metropolitan Board of Works had approved an application by John Walker of London, a "manufacturer of portable buildings," to construct "an iron building for workshops at Mr. Stocken's carriage manufactory . . . Pimlico."[111]

John Walker, together with some of his principal competitors— Tupper, Hemming, Morewood, Porter—was, in the mid-1850s, to be found advertising frequently in the *Builder*,[112] a journal meant largely for home consumption. In one such advertisement printed early in 1855, in pointing to his range of "Portable Galvanized or Painted Corrugated Iron Dwellings, Barracks, Hospitals, Stables, Warehouses, Theatres, Billiard and Concert Rooms," Walker claimed to be "under Patronage of the English and French Governments." This claim and the military nature of some of his products were indications that the prefabrication industry of Britain had turned its energies toward a new objective: the needs of the war then raging in the East.

CHAPTER 5

PREFABRICATED STRUCTURES FOR THE CRIMEAN WAR

The Crimean War is stamped by that ambivalence of attitude—romantically tradition-bound and ineffectual on the one hand, hard-headed, pragmatic, and forward-looking on the other—that was so characteristic of the mid-nineteenth century. From the point of view of military tactics and techniques the war proved to be a tragically ana-chronistic exercise. Moreover, it was, as one military analyst put it, "the last 19th-century campaign fought with 18th-century weapons."[1] However, in terms of certain problems of logistics and support operations (at least as they were conceived in Britain, if not always as they were exe-cuted in the field), it was the first war of the industrial era, and called into play the most sophisticated technology of the day.

The electric telegraph was used for the first time in a war, revol-utionizing communications between the front line and its faraway bases in London and Paris. A new generation of iron-built, steam-powered ships formed a bridge of supply across 3,000 miles of sea. Factories turned their new-found potential of mass production to the manufacture of armaments. A mobile, floating, flour mill designed by Fairbairn helped ensure bread supplies to the fighting men. War correspondents such as Roger Fenton transformed the art of reporting by using that new device, the photographic camera. By the end of 1854, only a few months after the dispatch of the 50,000-strong allied expeditionary force from Varna, "vessels left England carrying 1800 tons of rails and fastenings, 6000 sleepers, 600 loads of timber and about 3000 tons of other materials, to bring the first mechanization to the war,"[2] and construction of the 15-mile railway system designed to carry ammunition from the base at Balaklava to the artillery batteries at the front began.

Within this technological framework it is not surprising that the solution to the problem of housing the army in the Crimea—once the magnitude and the urgency of that problem was realized—was eventually conceived in terms of large-scale industrial effort rather than mere local improvisation. With the allied armies entrenched before Sebastopol, with winter approaching, with no proper facilities for housing men and horses, with little provision for caring for the wounded and the sick, a problem of crisis proportions suddenly revealed itself. Local resources were patently inadequate to deal with a problem of this magnitude: there was no skilled labor, the army was unable to spare men for construction purposes, and building materials were practically unobtainable locally. All available timber, trees, and houses had been converted to fuel; loose stones had been used for low screen walls. The solution to the housing problem of the Crimea, obviously, lay, not in the peninsula itself, but elsewhere.

Two lines of action were taken. The first was to scour the Black Sea ports for prepared timber, with the result that, from November 1854 to the following March, some 80,000 boards and planks and 20,000 scantlings arrived at Balaklava. For various reasons—lack of coordination of supplies of framing and cladding materials, lack of transportation to the front (the railway was not yet in operation and the main paved road had been cut by the Russians), inadequate storage facilities, and lack of labor—little of this building material was converted into usable shelter before the end of winter. Simultaneously, however, a second and more ambitious plan was initiated. "Contracts were also entered into in England, about the middle of November, for wooden huts, of which parts were so fitted that, with the aid of printed directions and lithographed plans, which accompanied them, the whole might be put together, even by unskilled workmen."[3]

As we have seen, in recent years Britain had dealt with comparable —if less hazardous—housing emergencies in an analogous manner. From pioneer beginnings in the 1830s, British industry had, by the time of the Crimean War, developed a significant technical competence and production capability for the manufacture of prefabricated buildings ranging from modest wooden or corrugated iron huts to the most elaborate iron villas, churches, and commercial buildings. When the demand came from the Crimea, the British were ready with the necessary technical capabilities, gained from their experience in manufacturing large numbers of prefabricated buildings quickly and exporting them to Australia, Africa, California, the West Indies, India, and the Far East.

The High Orchard Saw Mills of Gloucester (which were managed by William Eassie),[4] was one of the firms actively engaged in this export trade. "Since the discovery and rapid growth of the Australian gold-

fields," a contemporary account tells us, "enormous quantities of wooden houses, doors, windows, mouldings, and other wooden materials used in house buildings, have here been prepared by machinery, packed and shipped for the markets of Melbourne, Geelong and Sydney."[5] The production facilities, machinery, and experience of this firm inspired Richard Potter, one of the partners of the old established Gloucester timber merchants, Price, Walker & Co.,[6] to suggest that "barrack accommodation upon a large scale, and within a short space of time, could be provided at this establishment for the Army before Sebastopol."[7]

According to one authoritative source,[8] a proposal was actually made in August shortly before the army sailed, but somehow the plans were mislaid somewhere between the offices of the Secretary of State for War and the Ordnance Board. This incredible bungling set the project back by many weeks, a critical delay in terms of the impending winter, and, as we have seen, it was not until mid-November that the contracts were finally signed.

If Eassie's workshop provided the technical base for this venture, then Price, Walker & Co., through Potter, must be regarded as the initiating force. It is not known if any formal business ties linked the two firms at that time, although later there is evidence that some directors sat on the board of both companies.[9] Contemporary accounts are not clear, but it seems a reasonable inference that Price, Walker & Co. was responsible for the conception of the project; it is with them that the British government contracted for the initial supply of 500 huts, to be produced in Gloucester, probably at Eassie's factory. A further 500 were produced in Portsmouth, Southampton, and London. Altogether, about 1,400 of these huts were supplied to the British forces from all these sources. The speed of construction was incredible. Despite difficulty in obtaining transport, the first cargo arrived at Balaklava on 25 December 1854, followed before the year's end by three more shipments. Eight more arrived in January 1855, and by February, four months after the order had been placed, deliveries were completed.[10]

The huts, each designed for about 20 to 25 men sleeping on sloping bedboards, were 28 feet long, 16 feet wide, and about 11 feet high at the ridge and 6 feet high at the wall plate. The structure consisted of four structural bays with 3" X 3" posts, a light collar truss, and a gable-ended roof; the cladding of the walls and roof was 8" X ¾" boards, the joints of which were covered by 2" X ⅜" strips. At one end was placed a door with window above, and at the other, two sliding windows (fig. 5.1).

Potter took these designs to Paris and offered them to the French government. Emperor Napoleon III, who played no small role in the rebuilding of Paris, and who regarded himself as a quasi-architect, took a

personal interest in the matter. He suggested several amendments, such as lowering the height of the walls to 3½ feet (to reduce vulnerability to storms), adding an additional door and side windows, and altering other dimensions slightly. "His Majesty," we are told, "spent several hours in designing and determining these alterations."[11] Two prototypes were ordered from Gloucester, one of British, the other of French, design, and, "in the course of a few days," were received in France and erected in the gardens of the Tuileries by 20 engineers in three hours. There they were subjected to critical inspection and evaluation. A decision was made, a contract signed at the Ministry of War, and a detachment of engineers sent to Gloucester forthwith, to familiarize themselves with the processes of manufacture, and, especially, the techniques of erection, for which they were to be responsible in the Crimea.

Figure 5.1. Hut for the British army in the Crimea, 1854. The *Illustrated London News*, 9 December 1854. (Courtesy British Library Board.)

The efficiency of production and dispatch was impressive. A thousand men operated the factory day and night, in shifts. As the barracks were completed they were packed into portable packages, each numbered in accordance with the code contained on the instruction sheet. Special trains, each containing 80 to 100 huts, conveyed the finished products from Gloucester to the docks at Southampton, where they were transshipped to France. In one mouth, from mid-December 1854 to mid-January 1855, 1,500 huts for enlisted men and 350 for officers were thus completed and dispatched, via France, to the battlefront. From the initial order in mid-November, until mid-January, a total of 3,250 units were constructed, crated, and shipped out to the British and French armies.

In addition to this British effort, a Paris contractor supplied wooden stables for 10,000 horses, and 100 huts made by local craftsmen in the Cilli region, near Steiermark were shipped from Trieste to the British

army (fig. 5.2). These were described as being less complete and formed of heavier timber.[12]

It is an ironic commentary on the efficiency of these operations that the weakest link was at the receiving end. The port was chaotic and congested. The road to the Heights was a sea of mud. Horses died without shelter, mules were difficult to obtain. The men were debilitated, and so weakened by their sufferings that "it consequently required from 250 to 300 men to carry up a single hut sufficient to accommodate, at the utmost, 25 men." The official commission of enquiry reported that, by March, while huts "had been erected for a considerable portion of the corps in the immediate vicinity of Balaklava, only two or three of those in the front were hutted; by great exertion a few huts had been got up there for hospitals." So great were the problems of organization and transportation of the huts, that, in many cases, "the attempt had to be abandoned although that accommodation, if there had been transport, would have been of the utmost advantage during the rest of the winter."[13] That the users concurred with the opinion that the huts were of the "utmost ad-

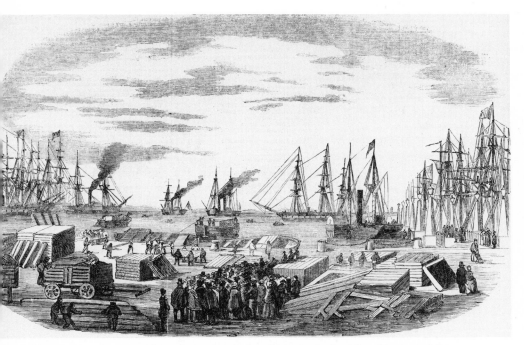

Figure 5.2. Austrian huts being loaded at Trieste, Italy. The *Illustrated London News*, 13 January 1855. (Courtesy British Library Board.)

vantage" is clear from the generally positive response given to the Commission of Enquiry's question, "Has the health and comfort of the men improved in the huts?" Although the replies were not uncritical of the huts, there was an overwhelming consensus that they had contributed significantly to the men's health and comfort.[14]

The war dragged wearily on, from month to month. In Britain the principal construction effort in the spring and summer was the erection of barracks in the army camps at home. Although it was considered desirable early in 1854 "at all times and under all circumstances that the building should be of such strength and materials that they should be calculated to last for at least 30 to 40 years,"[15] the realities of the times and circumstances demanded otherwise. Even as the first permanent brick building began to be erected at Aldershot, just before the outbreak of the war in 1854, a contract was drawn up for 1,260 wooden huts built of Memel and Niger fir, at an estimated cost of £150 each. The 1854–55 Army Estimates included an amount of £175,000 to be spent on 5,000 wooden huts at Aldershot and other camps. By mid-1855, construction was under way for 10,000 men at Aldershot, 1,034 at Haverfordwest, 3,895 at Gloucester, 3,322 at Colchester, and.3,313 at Shorncliff. At Pembroke dockyard, huts to accommodate 1,000 men were built, the contract with the Board of Ordnance stipulating a construction period of six weeks. Generally the huts at the army camps in Britain were slightly larger than the exported Gloucester huts, but they were of very similar pattern and construction.

By July 1855, as autumn approached, no end to the war was in sight. "The government are making active preparations for again wintering the army in the Crimea," it was reported. Several firms had just "entered into contracts to supply about 1000 huts for berthing the troops which are to be ready for shipment within one month from the present time."[16] These included Luke Camwell of Portsmouth, who had probably been responsible for the first Portsmouth hut; the builders William Piper and Locke and Nesham; Jackson, who had built the wood and slate church at the Shorncliff camp; Hayward and Nixon, the original contractors for Aldershot; Myers, builder of the South Camp there; Lucas Bros., a London firm of builders responsible for at least 250 of the huts; Eassie of Gloucester; and William Cubitt & Co., the firm headed by that renowned engineer who had recently been knighted for his role in the construction of the Crystal Palace.

The huts made by Eassie were slightly modified versions of the original Gloucester hut, with ventilated roof and side windows (fig. 5.3). The arrival of two ships with 280 such huts was noted, late in September, at Balaklava.[17] The huts of Cubitt and the others, made in accordance with plans prepared by the Board of Ordnance, were more complex and

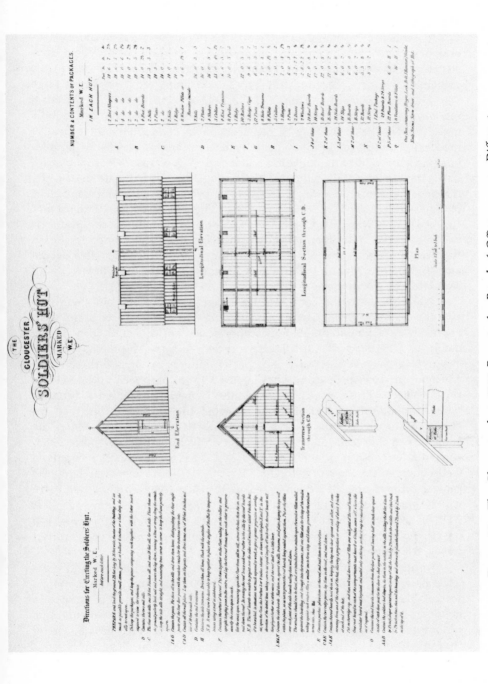

Figure 5.3 The Gloucester hut, 1855 *Report of a Board of Officers . . . on Different Principles and Methods of Hutting Troops.* (Courtesy British Library Board.)

ambitious. The demand for prefabricated barracks had been an obvious stimulus to imaginative design.

Patents for ingenious portable structures had been taken out by several designers[18] who generally incorporated some form of panel construction. The new Board of Ordnance designs also incorporated this principle. There were four hut types, consisting of two sizes, large (76' X 16' for 50 men) and small (32' X 16' for 25 men, or 32' X 20' for 8 officers), and of two types of construction, single boarded and double boarded. The basic system of construction is common to all types. A modular structure of grooved posts receives prepared single- or double-boarded panels, each panel being a standard 4' X 6' size. Most panels are solid, but some contain windows or doors. Although nails are used to fix the floor panels in position, the structural system itself is not dependent on site nailing, but is a bolted structure. The design of the "Panel Hut" (fig. 5.4), as it was called, reduced the labor on the site by the prefabrication of entire wall units, rather than the use of precut boards to sheath the prefabricated frame. There is a striking parallel between this design and that of the Manning Portable Colonial Cottage, the pioneer of all standardized wooden prefabs.

More thought had gone into the design of the huts, but there was also the need to consider the problems of erecting them. Two steps were taken. A detachment of 40 noncommissioned officers and men of the engineers (the Sappers and Miners) traveled with the shipments of huts, "so as to undertake their safe and speedy delivery on arrival there."[19] In addition, Sir Joseph Paxton, who, in April 1855, had been authorized to raise a special army works corps for the Crimea, assembled a force of 1,000 mechanics and artisans, mainly from the workmen who had re-erected the Crystal Palace for him at Sydenham.[20] Included among the functions of this task force was the erection of huts. By September 1855, some 450 of these men had already sailed. They were, by all accounts, a well-equipped force. Not only had Paxton designed a special tent, the central tubular pole of which acted as the flue for a stove,[21] but there was also a Paxton hut of very high quality for use by the army corps. It was of sandwich construction, double lined, with felt in between—a heavy, waterproof, well-built article, but not, as a later report put it wryly, for military use.

In addition to the processes of manufacture, distribution, and erection, a stage of evaluation was now added. At home, an official committee on barrack accommodation for the army, of which Paxton was a member, was set up in 1855. In the Crimea, a board of officers was constituted to examine the various systems of prefabricated huts in use by the British forces. The report was submitted to the War Department on 1 July 1856,[22] and their comments make interesting reading. The double-

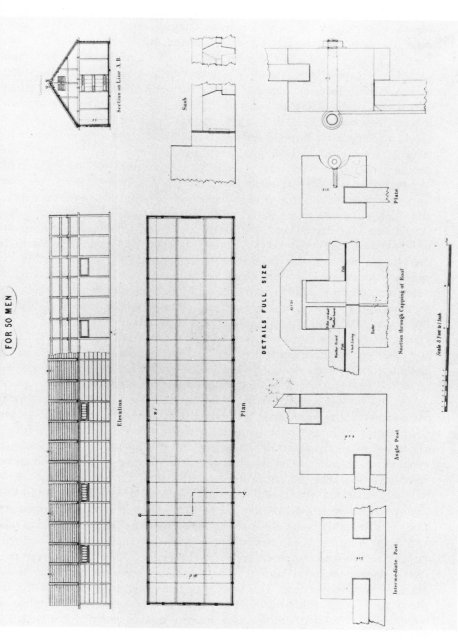

Figure 5.4. *The panel hut, 1855. Report of a Board of Officers . . . on Different Principles and Methods of Hutting Troops.* (Courtesy British Library Board.)

boarded panel huts were roomy, warm, and generally waterproof, except when inaccurately fitted. Because of their use of bolts and screws, they were easy to assemble and dismantle. They were heavy to move, however. The large hut was regarded as too long, while the smaller hut was seen as more serviceable. The single-boarded panel hut was light and easier to transport. It was not weatherproof, however, and was regarded as structurally inferior. The old Portsmouth huts, framed and sheathed with feather-edged boards, were sufficiently light to be transported bodily, but they could not be dismantled and reassembled.

The Gloucester hut had similar characteristics. As a lightweight hut, it could be moved bodily. The army report glossed over its weather-proofing qualities, merely stating that, as a single-boarded hut, it required a covering of felt. Nevertheless, the army liked it. It was simple, easy to issue, and easy to put into use. It was easily repaired, without the necessity for specialized spare parts, and—a corollary of this—if there was surplus material, it could readily be used elsewhere. It was, in the words of the report, the most serviceable of all huts. The commission's own preferences are apparent from its recommendations. It wanted a hut of simple components: standardized posts, joists, and boards; premade doors and windows; and tarred, calico linings. The huts should be easy to transport on ship, easy to erect on land (that is, within the capability of the regiment's own skills), and easy to repair, using improvised parts. Had the war extended to a third winter, it would have been interesting to see whether the next generation of designs responded to these clearly articulated user-requirements. However, by the time the report was issued, the Treaty of Paris had been signed and the war ended.

Thus far we have dealt with the problem of housing the fighting men. Numerically, of course, this was the dominant problem. However, the question of housing the wounded and the sick was, in many ways, a graver, even more intractable problem. At the outset of hostilities the problem of hospitalization was not seriously considered. When the army assembled at Varna, it was equipped with some 120 hospital tents. Apparently most of these were left behind when the force sailed, and in the Crimea there were only 37 hospital tents for the entire army. Makeshift measures included using ships anchored offshore as improvised hospitals and developing the base hospitals at Scutari, 300 miles away. When the huts from England began to arrive at the end of 1854, many were put into service as hospital huts, usually three huts for each battalion being set aside for this purpose. This need was generally given first priority. In the second round of orders, for the winter of 1855, special hospital huts were designed. One of these was a framed, double-boarded hut with 24 beds, a draught lobby at each end, a storeroom, heating stoves, and a ventilated roof (fig. 5.5). The Gloucester hospital hut resembled the

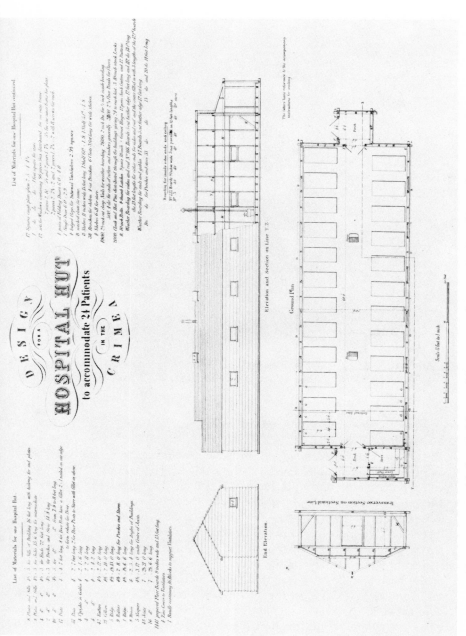

Figure 5.5. Double-boarded hospital huts, 1855. *Report of a Board of Officers . . . on Different Principles and Methods of Hutting Troops.* (Courtesy British Library Board.)

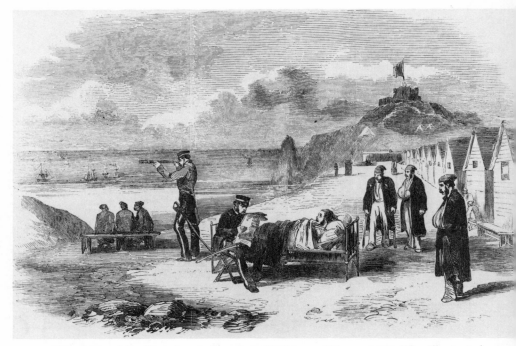

Figure 5.6. The New Castle Hospital, Balaklava, Crimea, 1855. The *Illustrated London News*, 28 July 1855 (Courtesy British Library Board.)

original barracks but was lined internally and had a flat floor instead of the inclined bedboards.

These huts, used singly or in groups of three, were, perhaps, adequate for the immediate needs of the front line battalions. According to one report, there were huts for 4,300 sick in the Crimea by the end of 1855, but these figures probably include the more substantial accommodation built at the main base at Balaklava. In a letter to Dr. Hall, the Inspector General of Hospitals, Dr. Smith, director of the medical department of the army, said that he thought this estimate inflated, and was critical of the adequacy of the huts, as some were not watertight.[23] One of the base installations was the New Castle Hospital, situated near the sea front at Balaklava, in the shadow of the old Genoese castle, which dominated the harbor view. No details of this hospital are known to me, but a contemporary illustration (fig. 5.6) shows about a dozen wooden huts set in a row at right angles to the beach and terminating in what appears to be a service building—probably the kitchen.

Without doubt, the most ambitious undertaking was the building of

the hospital at Renkioi, on the Dardanelles. Early in 1855 the British government decided to build new base hospitals in Turkey in anticipation of developments in the war in the spring and summer. A hospital was improvised in Smyrna which was immediately filled to overflowing. Consequently "it was determined to send out from England wooden houses, which might be erected in some convenient spot, as an additional hospital, capable of holding 1,000 sick."[24] We are fortunate that, in addition to the press reports[25]—for the hospital aroused great public interest —there are two intelligent accounts of the design and construction of this hospital. The first is the report on the Renkioi Hospital[26] by E. A. Parkes, the superintendent of the hospital, which was addressed to the Secretary of State for War on 1 December 1856; the second, an appendix to that report, is a memorandum by Isambard Kingdom Brunel, who was responsible for its design.[27] On this report, and its appendix, we base the following account.

According to Brunel, four principles governed the design of the hospital buildings:

> First—That they should be capable of adapting themselves to any plot of ground that might be selected, whatever its form, level or inclination, within reasonable limits.
> Secondly—That each set of buildings should be capable of being easily extended from one holding 500 patients, to one for 1,000 or 1,500 or whatever might be the limit which sanitary or other conditions might prescribe.
> Thirdly—That when erected, they might be sure to contain every comfort which it would be possible under the circumstances to afford. And,
> Fourthly—That they should be very portable, and of the cheapest construction.

Scrupulously following these criteria for design, Brunel produced a plan for a 22-unit pavilion hospital linked by a broad 22-foot-wide covered way open to the breeze in the summer and screened from the wind in the winter. Each pavilion contained two wards of 26 beds each plus a bathroom, washbasins, toilets, a storeroom, an operating room, a nurse's room, and a room for ventilating equipment. For each group of pavilions housing 500 patients, a kitchen unit was provided; a laundry, with machinery for washing and drying, was provided for each 1,000 patients. Stores, dispensaries, and staff accommodation for officers and men completed the facility.

The pavilions, being 100 feet long, 40 feet wide and 25 feet high at the ridge (fig. 5.7), were, of course, much larger than the Crimean hospital huts. Each pavilion was constructed of timber, single-boarded, but with provision for adding an inner lining plus an inert insulating material, should the buildings be required for winter. The exterior surfaces were covered with thin, highly polished tin to reflect the heat, or else

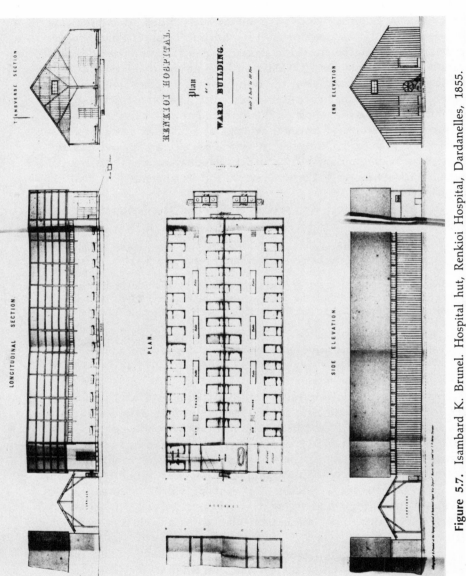

Figure 5.7. Isambard K. Brunel. Hospital hut, Renkioi Hospital, Dardanelles, 1855. Parkes, *Renkioi Hospital, Turkey*. (Courtesy of the Commandant of the Royal Army Medical College.)

whitewashed. Internally, the limewash was tinted to reduce glare. In every detail there is a sensitivity to problems of comfort in terms of climate control. Long, narrow windows allowed for good ventilation, but were deliberately placed high so that "the eaves [would] protect them from the direct rays of the sun." Natural ventilation was supplemented by a forced-air system, the air being taken in ducts through the length of the pavilion from a manually operated rotary air pump capable of supplying over 1,000 cubic feet per minute. Because of the dryness of the heat, the plan was to pass this stream of air over a water surface to cool and humidify it. With each set of buildings came a small reservoir, a pumping apparatus, and a complete set of pipes for water supply and drainage.

"The construction of each building," Brunel wrote, "has been studied with very great care, so as to secure the minimum amount of material, the least possible amount of work in construction or erection, and the means of arranging all the parts in separate packages, capable each of being carried by two men."

Brunel entrusted the erection of the hospital, on a site chosen with great care by Dr. Parkes, to Mr. Brunton, the resident engineer. The units were put up by Brunton, who was assisted by Mr. Eassie, Jr. (probably of the Gloucester firm), and a team of thirteen carpenters, one pipelayer, three plumbers, and a smith. Greek carpenters from adjacent villages were employed as assistants, but the erection of the framework of the large huts was entrusted to the trained team of English artisans.

The first steamer arrived on 7 May 1855, and the erection of the buildings commenced two weeks later. By 12 July the hospital was ready for 300 patients, a month later, for 500. At the beginning of December, 1,000 patients could be housed. Dr. Parkes reports, "By January 1856, viz., seven months after its commencement, it was ready for 1,500 sick, and when the works were discontinued at the end of March 1856, we could, with a little pressure, have admitted 2,200 patients. In about three months more, this immense establishment for 3,000 sick could have been finished and in full activity."

The hospital for 3,000 was planned in five divisions, two side divisions for 750 patients each, and three central divisions for 500 each (fig. 5.8). Each division was planned to be completely self-contained. To carry through this vast operation to such a successful conclusion required, not only the meticulous planning of Brunel at the initiating end, but also the transportation (23 ships), unloading, storage, and proper distribution of some 11,500 tons of building material, a first-class example of efficient site organization.

Brunel and Parkes make references to iron hospitals and laundries in their reports. This raises an interesting question for us. The massive program of prefabrication for the Crimea, both of huts and of hospitals, was

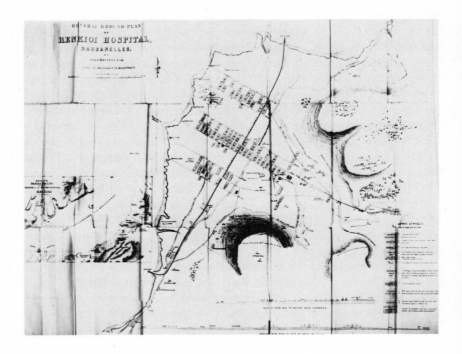

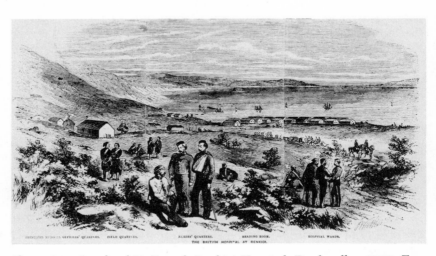

Figure 5.8. Isambard K. Brunel. Renkioi Hospital, Dardanelles, 1855. *Top*, plan. Parkes, *Renkioi Hospital, Turkey; Bottom*, view. The *Illustrated Times*, 1 December 1855. (Courtesy of the Commandant of the Royal Army Medical College.)

based upon timber construction. And yet, from the early 1840s, there had been a spectacular development of building in iron. Cast-iron and corrugated iron prefabs had been dominant in the trade with California in 1849, and with Victoria since 1851. Why then were the Crimean huts made of timber, and what role, if any, did iron play during the Crimean War?

In the years immediately prior to the war, despite the dramatic development of iron building, the construction and exportation of wooden prefabs had never really ceased. As we have seen, Eassie himself had been active in this trade, making wooden buildings and building components for the Australian market. The extent of this trade in portable wooden buildings up to the outbreak of the war is indicated by the many advertisements in papers such as the Melbourne *Argus* that offered for sale an impressive quantity of wooden houses, ranging from modest two-room cottages (each house arriving complete in 10 packages), to "an elegant and commodious six-roomed English house,"[28] massively constructed of 1½-inch weatherboarding.

Parallel with iron construction, then, we have the continuing tradition of building in wood. And, it is relevant to note, even the makers of iron buildings made extensive use of timber elements. John Henderson Porter, one of the pioneers of corrugated iron in the 1840s, later patented a system of fixing the iron sheets to timber framing;[29] John Walker had his own sawmills; and Hemming, that most specialized of iron-house builders, used scantlings and sills of oak or Memel fir together with wooden doors, windows, shutters, architraves, skirtings, internal linings, and floors, all the woodwork being carefully seasoned prior to installation in an "apparatus" at the works.

Even an inventive man like Paxton, regarded as one of the most progressive of the age, was more at home with timber than with iron; such "iron" buildings as the Hyde Park Crystal Palace have a surprisingly large content of timber elements, deriving from the traditional skills of British joiners, which had been expanded by new industrial techniques of production. It is instructive to see the extent to which the Crystal Palace at Hyde Park depends upon timber elements. Apart from the iron structural columns at 24-foot centers and the purely decorative pseudoarches in cast iron, the entire framing of the external skin—the curtain wall—is wooden. The intermediate columns at 8-foot centers, the sills and heads, the window frames and mullions, even the great semicircular window in the spandrels of the transept, all are of timber; the infill of the entire ground floor except the louvered ventilators is not of glass, as is commonly thought, but of boarded panels, approximately 7½ feet wide and nearly 15 feet high. All this, in addition to the use of wood in some of the girders, in Paxton's patent timber roofing system, and in the laminated

arches over the transept, make the Crystal Palace as much a tour de force of wooden construction as a demonstration of the potentialities of iron.

But this use of timber was far from conservative, although it grew out of long-standing techniques. There are few traditional joinery methods to be found in such buildings as the Crystal Palace, but extensive use is made of quick-fastening systems of bolting and ingenious metal clamps and fasteners. This is the maturation of techniques originally pioneered by Manning and the forerunner of methods used in the more sophisticated models of the wooden Crimean hut.

By the time of the Crimean War timber manufacturing and assembling techniques were highly developed. They could be used by general contractors, who, by tradition, were carpenters and joiners, as well as by prefab specialists. It is, perhaps, natural that a conservative Board of Ordnance would turn to such an industry, long established and of sound repute, rather than to the more adventurous pioneers of iron building.

Of the use of iron in the Crimea itself we have little information. There are references to iron huts in the official correspondence—one requisition refers to an iron hut 20' X 30' X 14' high—and we know from these that iron buildings were sent out to Balaklava for the storage of commissariat supplies.[30] Photographs in the Victoria and Albert Museum taken of Balaklava in 1855 by Robertson[31] show sheds with corrugated iron roofs and Quonset-type, barrel-vaulted, corrugated iron sheds. The end building of the New Castle hospital also appears to have been made of corrugated iron. The iron auxiliary buildings at Renkioi appear to be segmentally roofed corrugated iron huts. Such barrel-vaulted structures were of the type originally developed in London by Richard and John Walker and which, as we have seen, soon became a generic form used by many firms. John Walker, who had business contacts with the War Department at the end of 1854[32] and claimed to be "Under Patronage of the English and French Governments," advertised the supply of portable galvanized or painted corrugated iron dwellings, barracks, hospitals, stables, etc.[33] The previous month it had, in fact, been announced that "the Government has ordered iron stabling for 2000 horses to be constructed, to be ready for despatch to the Crimea in three weeks."[34] There is, as yet, no firm evidence that barracks and hospitals of iron were sent to the war zone, and within the limits of our present knowledge we may suggest that the use of iron structures in the Crimea was not extensive. Possibly iron was in short supply, as the demands for armaments and ammunition grew. Certainly by mid-1855 there were restrictions on the exportation of iron from Britain.[35]

It would appear that on the home front greater advantage was taken of the industrial capacity to produce iron buildings. Barracks made of corrugated iron were certainly in use, although the response of conserva-

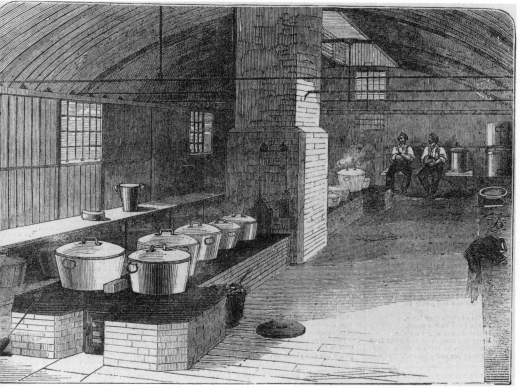

Figure 5.9. Charles D. Young. Corrugated iron kitchen, Aldershot, England, 1855. The *Illustrated London News*, 13 October 1855. (Courtesy British Library Board.)

tive army health officers was perhaps a trifle ambiguous. "Corrugated iron huts are, so far as the material is concerned, perfectly impervious to air, and they are subject to rapid alterations of temperature. The latter defect can be remedied by suitable lining; but iron huts at the best realize no more than the advantage of subdivision,"[36]—whatever that means. One of the iron barracks from Larkhill Camp, on Salisbury Plain, was sold about 50 years ago as army surplus, and found its way to Bristol, where it served, first as headquarters of the Young Men's Christian Association, and now as a Methodist schoolhall; at least the iron huts had the advantage of longevity.[37] John Walker had tendered for the supply of iron barrack huts for the camp at Aldershot,[38] and C. D. Young & Co., the Edinburgh ironfounders, undertook large contracts for barracks at both the Aldershot and Colchester camps.[39] Young's also built the iron kitchen and stores at these camps; a report on one of these kitchens

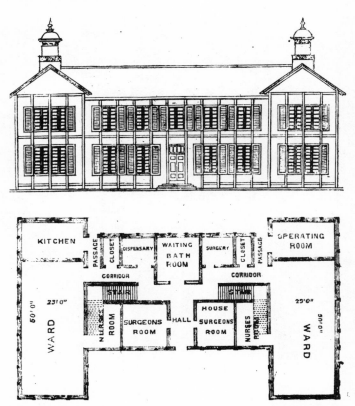

Figure 5.10. Charles D. Young. Design for a two-story iron hospital. C. D. Young & Co., *Illustrations of Iron Structures for Home and Abroad.* (Courtesy Royal Institute of British Architects.)

in the *Illustrated London News*[40] showed it to be a large, segmentally roofed, corrugated iron structure with a louvered monitor running down the full length for light and ventilation (fig. 5.9). A similar roof is shown in an illustration by Young of a two-ward military hospital, complete with an ablution block, toilets, and operating theater. These hospitals, based upon a government design, were intended for the army camps at home. A much more ambitious hospital was proposed by Young, intended for up to 200 patients. This was a two-story building with a modular structure of cast iron, and corrugated iron infill panels (fig. 5.10). It is not known, however, if this latter design was ever actually executed.

At Aldershot and perhaps at other camps, there were buildings other than barrack huts that were made of iron, including three wood and iron churches, two of which remained in use for about one hundred

years. At least one of these churches, as we shall see in the next chapter, was made by Samuel Hemming,[41] who was also the manufacturer of the Royal Aldershot Clubhouse, an imposing iron-sheathed structure, 82 feet wide and 130 feet deep, of three parallel gable-roofed blocks. This clubhouse, containing such elaborate accommodation as a reading room, a coffee room, three billiard rooms, a cardroom, a smoking room, and various offices, was handsomely appointed. "The decorations, designed by Mr. Hemming are chaste and appropriate," it was reported enthusiastically. "The carpet for the principal room has been designed expressly for the purpose, and contains upwards of four hundred yards. The room is handsomely lighted up (for the present) by three or-moulu chandeliers of forty-eight lights each, till the arrangements shall have been completed for gas."[42]

This complex and well-executed clubhouse was begun on 28 July 1855 and was ready to receive the furniture exactly one month later. In character and extravagance of detailing, it is a far cry from the barracks and hospitals then being prepared for the army in the Crimea. A contemporary illustration (fig. 5.11) shows it surrounded by officers resplendent in their dress uniforms, standing on the lawn with their genteel parasoled ladies, listening to the military band. It is a world remote from the death and suffering outside Sebastopol, 3,000 miles away. The

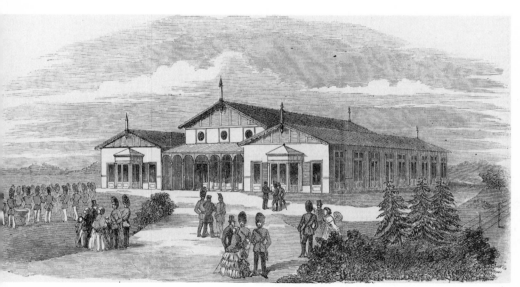

Figure 5.11. Samuel Hemming. The Royal Aldershot Clubhouse, England, 1855. The *Illustrated London News*, 29 September 1855. (Courtesy British Library Board.)

Crimean War had two faces, and in this it was characteristically Victorian. The advanced technology of the British construction industry, evolving new techniques of prefabrication, responded equally to the calls for elegance at home and utility on the battlefield.

The British experience with the utility of prefabricated military buildings at Crimea was not without influence on other armies, as the extensive use of paneled prefabricated hospitals during the American Civil War indicates. But the pioneer British, sad to say, failed to benefit in the long run from their own inventiveness. In the Boer War, a half-century later, the wounded and the sick of the British Army were attended to in the inadequate shelter of stormblown tents. The high mortality rate provoked the following wry comment at the subsequent Royal Commission of Enquiry on the waging of the war: "In the German Army, in time of peace, they provided huts on well-known, well-studied systems, capable of being packed into boxes and carried, and put up anywhere. England had not one of those, and there was the very greatest want of them."[43]

CHAPTER 6

THE TEMPORARY CHURCH FOR HOME AND ABROAD

One of the characteristics of the Victorian era was outward piety, that manifestation of formal religious observance that made regular church attendance a mandatory social ritual. In the middle-class enclaves of every metropolis and on the expanding fringes of Britain's industrial towns, the urban population explosion of the nineteenth century induced, among other, less salubrious, events, a compulsive wave of church building. And, even in the farthest corners of the colonial empire, even on each new frontier, the provision of places of worship was high on the scale of public priorities, for the church fulfilled social as well as spiritual needs.

In these newly established settlements, resources of materials and technical knowledge were inadequate to provide the enduring fabric of permanent buildings, so temporary expedients were sought. In Melbourne alone, between 1836 and 1851, 19 temporary churches were built of local materials, generally timber.[1] These hastily improvised structures were crude and primitive; a more sophisticated alternative was the importation of "portable" churches, dispatched in component form by manufacturers in the home country and easily and quickly assembled and erected for instant worship. I have already dealt with the earliest examples of these prefabricated timber churches, which were sent, in the late eighteenth and early nineteenth centuries, to Sierra Leone, to South Africa, and to Australia. A building like the Friends' Meeting House at Adelaide demonstrates the high degree of technological sophistication reached in this field over 130 years ago.

One of the British manufacturers of "portable colonial cottages" who

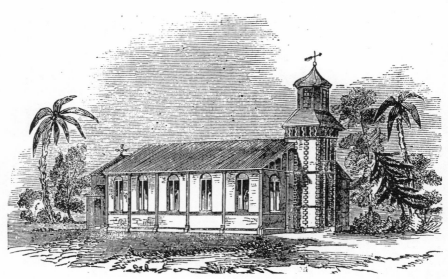

Figure 6.1. Peter Thompson. Iron church for Jamaica, 1844. The *Illustrated London News*, 28 September 1844.

was also concerned with the problem of the temporary timber church was Peter Thompson. Thompson was not only an exporter of such buildings, but had erected several examples in various districts of London between 1844 and 1848. In addition to his pioneer work in this field, Thompson was responsible for a major technological innovation. He had fabricated a large church for shipment to Jamaica (fig. 6.1), not of timber, but of iron, whose "pilaster supports [were] of cast iron, on which [were] fixed the frame roof, of wrought iron, of an ingenious construction, combining great strength with simplicity of arrangement; the whole [was] covered in corrugated iron."[2] With this iron church, we enter a new era in the history of prefabrication.

The first episode of this story takes place in Australia in the early 1850s, following the Victorian gold rush, when the sudden influx of population generated demands for buildings that local supplies of labor and materials could not meet. Other, more radical and adventurous, solutions had to be sought; as a church report of 1852 records, "our friends, . . . as there is no possibility of erecting stone or brick buildings, have taken upon themselves the responsibility of ordering from England, *six iron churches* of different dimensions, which will enable us to provide additional sittings to the extent of about five thousand persons."[3] There are, moreover, contemporary accounts of a contract made with the local agents of the British manufacturers Morewood and Rogers for the supply

of 30 tons of iron for the erection of five churches, together with a large and elegant church in the decorated Gothic style that had been designed by architect George Wharton and was to be "fitted in England and prepared for erection upon arrival in Victoria."[4] Because of the rising prices of iron in England, this church was apparently never built, but the 30 tons of iron eventually arrived and were used partly for roofing the church at Brunswick Street; the remainder was sold, we are told, at a handsome profit. Morewood and Rogers were pioneer manufacturers of galvanized corrugated iron and supplied this material as far away as the United States, Jamaica, South Africa, and Australia. They advertised a range of corrugated iron cottages and warehouses for export, but I have no knowledge of their dealing in churches.

Let us return to the six iron churches that were to be imported from England to Australia. It is, I believe, a reasonable assumption that this order was placed with Samuel Hemming's Iron Building Manufactory, of Bristol. In the period from 1853 up to his move from Bristol to Bow (in about 1855), Hemming claimed to have sent six iron churches to Australia.[5] We have sufficient information to be able to give at least a partial description of three examples of these buildings: in the documents, two are labeled as the "first and second iron churches built for the Diocese of Melbourne," and the third simply as an "iron church sent to Melbourne."[6] Robertson[7] refers to three iron churches imported to Victoria at this time, and gives details of the erection of one at Sandridge (Port Melbourne); one at Gisborne, in which services were held until 1949; and one, complete with parsonage, at Williamstown. The latter he specifically identifies with that called by Hemming "The Second Iron Church for the Diocese of Melbourne."

The first iron church was for a congregation of 650 to 700 persons. About 70' X 45', it comprised a nave, side aisles, baptistery, vestry, and bell tower, and was furnished with communion table and reading desk. No details are given of the structural frame, but the roof and external walls were covered with galvanized corrugated iron, while the interior was lined with ½-inch boarding and canvas prepared for papering. In both the walls and the ceiling, an air space and a lining of inodorous felt were provided as a measure of thermal solution. When it was packed and ready for dispatch, the church weighed about 50 tons, cost £1,000, and had taken only five weeks to construct. Hemming hoped, if the promise of an order for ten such churches were to materialize, to be able to produce one church per month. When this first church was erected at the factory—it was the practice of Hemming and other manufacturers to fully erect each building as a final check before crating the components—it attracted much public attention. On Friday, 13 May 1853, a special inaugural service was held in the church at Clift House. The archdeacon of

Melbourne himself, assisted by the local clergy and the choristers of Bedminster Church, performed the divine service. Admission was by ticket only, and some 800 congregants crowded into the iron church.

It would seem that a church almost identical with the first Melbourne church was also sent to Sydney.[8] Ordered late in 1853 by the Congregational community, it arrived on the *Severn* in October 1854 and was erected on a site on Bourke Street. It was raised above ground level to allow for a semiexcavated schoolroom under the chapel, and this necessitated a flight of steps at the entrance. It is interesting to note that the price quoted in 1853 of £1,100 had, a year later, risen to £1,600. The principal cause of this inflation was the phenomenal increase in the price of iron in Britain—the result, no doubt, of the war then raging in the Crimea.

The second church for the Diocese of Melbourne soon followed and was erected, as we have mentioned, at Williamstown. It was similar in appearance to the first, but somewhat larger, being designed to hold 1,000 worshipers. A contemporary lithograph of the interior (fig. 6.2) shows a square-section nave and two low side aisles; paired, pointed windows with diamond lattice glazing, all contained within a rectangular frame; a flat ceiling divided into panels by beams that are supported by curlicue brackets projecting from the pilasters, which articulate the clerestory wall into bays; and a range of cast-iron columns with Tuscan caps, which separate nave from aisles. The low-pitched roof of corrugated iron gives the exterior (fig. 6.3) an Italianate look, while a classical spirit marks the interior, despite incipient Gothic details. The result is a building whose total character is purposeful, simple, even austere. No wonder that later Victorian judgment found its utilitarian aesthetics unacceptable. "The style of architecture is hopelessly unpleasing, and such as suggests the factory or the warehouse."[9]

It was, perhaps, to meet criticisms such as these that Hemming expanded the style of his later work. An engraving of our third example made at Bristol, entitled "Iron Church sent to Melbourne" (fig. 6.4), but not otherwise identified, shows a more elaborate interior. Here the flat ceiling is replaced by an open roof with exposed, pointed, arched trusses in iron; open-web arches span the faceted columns; the window heads are now pointed, and the tracery of the windows is richer, more complex. While it has nothing of the exuberance of the Gothic revival, it is, nevertheless, more pretentious than its predecessors. The design becomes more self-consciously "architectural," but in doing so, something of the directness, the essential simplicity that comes from the discipline of the production process, is lost. The character of the earlier churches derives from the demands of the industrial process and materials, and is in complete

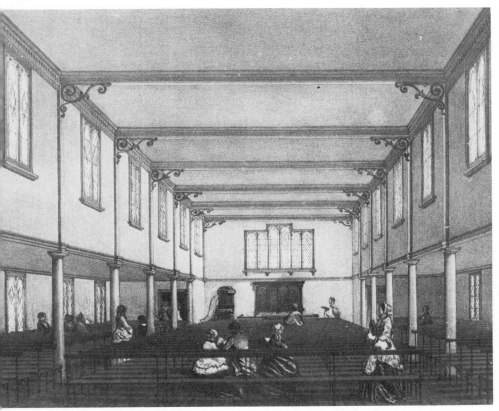

Figure 6.2. Samuel Hemming. Second iron church for Melbourne, Australia, 1853. Interior view. (Braikenridge Collection, courtesy Bristol Library.)

harmony with all the other buildings produced by Hemming: there is a unity of concept, for instance, that informs both his second church and the practical, comfortable parsonage house that accompanied it. In the later example, however, the inexorable pressure of Victorian taste makes considerations of architectural style and ecclesiastic character take precedence over the logical expression of the prefabrication process and the nature of the components involved. There is, for instance, an inherent conflict to be found in fitting pointed windows into a corrugated iron wall.

It was, no doubt, the desire to reconcile the undeniable practical advantages of iron in the construction of "portable" churches with architectural forms more acceptable to the taste of the day, that, in 1853, led

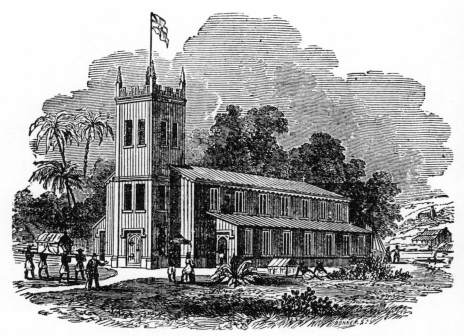

Figure 6.3. Samuel Hemming. Second iron church for Melbourne, Australia, 1853. Exterior view. (Braikenridge Collection, courtesy Bristol Library.)

the Ecclesiological Society to sponsor the design of an iron church. If the problem was "how to employ iron for an ecclesiastical building in accordance with the qualities and conditions of the material," then the society plainly considered "that the iron churches, of which several have been sent out to the colonies, or erected as temporary churches at home, have fulfilled these conditions."[10]

The elaborate cast-iron interior as William Slater eventually developed it is too well known to need more than mentioning here, but perhaps it is relevant to cite Hersey's apposite comment: "Throughout, machine forms wittily do duty for standard Gothic; indeed the erected building would have resembled a steel engraving of a Gothic Revival stone church."[11] This incidentally, was the burden of enlightened contemporary criticism, which complained that "Mr. Slater's is a stone church built in iron, and not one composed on purely metallic principles," an architecture where "iron and analogous materials are . . . completely in fetters."[12]

The exterior, which, perhaps, is less well known, is surprisingly austere.[13] It is of corrugated iron, which does not lend itself to extravagant detailing or highly modeled forms. It was left to the manufacturers

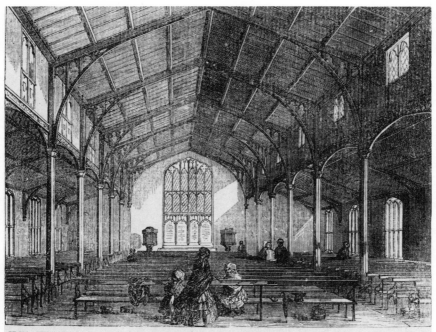

IRON CHURCH, sent to MELBOURNE by Messrs. HEMMING, AVON CLIFT IRON WORKS, BRISTOL.

Figure 6.4. Samuel Hemming. Iron church for Melbourne, Australia, before 1855. Interior view. (Braikenridge Collection, courtesy Bristol Library.)

of cast-iron churches to achieve the unholy alliance of technologically advanced prefabrication techniques and the exuberance of Victorian eclecticism.

A note from 1854 gives us an account of such cast-iron churches destined for Australia: "Two iron churches in the building yard of Robertson and Lister, Glasgow, are now completed. They are similar in size and general appearance, with the exception that one has two spires, on each side, and the other one spire, springing from the centre of the pediment. The chief feature of the front elevation is an arcade of ornamental columns and arches, standing out in bold relief, supporting a pediment, and flanked at the side by massive towers in which are placed the stairs leading to the galleries. The lower series of columns is roofed by a balcony, forming an open porch."[14] This elaborate exterior formed an appropriate adjunct to the lofty galleried interior with its 20-foot-high roundheaded windows, stained glass, and exposed cast-iron arched girders springing from iron columns.

These classical iron churches of Robertson and Lister are very close

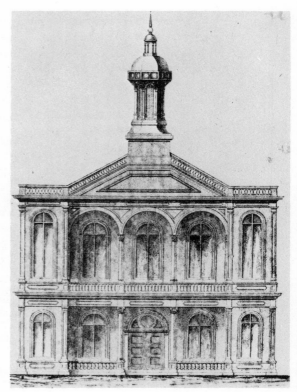

Figure 6.5. Charles D. Young. Iron church with cast-iron front, before 1856. C. D. Young & Co., *Illustrations of Iron Structures for Home and Abroad.* (Courtesy Royal Institute of British Architects.)

in construction and appearance (as far as one can judge from the description) to the churches produced by Young & Co., which they illustrated in their pamphlet. In particular, they bear comparison with two churches "of considerable dimensions, with galleries, &C., complete," which Young claimed to have sent out to Australia. The plate[15] illustrating these churches shows a façade consisting of a two-story entrance gallery, colonnaded below, arcaded above, topped by a pediment with a raking balustrade (fig. 6.5). The windows are elongated and round-headed, and the double doorway has a rounded fanlight. From the center of the pediment rises an octagonal colonnaded turret surmounted by a dome and miniature spire-topped lantern. In material, form, disposition of elements, architectural character, size, and proportion, this building by

Figure 6.6. Charles D. Young? Iron church, Macquarie Street, Sydney, Australia, 1855. (Courtesy Mitchell Library, Sydney.)

Young is almost identical with the famous iron church of Macquarie Street in Sydney (fig. 6.6), whose history we shall shortly recapitulate. Only in one significant respect does the Young prototype differ from the actual church in Sydney: in place of the central turret in Young's, there are two flanking towers. However, as we have seen in the case of Robertson and Lister, it was possible to manufacture two almost identical churches with these alternative dispositions.

The story of the iron church of Macquarie Street is piquant.[16] On 22 August 1853, at a church meeting of the Presbyterian Free Church of Sydney, the decision was made to order from Britain[17] an iron church that would seat 800 congregants and cost about £1,250. The reason given for importing a church rather than constructing one in Sydney was "the great expense of building material and the high price of labour." In other words, the impact of the Victorian gold boom was being felt in neigh-

boring New South Wales. It was hoped that the building would arrive in Sydney within eight months, but the church was not erected until 1855. This iron structure, "a commodious substantial building with handsome elevation," fitted with spacious galleries, pews, pulpit, and gaslights, served as a church for nearly 20 years, first as the Macquarie Street Free Church, and then as St. Stephen's Presbyterian Church. In 1874 it was purchased by the government of New South Wales, and for nearly a quarter of a century was used for the lending branch of the public library. In 1899 it was dismantled, and its 199-ton bulk was transported to the Rosewood Asylum (the state hospital and home at Lidcombe), where it was reerected, serving as a dining hall for the inmates of six new wards, and as a chapel. It was eventually demolished in 1958, after an active life lasting nearly a century.

An examination of photographs of the iron church shows it to be an imposing structure. The main façade is of two stories, colonnaded below, arcaded above. Flanking this open façade are two towers graced by elongated roundheaded windows and topped by octagonal colonnaded turrets. Spanning between the turrets is a pedimented roof finishing against the skyline with a raking cast-filigree parapet. The front is in cast iron, but the side elevations appear to be corrugated iron spanning horizontally between cast-iron stanchions.

It is not known which Scottish foundry designed and manufactured this church. On the basis of the evidence known to us, two possibilities present themselves. The first is that the churches by Robertson and Lister on the one hand, and that of Young on the other, are identical. If this is so, then we must presuppose a case of industrial plagiarism, and here we must not forget the prima facie evidence of copying we have already leveled against Young, in an earlier chapter, in the case of Bellhouse. In this instance, either of the two Scottish iron founders could be the manufacturer of the church. The second possibility is simpler and more direct. This possibility sets aside the written description of the Robertson and Lister church, and goes by the very strong visual evidence in the Young pamphlet. On this basis we may assume that the responsibility of the manufacture of the Macquarie Street iron church was that of Charles D. Young & Co. Certainly, the techniques of construction are those known to have been employed in other works by Young.[18]

At this time the Crimean War deflected British manufacturing efforts away from colonial and toward military needs. Most of the potential of the prefabrication industry—that is, of the wood and iron portable building manufacturers—was directed toward the provision of barracks and hospitals for the war. On the home front there was much activity connected with the construction of the major army camps. At Aldershot three temporary iron churches were erected, two of which remained in

Figure 6.7. Samuel Hemming? Iron church, Aldershot, England, 1855. Cole, *Story of Aldershot*, 1951.

use for about a hundred years (fig. 6.7). These army churches were a far cry from the highly ornamented structures then being exported to the colonies, for, in ordering them, the Board of Ordnance had specified utilitarian structures "to be erected on the plan of a covered railway station, and are to have no galleries and nothing in them except forms."[19] One of these churches, known affectionately as the "Tin Tabernacle," was, nevertheless, described as particularly light and elegant. Hemming, who had also prefabricated the clubhouse at Aldershot, is known to have made at least one of the churches at Aldershot,[20] and may have fabricated them all.

After this time, Hemming appears to have concentrated on the home market. As the need for the "portable" church for the colonies diminished, it was replaced by the demands of the rapidly expanding cities at home for "temporary" churches, which were desperately needed to house the congregations of newly populated urban and suburban areas. The technology of prefabrication, of the manufacture of ready-made components that were easily assembled and demanded a minimum of site work and special skills, had met many of the urgent and immediate needs of the colonial settlements, which had been initially restricted in resources of skilled labor and conventional materials. Now the same industry responded to the demands of the home market, in terms of speed and economy, to meet the crisis engendered by the population explosion. In London, Hemming was better situated than he had been in provincial Bristol, in relation to this new potential of the expanding metropolis.

107

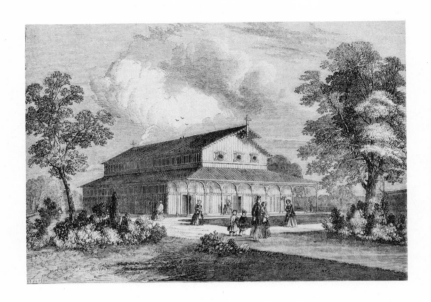

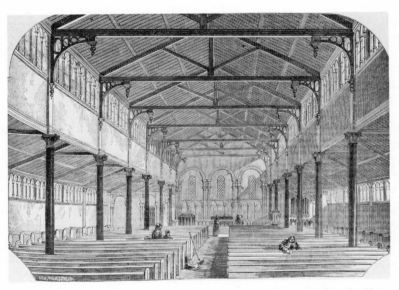

Figure 6.8. Samuel Hemming. St. Paul's temporary iron church, Kensington, London, 1855. The *Builder*, 27 October 1855. (Courtesy British Library Board.)

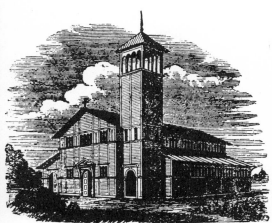

IRON CHURCHES.

THE ADVERTISER, having erected several Iron Churches, both permanent and temporary, in England and the Colonies, is prepared to erect Churches of a similar construction, capable of holding any given number of persons, in any part of the United Kingdom, or for Foreign Countries.

These Buildings possess every requisite and accommodation for the purposes intended, and have been found by experience especially adapted both to hot and cold climates. An Iron Church for 1,000 persons has been erected by the Advertiser for the Government at the Camp at Aldershott; also, one in the Vicarage grounds at Kensington; and many others are in the immediate vicinity of London.

Satisfactory references can be given as to the comfort and durability of these buildings.

Dwelling-houses, Stores, Buildings, of every description. Iron roofs constructed for every part of the World.

Apply to

SAMUEL HEMMING,

IRON HOUSE FACTORY,

CLIFT HOUSE WORKS, BOW.

LONDON OFFICE — 11, PALL MALL EAST.

Figure 6.9. Samuel Hemming. Advertisement for iron churches, 1857. *Building News*, 22 May 1857. (Courtesy Royal Institute of British Architects.)

In 1855 Hemming erected the first temporary church in iron in Metropolitan London[21] on the grounds of the vicarage at Kensington (fig. 6.8). In size and scope, it followed its precedents fairly closely: for 800 congregants, the church contained porch, aisled nave, chancel, and vestry. It was a simple basilica with open roof, stained-deal ceilings, cast-iron Corinthian columns, and continuous rows of arcaded windows; its exterior, sheathed in corrugated iron, was as plain as an early Christian church, and had something of the same appealing directness.

A spate of temporary iron churches followed. A year or so later, when Hemming applied for permission to construct a temporary church in iron at Lambeth Walk, Brixton, the usually conservative Metropolitan Board of Works approved the application on the ground that "the building was designed in accordance with several former structures submitted by Mr. Hemming."[22] Indeed, Hemming advertised at this time that he had "erected several iron churches, both permanent and temporary, in England and the Colonies."[23] The churches he illustrated (fig. 6.9) in these advertisements are in his normal genre, and their framed and paneled exteriors clearly indicate the nature of their construction, of their assembly out of premade units.

In his advertisements Hemming claimed that "these buildings . . . have been found by experience especially adapted both to hot and cold climates." From the earliest days in Bristol, Hemming had given the problem of climatic control much thought. He had provided double-skinned walls and roofs, had used insulation materials, had allowed good ventilation, and—in his houses—had provided sun-screening shutters and

109

louvers. Despite his awareness of the problem and his attempts at solution, the buildings had failed to perform adequately in hot Australia, and they soon earned the sobriquet "iron pots." But in temperate England they were apparently much more successful. "The iron churches erected in London," a commentator wrote in 1859, "are found to answer every purpose for which they were designed. There are now five of them, in each of the following districts: Kennington, Kentish-town, Newington Butts, St. George's East and Holloway. The Holloway church cost £1000, and is capable of housing 900 people. It is described as 'a most comfortable place of worship, well ventilated, warm in winter, cool in summer, and can easily be taken down when not needed in the district.' "[24]

Criticism of the temporary churches reflected not only functional problems of thermal control, but also an abiding interest in the problem of architectural character. The pragmatism of nineteenth-century thinking did not deflect architects from searching for architectural styles appropriate to the spirit of the age, its unique problems, its burgeoning richness of technological potential, and its heavy sense of history. The iron church was not a central issue in these debates, but it caused piquant comment from the sidelines. Iron churches—except for Slater's experiment for the Ecclesiologists—were regarded as the products of industry, not as works of architecture that were subject to the normal canons of criticism. But the problem could not be avoided when serious architects entered this field of design. In the Architectural Exhibition of 1857–58, held at the galleries of the Society of British Artists, an iron church was exhibited: a church commissioned by the East India Company and designed by the eminent architect Matthew Digby Wyatt. This provoked immediate comment. "Mr. Wyatt's 'Corrugated Iron Church' was doubtless a structure of stern necessity for exportation to Rangoon," wrote a sympathetic correspondent in the *Building News*. However, he went on to comment, "how indocile to the Ithuriel touch of an architect is this very untoward material . . . what could even William of Wykeham have done with *corrugated iron*?"[25]

Later in the year, in the correspondence columns of the same journal, an exchange of views took place on this topic. On 29 August 1858, one "A. R." wrote to the editor of the *Building News*: "Do you think that as iron has become a building material applicable for building purposes —to wit, churches—that it would be very desirable for some of the eminent firms in the iron trade to consult architects more generally as regards the design and general character of their structures? As it stands at present, I do not think there is a good iron church or school-house in existence. . . . I think myself that iron is capable of being made a most elegant, light and constructive feature, both in respect to churches,

schools and warehouses." The writer ended this note, progressive and perceptive in its understanding of the nature of the new material, with a practical appeal: "Trusting that these lines may call forth . . . a ready response from the iron trade."

On 3 September "Zeta" wrote concurring with A. R., expressing the view that, if properly designed, iron churches could well be permanent rather than temporary, and calling for architect-designed iron churches. Further support for this view came from "Cerca" on 10 September, but the tone of this letter tended to be negative, even hostile. "The iron abortions at Islington, Barnsbury, Bow and Kingsland ought certainly to be stopped, or a much greater improvement made; they remind one too much of a California gold mining district, where cheapness and mean utility is the paramount object to be obtained. Why does not the eminent firm of Hemming (s) and Co. employ some one to design for them?"

There was no reply from Hemming to this appeal, but another letter on the same day gave the manufacturers' viewpoint. This was Tupper & Co., formerly Tupper and Carr, who were well-known producers of galvanized corrugated iron and other products. Originally making only iron components, they expanded into the manufacture of complete iron buildings, and in the various London and Birmingham trade directories they are listed as "Iron Church and House Builders" until at least 1886. In their letter to the *Building News* they claimed responsibility for the manufacture of Wyatt's Rangoon church (at that time on its way east by sea), and mentioned that they had also constructed several iron churches at home, including the Bournemouth Scottish Church, the church at Islington for the Reverend J. K. Harrison, and the Presbyterian Church at Dalston, which was nearly completed. They stated that they now employed an architect, George Adam Burn, who was preparing a series of designs for iron churches at their request.

Another major British firm that used the services of an architect for the design of their iron churches was Francis Morton & Co. of Liverpool. This old, established engineering firm had diversified interests and had gradually moved into the field of galvanized-iron elements, and from there, like Tuppers, into the field of complete buildings. In 1855 they bought the machinery of Porter Bros. and Stuart, of Birmingham, to increase their capacity for manufacturing corrugated iron; in 1863 they opened additional works at Marybone, Liverpool, solely for the construction of corrugated iron buildings and roofs. By 1880 they had expanded significantly, and had taken over the Hamilton Windsor Iron Works at Garston, a vast establishment where they developed a capacity for producing corrugated and galvanized sheets at the rate of over 200 tons per week. By the mid-1860s they had established a special depart-

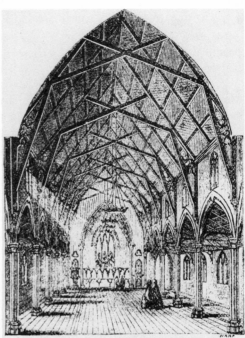

Figure 6.10. Francis Morton. St. Mark's permanent iron church, Birkenhead, England, 1867. Wyman's Architects, Engineers, and Building Trades Directory, 1868.

INTERIOR OF ST. MARK'S PERMANENT IRON CHURCH,

ment for the manufacture of iron churches, chapels, and schoolhouses that was under the direction of the company's architect, and this department was active for at least 20 years.[26]

In establishing this department Morton's aim was "to ensure all the comfort and good appearance of Stone Buildings, whether for erection at home or for Hot Climates abroad." As it was stated in the 1873 catalogue, "This Company has lately turned its special attention to the improvement and development of *Iron Church and Chapel Building*, being anxious to show that this material, in practical and tasteful hands, may be utilized in producing structures at one economical, as comfortable as stone-buildings, pleasing in their architectural appearance, and meeting a great desideratum for additional church accommodation throughout the country." This design approach is indicated in St. Mark's permanent iron church (fig. 6.10) consecrated in April 1867. A full description of the structure appeared in the contemporary press.

> It is altogether of a different class to the temporary Iron Churches that we often see put up for the accommodation of a Congregation, whilst their Stone Church is being erected. These may be useful in their way, but St. Mark's is for no such purpose. It possesses all the beauty, comfort, and solidity of a Stone Church inside, and the outside presents a very

112

pleasing appearance, and strikes one at once as being a substantial and durable structure. Outside, the walls are covered with Galvanized Corrugated Iron Plates, while the roof is covered with . . . Galvanized Iron Tiles. Inside, the walls are lined with boards to the height of the window sills, above this they are lined with plaster. The roof is of open timber work very strongly braced together. . . . The roof over the chancel is coloured azure blue and powdered with gold stars.[27]

Despite a spell of unusually inclement weather, the building took only four to five months to build; it cost about £2,000 and accommodated a congregation of 500. The iron church was connected to St. John's Birkenhead as a "chapel of ease"; St. John's minister was delighted with the new building and wrote of it enthusiastically in a letter to the manufacturers: "Its exterior architectural features are so very beautiful, and in harmony with the general type of Ecclesiastical buildings in this country, that it is quite an ornament to the neighbourhood in which it stands. Its interior arrangements are so very commodious, and in such strict accordance with our Church system, that it leaves nothing to be wished for. . . . I have, since its completion, often wondered that in these days when so much Church room is wanted throughout the country, this class of Churches which is so cheap, substantial, ornamental, and quickly raised, should not have been made more use of than it had."[28]

Production of iron churches continued for at least 50 years, and was the work of large, well-established firms as well as of small-scale enterprises on the fringes of industry. Major engineering works and iron foundries—sound, durable, respectable firms—were engaged in the production of iron buildings, well-known establishments such as Croggon, Morton, Tupper, Braby, Walker, MacLellan, Davies, and Morewood. These firms, it is true, all had other important interests, but they saw fit, over the decades, to list themselves in the trade directories under the heading "Builders of Iron Churches," to advertise in such journals as the *Builder*, and to publish their designs in catalogues. Frederick Braby & Co. of Glasgow,[29] for instance, had registered designs for a simple church seating 198 persons, a larger version for 288, and an elaborate, cross-shaped plan for 460 (fig. 6.11), all with Gothic traceried windows, corrugated iron sheathing, ventilated double roof, and a soaring flèche, which they illustrated in their extensive catalogue of 1889 as part of their wide range of products. It is possible that the German Lutheran Church of St. Martini in Kimberley, erected in 1875, and the first English Church at Barberton, of 1887, are Braby churches, since they are very similar in general form to those advertised.[30]

Another, similar catalogue was the comprehensive compendium of designs for iron buildings produced in 1888 by Crompton and Fawkes, of which the *Building News* had this to say: "Examples of galvanized iron

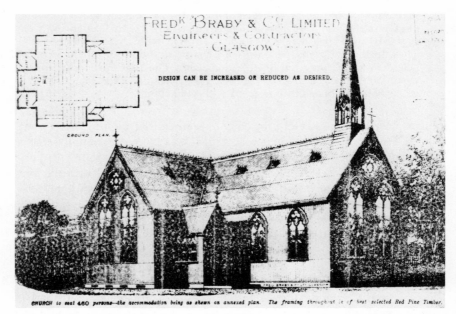

Figure 6.11. Frederick Braby. Iron church to seat 460. Frederick Braby & Co., *Illustrated Catalogue*, 1889. (Courtesy City of Liverpool Library.)

churches and chapels so commonly erected in new districts are illustrated; these consist of a single span roof, with a porch or tower at one end or corner, and a separate chancel, three rows of seats and a vestry. The framework is of timber, the roof and sides are lined by inodorous felt, and covered externally by galvanized corrugated sheets, 24 B.W.G.; the interior is match boarded. These buildings are so constructed that they may be erected by unskilled labour."[31] In a sense, the wheel had come full circle, for this description of the building, this range of materials, and this concept of erection was precisely that specified by Hemming in his pioneer development of the "portable iron church" 35 years previously. The significance is this: what had been a daring experiment at mid-century had, by 1888, become almost standard practice, in the churches now "so commonly erected."

CHAPTER 7

DEVELOPMENT
AND DECLINE

When iron buildings for exportation first made their appearance in the 1840s and 1850s, they were an exciting new phenomenon; each new example evoked considerable public interest. They were extensively reported in the daily press and illustrated in detail in the weekly pictorial magazines. In addition, the public took every opportunity to examine the new products. In 1843, when Laycock built his iron palace for King Eyambo, he opened it to public exhibition in England and charged an entrance fee that went to charity.[1] When Hemming built his first iron church for Melbourne, he invited more than 800 people to attend the inaugural service that was held while the building stood in the factory yard at Bristol.[2] Before Robertson and Lister sent a giant iron warehouse to Melbourne in 1853, they held a ball in the structure in Glasgow. "Delight and astonishment were scarcely diminished when, on driving to the spot at the appointed hour," a journalist wrote enthusiastically, "we found external crowds and lines of civic force guarding the living avenues of approach [to the corrugated iron structure, which was] the scene of the most gay and gorgeous festivities."[3] And, in 1854, when Bellhouse put the Payta customs house on show at his Manchester foundry, 25,000 people visited it in 10 days.[4]

Fifteen or twenty years later an entirely different situation prevailed. During the last third of the nineteenth century the prefabricated corrugated iron building had become commonplace and unspectacular. The lay press no longer gave publicity to buildings for export, for the novelty had worn off; the professional journals disdained to illustrate corrugated iron buildings for, aesthetically, they were incompatible with the ruling taste and, technically, they were no longer exciting—they were, however, undoubtedly a fact of life.

Because the use of corrugated iron in Britain had become wide-

spread, for a large variety of purposes, in 1888 the local government board, always conservative in the face of technical innovation, felt compelled to add to its "Model By-laws" a new code governing temporary iron buildings, "the external walls and roofs of which shall be constructed of or wholly covered with galvanized, corrugated, or other sheet iron."[5] Corrugated iron, the Cinderella material "so indocile to the Ithuriel touch," had at last received some form of official recognition.

The Victorian attitude to this material was ambivalent. Because of its obvious utility its applications proliferated, but, at the same time, it was looked upon with a critical eye and was spoken of derisively. An article written in 1889 reveals something of this ambiguity. Aesthetically, corrugated iron was obviously not acceptable—"exposed galvanized iron looks poor and ill-adapted for permanent buildings"—but it did have the virtues of strength, practical convenience, and low cost. However, it was not a faultless material; the colonial experience had revealed its climatic shortcomings, but there were additional problems in Britain, such as condensation and the corrosive effect of the industrially polluted atmosphere, which quickly became apparent: "the smoke of coal and fires is injurious to the zinc coating, and the damp atmospheres, impregnated with smoke, soon find out weak points in the metal." Besides these inherent weaknesses, there had been a certain lowering of standards, a deterioration of quality. "The sheets are thin and poorly coated, they are seldom painted with oxide of iron paint at the time of their erection, and the injury done by cutting and punching holes in the sheets is the cause of their speedy destruction."[6]

These strictures suggest a decline in the quality of material and the standards of workmanship. From a qualitative point of view the 1850s represented a high peak. The iron itself was of outstanding durability, workmanship was meticulous, and design reflected an inventive response to technical challenge. From many points of view we see in the 1880s a regression from these high standards and a return, as we shall argue, to a more simplistic, even primitive approach. What technological advance there was in these years was, in effect, subterranean, for the development of steel, which would eventually replace corrugated iron on a commercial basis, was quietly taking place. However, an economical process for producing the necessary light-gauge steel sheets that were the basis for corrugating was not developed on a practicable basis until the last decade of the century. As far as our story goes, then, the material with which we remain concerned is corrugated *iron*, in substance as well as in name.

The late nineteenth century, therefore, was not marked by radical technological innovation or by finesse in use, but, rather, by the consolidation of the market and expansion of production of the corrugated iron

116

sheet, and by the continued application of it in the construction of iron buildings. The output of corrugated iron, always impressive, now became substantial. By 1891 Britain's annual production exceeded 200,000 tons, of which perhaps 75 percent was exported; by the end of the century 250,000 tons was being exported annually, largely to the colonial empire and developing countries.[7] While the bulk of this material was shipped out in sheet form, to be used as a simple building material for walls and roofs, the makers of iron buildings remained active in both the home and the overseas markets. It is difficult to assess the total output of the iron building industry in these years, but it seems reasonable to speculate that it was considerable. If we look in the trade directories, for instance, we see long lists of names under such headings as iron church and house builders; builders of portable houses; iron church, chapel, and schoolhouse builders; iron hospital builders; and so on. In Kelly's Building Trade Directory for 1886, for instance, these categories contain about 24 firms, many of them large establishments; about one-third of these had been engaged in the manufacture of portable buildings for 15 years or more. If we consider the many other firms that were active in this trade but listed themselves under more general categories such as ironfounders, and when we consider the numerous factories in cities other than London —in Derby, Birmingham, Liverpool, and Glasgow—we may, I believe, safely infer a continuing considerable trade in iron portable buildings.

Sometimes we learn of a lone example shipped by a manufacturer not mentioned in any standard source. There is the fascinating story, for instance, of perhaps the most remote example of all prefabricated buildings.[8] This is the Harberton house at Tierra del Fuego in the Argentine, a wood and iron two-story house, premade in the workshops of a carpenter in Devon—the father of an emigrant to one of the farthest corners of the globe—and shipped out in 1886. Such stories are piquant; they reiterate the recurring theme of the challenge emigration offered to a concerned and inventive parent; and they serve to enrich our central study, which is not the fascinating isolated instance, but, rather, the place of organized industry in the development of nineteenth-century prefabrication.

As an indication of the role of industry at this late stage, let us look at the complex range of products being produced by two of Britain's major industrial firms, Francis Morton & Co. of Liverpool (fig. 7.1) and Frederick Braby & Co. of Glasgow. We have already mentioned their iron churches; now let us turn to the general catalogues of their "iron buildings departments."[9] Morton's indicate that their products are for home and for export, and it is interesting to note—as a commentary on the international character of the trade in prefabricated buildings—that the explanatory foreword to the catalogue is in English, French, and German. Home products embrace an eclectic range: farm buildings; an iron

Figure 7.1. Francis Morton & Co. View of head office and works, Liverpool, England. *Catalogue, 8/B.* (Courtesy City of Liverpool Library.)

drill hall for the 19th Surrey Rifles; a clubhouse, complete with beer cellar, for Liverpool's Anfield Cricket Club; two country houses erected for Lord Hill in the Isle of Skye; a truly vast ironworks in Staffordshire, with one curved structure 600 feet long, for the Earl of Granville; warehouses for canals, docks, and railways; and a variety of simple cottages for lodges, shooting boxes, and—for emigrants. Forty years or more after Manning's pioneering effort, the "portable colonial cottage for emigrants" was still being offered to Britain's departing sons.[10]

But most of Morton's buildings for export are of a more substantial nature. There is a large, two-story warehouse for the customs department of the New Zealand government; cotton gin factories of considerable size for India and for Egypt (fig. 7.2); a squarish, two-story warehouse and dwelling for Turk's Island in the West Indies that "weathered the fearful Tornado of 1866, while nearly all surrounding buildings were destroyed"; and a complex range of structures for the Cuñapiro Gold Mining Co. Ltd. (fig. 7.3) in Uruguay, providing extensive facilities, which included the

Figure 7.2. Francis Morton. Cotton gin factory for Egypt, c. 1870. *Catalogue 8/B.* (Courtesy of Liverpool Library.)

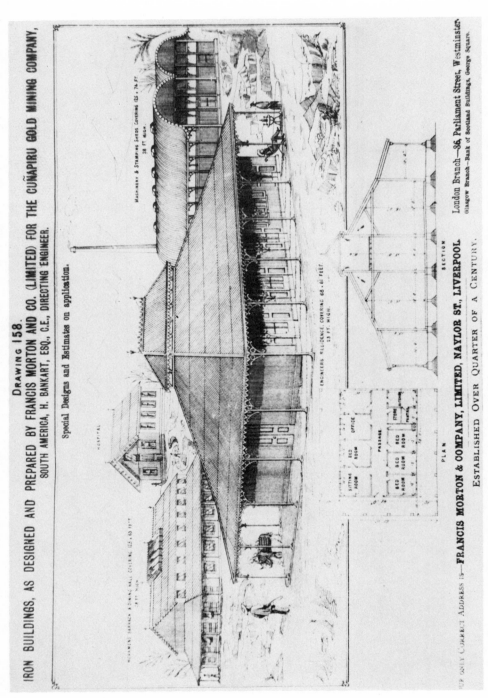

Figure 7.3. Francis Morton. Iron buildings for Cuñapiru Gold Mining Co., Uruguay, c. 1870. *Catalogue 8/B.* (Courtesy City of Liverpool Library.)

machinery and stamping sheds, the workers' barracks and dining hall (with over 15,000 square feet of accommodation), a hospital, and a lavish residence for the British engineer in charge.

The roof forms of these buildings are varied. Usually they are the almost-traditional segmental barrel vault of corrugated iron carried on ranges of cast-iron columns, but there are also concave roofs (like the ones Bellhouse had used in California constructions more than 20 years previously) and many simple double-pitched gable roofs. Of special interest, in view of the somewhat unhappy history of the "iron pots," are the roofs especially designed for hot climates: these are of double-skin construction ingeniously ventilated at the ridge in a way that also exhausts the hot air from within the buildings. "Great success has attended the endeavours of this firm to improve upon the existing methods, and to devise *new methods*, to meet the requirements of different climates," Morton's catalogue claimed, "so that whatever may be the temperature of the country for which a building is intended, they endeavour to construct it so that a comfortable and healthy degree of heat shall exist within it."

The general standard of these designs is competent, but—notwithstanding the claim to new methods—one is left with the impression that there has been some stagnation of development since the innovative days of Walker, Porter, Bellhouse, and Hemming. This impression is confirmed by the examples illustrated in Braby's catalogue of 1889. In this there is a curious combination of engineering competence and technical conservatism. The range of Braby's products is impressive; there are structures for a variety of agricultural purposes, railway buildings, warehouses in single and multiple units, large tea houses for the Indian plantations up to three stories in height, market buildings, a range of dwellings from modest cottages to ambitious verandaed villas for tropical climates, a telegraph cable station, sports clubs and pavilions, various churches, and two types of iron hospitals. As Braby's catalogue took care to point out, these are real projects, designs representing "contracts actually carried out," and there is an air of substantial realism about them. We have an impression of fully considered, carefully detailed, well-built structures. The frames are of timber, of cast iron, or of rolled H-sections, depending on the size and nature of the building; the external cladding of walls and roof is the ubiquitous corrugated iron sheet; in many examples there is an internal lining of tongue-and-groove boarding; inodorous felt is used as thermal insulation, the windows are shuttered, and the roof space ventilated by dormers and gable vents. This is traditional British workmanship and engineering at its very best. It is also an indication of that late-nineteenth-century caution that gave the end of the Victorian era a different stamp

in comparison with the vitality, ingenuity, and bravura displays of virtuosity of the mid-century.

In forms and techniques this later work represents an unbroken line of continuity evolving from the early pioneers and the successful manufacturers of the 1850s. There were further refinements of the structural elements—Goldie and Inglis's highly sophisticated cast mullions (fig. 7.4) designed to receive both double-skinned external walls and internal partitions,[11] or Robert Walker's concept of a universal structural post capable of receiving modular partitions in four directions[12]—but such concepts somehow never entered the mainstream of technical development. Experimental systems, radical new ways of thinking about the problem of the portable building (such as Calvert and Light's lightweight system[13] with its screw-pile foundations and fibrous slab walls (fig. 7.5), the precast concrete panel system patented by William Henry Lascelles in 1875, in which the concrete wall slabs were fixed to either timber or concrete posts,[14] or the lightweight, thermally efficient products of the Patent Wire Wove Waterproofing Roofing Company of London, which included a translucent glass-substitute, and a building sheet composed of steel wire and papier-mâché),[15] these innovations remain fringe activities that were never properly absorbed into the industrial processes or adequately developed. The portable building industry of the late nineteenth century remained wedded to the techniques of the pioneers, and in so doing, became conservative. This conservatism was not merely a standing still; it caused an eventual regression to technically simpler systems, and, almost inevitably, this regression was accompanied by aesthetically more brutal forms. The reversion, I would suggest, was from the structurally and conceptually sophisticated corrugated iron prefabs of the 1850s to the utilitarian directness of the wood and iron buildings of the 1880s.

As an illustration of the ubiquity of corrugated iron and of the tendency to use it simply, even brutally, in both prefabricated and site-built structures (often indistinguishable from one another after completion), let us turn to the South African mining towns of the last third of the century: to the Vaal diggings and to Kimberley in the Cape, founded upon the diamond discoveries of the early 1870s; to the Barberton district, scene of the gold rush of 1882–86, in the Eastern Transvaal; and, finally, to Johannesburg, heart of the Witwatersrand gold region from

Figure 7.4. Goldie and Inglis, ironfounders; James Henderson, architect. House for Melbourne, Australia, 1853. *Top*, Front elevation; *Bottom*, Detail: Cast-iron columns and window frames; corrugated outside lining of outer walls; tongued and grooved deal inner linings and partitions; mahogany window frames and sashes. The *Civil Engineer and Architect's Journal*, 1853, p. 456. (Courtesy Royal Institute of British Architects.)

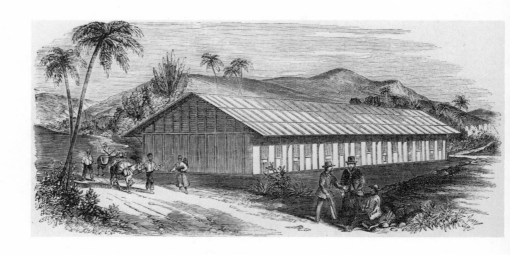

Figure 7.5. Calvert and Light. Portable building system, 1860. The *Mechanics'*
Magazine, September 1860, p. 199. (Courtesy British Library Board.)

1886 onward. Here, in each case, is the classic situation of prefabrication: a sudden, unpremeditated demand, and negligible local resources with which to meet it. These new settlements, emerging breathlessly and brazenly from their primitive mining camp embryos, were, almost literally, towns of corrugated iron, for, despite the occasional brick house and the occasional thatched roof, the predominant material was corrugated iron, brought laboriously overland, partially by train, largely by ox wagon, from the far-off ports at Cape Town, Port Elizabeth, Durban, and Delagoa Bay.[16] The typical beginnings of the diamond field settlements, whether on the Vaal River at Pniel or Klipdrift, or later at Kimberley itself, show an evolutionary development of the dwelling. Side by side with the improvised, primitive shelters—the packing-case and kerosene-tin shanties, the wattle-and-daub huts, the crude, sun-dried brick hovels—we get a series of attempts to create stronger, more impervious homes in an ascending scale of comparative comfort, and even an occasional pretense of permanence. There were, as a contributor to the *Digger's News* wrote in 1889, "distinct periods or 'strata' in the human habitation of Kimberley. First came the tent, with all its attendant miseries; next the 'canvas frame house'; then the iron 'shanty.' . . ."[17] It is as if the whole history of the prefab, as we have outlined it in our narrative, has been compressed into a brief instance of time and recapitulated, as it were, on the shimmering African veld, from primitive beginnings, to the "high" technology of the demountable corrugated iron building. The erection of shelter proceeded at a frenetic pace. "In the latter part of the year 1870," it was reported of the Vaal River diggings, "both sides of the river were covered from the hill-tops to the river's brink with canvas tents and houses, carts, wagons and iron buildings"; at Du Toit's Pan, "in two months the wild waste was covered with houses, stores, hotels, diamond merchants' offices."[18]

The need for immediate shelter in this rough, isolated, hostile environment was imperative, and local resources were pitifully inadequate. There was no timber available for building, and few bricks; the bricks that did exist were sun dried because there was no firewood with which to burn them—at Kimberley, there was not even any water with which to mold the clay. Conventional building material transported laboriously from the coast by ox wagon was terribly expensive, at £30 per wagonload.[19] Moreover, skilled tradesmen were scarce in the early days, and those few builders who did come to the diggings had their hands full. It was that kind of situation, as we have stressed previously, to which partial or total prefabrication was the logical response. To fulfill the urgent need for housing, the two-wheeled covered Cape Cart and the traditional tented wagon were reused for dwelling purposes—two of the earliest manifestations of the "mobile home" concept. Then we have the

Figure 7.6. Wood and canvas frame house, Old De Beers, South Africa, 1870s. (Courtesy Alexander McGregor Museum.)

tent, including such well-made examples as "The Diggers' Friend," a 12′ X 10′ X 9′ high tent with optional lining of druggeting, "an exact facsimile of tents used by diggers in Australia and New Zealand."[20] On a more ambitious scale there were timber-framed canvas houses, a strange throwback to a type used and then discarded in eighteenth-century New South Wales. According to a contemporary account of the diamond fields, there were two origins for these canvas houses. "Some have built frames in the shape of a house, which they cover with canvas, having swinging doors and windows to them (fig. 7.6). Others have had frame houses built at the colonial towns, and brought up in pieces on ox-wagons; others brought corrugated iron houses."[21]

These corrugated iron houses are our main theme, the one to which we will return shortly. But let us, for a moment, deal with the "frame houses" to which these early accounts refer. Many of these, as we have indicated, were canvas covered, "portable canvas frame houses" as the newspaper advertisements have it.[22] Some were obviously quite extensive, and fulfilled diverse needs: the Diggers' Hospital, for instance, was such a canvas-covered structure, and so, too, was the Crown Hotel, which was advertised in 1878 "to be sold and removed."[23] But many of the

frame houses were genuine wooden prefabs with cladding far more substantial than mere canvas.

Among the original Kimberley buildings now reerected at the Kimberley Mine Museum stands a small, reddish-brown wooden cottage, reputed to be the oldest surviving house of the town. This is a well-made timber prefab (fig. 7.7), modest in size but pretentious in its classical front, complete with Tuscan pilasters, roundheaded windows, and an elaborate pediment, incorporating, somewhat incongruously, a louvered ventilator. This structure was made in England in 1877 and brought to Kimberley from the coast by ox wagon. Many early illustrations of the diggings show timber-framed, horizontally boarded, gable-ended structures of varying degrees of simplicity.[24] One of these, the "New Found Out" pub (fig. 7.8), a peripatetic camp follower that moved from one digging to the next, bore a striking resemblance to the "oldest house." Some wooden prefabs have corrugated iron roofs, a hybrid of obvious utility. One such building, providing three large rooms and a kitchen, made of deal and covered with an iron roof, was proudly described as "certainly *the best* on the Fields, and having been imported direct from England, is made of the very best Material and Workmanship."[25] The merit of another such boarded house, "a most comfortable and commodious residence," was that it "is well bolted together and can easily be removed."[26]

The demountability of a house was a property stressed in many an advertisement. Take, for instance, the dwelling of Charles Key. It was a wooden house of two apartments with a veranda and an unusual double roof; the corrugated iron sheeting was 5 inches above the timber roof, and the intervening space was filled with reeds for thermal insulation—a necessary precaution in an area of such fierce heat that, in the summer, it was "hot enough upon the corrugated iron roof to fry a beef steak or cook an omelet."[27] This house, we are told, "is put together in Panels and Fastened inside by Iron Buttons, and can be taken down and put up again in two hours."[28] Demountability, portability, ease of reerection—these were highly prized qualities in an age of uncertainty and flux. The scene on the diamond fields, as another, new, rich strike was made, was described in a vivid contemporary account: "The watchword of a 'new rush' is proclaimed, and it goes through the camp like wildfire. Many busy hands are at once employed to strike tents, unscrew and disjoint wooden houses, which are quickly and orderly packed away. Each piece and plank being numbered, little time is required to erect them in all their pristine grandeur, when and where required."[29]

Notwithstanding the widespread use of the timber house, corrugated iron was king (fig. 7.9), having grown in importance from its first appearance in the earliest days of the diggings.[30] A view, in 1873, of De

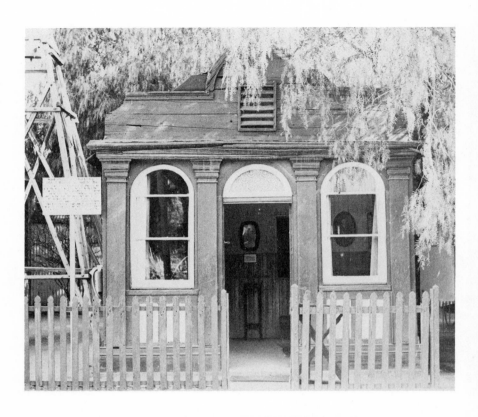

Kimberley's Oldest House | Kimberley Se Oudste Huis

THIS HOUSE WAS PREFABRICATED IN ENGLAND IN 1877, CONVEYED FROM THE COAST TO THE DIAMOND FIELDS BY OXWAGON AND ERECTED AT 14 PNIEL RD. FIRST REGISTERED OWNER MR. A.J. PETERSEN. REMOVED TO PRESENT SITE IN JULY 1952. | HIERDIE OPSLAANGEBOU WAS IN 1877 IN ENGELAND VERVAARDIG, PER OSSEWA NA DIE DIAMANTVELDE VERVOER, EN BY PNIEL WEG 14 OPGERIG. DIE EERSTE GEREGESTREERDE EIENAAR WAS MNR. A.J. PETERSEN. DIT WAS NA DIE HUIDIGE STAANPLEK IN JULIE 1952 VERPLAAS.

Figure 7.7. "Oldest house," Kimberley, South Africa, 1877; reerected at the Kimberley Open Mine Museum. *Top,* Façade; *Bottom,* Detail of sign. Photo Ivor Haberfeld.

Figure 7.8. "New Found Out" pub, New Rush, South Africa, 1874–75. (Courtesy Alexander McGregor Museum.)

Beers New Rush (soon to be renamed Kimberley) shows a panorama of corrugated iron structures, from the post office to the unpretentious residence of the lieutenant governor. On the street leading to the diamond market, every building—every house, shop, hotel, warehouse—was of corrugated iron. It was the material chosen by the diamond magnates, by Alfred Beit for his offices, by Sir David Harris for his grand ballroom with its interior walls and ceiling of richly patterned sheet metal. And, even prior to the construction of the Seventh Day Adventist Church in Beaconsfield—a building that is a monument to the age of iron—the German Lutheran congregation erected the very first church in Kimberley (fig. 7.10), which was consecrated in 1875. This little building, its hessian-lined interior dimly lit through "Gothic" windows with simulated leaded lights, was an imported wood-framed, ironclad structure, which had been transported overland by ox wagon to Kimberley from Port Elizabeth.[31]

According to all accounts, therefore, the Vaal diggings and the flourishing "diamondopolis" of Kimberley itself were constructed almost

Figure 7.9. Mine manager's house, Kimberley, South Africa, 1870s; reerected at the Kimberley Open Mine Museum. Photo Ivor Haberfeld.

exclusively of corrugated iron.[32] The question that interests us here is whether these wood and iron buildings were prefabricated; the answer is twofold. In a sense, all wood and iron structures are partially prefabricated, because the major element, both for roofing and for wall cladding, is the manufactured corrugated iron sheet. Moreover, all of these buildings are "portable" in the sense in which we have previously used the term; that is, they may easily be taken to pieces and reassembled or reerected elsewhere. It is difficult, therefore, to distinguish between the iron building made locally and that brought in, in component form, from the coastal towns, or imported from England. We may be sure that many of these structures were site-built from materials available in the locality and put up quickly by local workmen, since the construction of these simple buildings required little technical skill or experience in the building trade. As we have seen, building material for conventional structures was expensive because of high transportation costs, but this factor favored lightweight construction. As early as 1870, at the Vaal diggings, coastal dealers were advertising corrugated and sheet iron at Port Elizabeth prices.[33] By 1872 local merchants were handling considerable stocks, one auctioneer alone disposing of 50,000 pounds of galvanized iron. Within a few years considerable quantities of all the required elements and components of a wood and iron building were readily available locally: deals, flooring and ceiling boards, panel doors, window

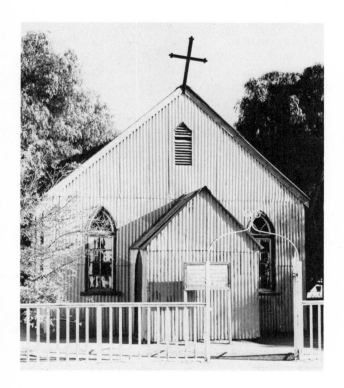

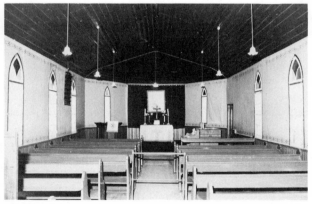

Figure 7.10. Lutheran Church, Kimberley, South Africa, 1875; reerected at the Kimberley Open Mine Museum. *Top*, exterior view; *Bottom*, interior view. Photo Ivor Haberfeld.

glass, galvanized iron sheeting and ridging; a local steam sawmill could proudly announce: "building material of every description always on hand."[34] Bids were called for the erection of iron buildings, "the contractor to supply all the materials and complete the work within fourteen days";[35] and there were even architect-designed corrugated iron buildings.[36]

The advertisement columns of the Kimberley newspapers reveal that there was a considerable trade in iron houses throughout the 1870s. It may be assumed that as building material became more readily available on the local market, the proportion of wood and iron houses made locally increased. This is a likely supposition, but it cannot be proved conclusively. So many of the references are tantalizingly ambiguous. Is the "detached iron building (Gothic architecture), boarded and ceiled and most tastefully arranged, nice paper, lofty roof, and c."[37] a work of local initiative, or is it an imported prefab? We cannot even take it for granted when an advertisement suggests portability—"a pretty and well-built iron house . . . quite new, and built with the object of moving it without delay"[38]—that this implies an imported prefab, because, as we have noted, demountability was a built-in characteristic, to a greater or lesser degree, of all wood-framed, ironclad houses.

However, there is another important and significant category of the wood and iron building that was clearly prefabricated in the fuller sense of the term, and that was brought into the diamond fields complete and ready for assembly. Especially in the early years, these buildings were awaited eagerly: "The Iron Store belonging to the Proprietors of the Cheapside London Cash Establishment has at last arrived. We have engaged good workmen to have it finished sharp . . ."[39] Unfortunately for them their business did not flourish, and within a year the new iron stores, 36' X 20' X 12' high at New Rush and 35' X 20' X 15' high at Klipdrift, had to be put up for sale. Many advertisements at this time stressed the portability and ease of erection of these imported houses. One told of "a new portable iron house, 20 X 14 feet put together with nuts and bolts. Suitable for a dwelling house or store. The purchaser can have it delivered to any of the 'camps'."[40] William Schulz of Klipdrift offered a range of iron houses: a small model, 12' X 15', with ceiling, suitable for offices or small digging parties; and a more substantial house type for diggers with a family, it was suggested, or even a branch store, this model containing one large and two small rooms, a kitchen, a veranda, floor, and ceiling, "everything complete, ready to be put up at once."[41] A couple of months later, Barnsdorf & Co. advertised an identical range of products.[42] There was now a growing trade in these imported prefabs. The agents Ben Benjamin and Phillip were active in this thriving business. At the end of 1871 they offered "two magnificently made Iron Houses—any person

132

requiring a good home for the summer will find them just the thing," and obviously had no difficulty in disposing of them, for, three months later, they gave notice that they had "just received two Iron Houses, 30 X 17 feet (similar to those supplied to Mr. J. B. Ebden, Mr. Osche, and several others)."[43]

Some of these prefabricated buildings were made in South Africa itself, in those "colonial towns"—the well-established coastal cities—that we noted earlier in connection with the manufacture of frame houses. Durban was probably one of these centers of manufacture, and Port Elizabeth, where "the noted builder Murell" was active in this trade, was another.[44] Another obvious source was Britain. Take, for instance, Parker's Pavilion, that fabulous pleasure palace of the diamond city, with its 1,500-square-foot hall, plus stage; its two large and handsome bars, "beautifully finished after the London Palace style"; its card room and gun room and shooting gallery, 120 feet long. All of this was under a corrugated iron roof with six magnificent skylights operated by pulleys. The structure was wood-framed, the external walls were of corrugated iron, the partitions were timber, and the floor was laid on solid deal—the building was "altogether of English design and construction." When the building was offered for sale in 1873, it was noted that "there are wooden models by which the building can be taken down and re-erected without the least difficulty even by persons having no mechanical knowledge whatever."[45] One major British manufacturer was obviously attracted by the potential of the diamond fields market, and for over six months the following announcement appeared regularly in the *Diamond News and Vaal Advertiser*: "Iron Houses for the Diamond Fields. Messrs. Morewood and Company of London and Birmingham, whose IRON HOUSES obtained such an enormous sale at the Australian and Californian Gold Diggings, are now prepared to execute orders for similar houses, suitable for the Diamond Fields, at a few days notice. Mr. Ryall (of Messrs. Ryall and King, Grahamstown) who is on a visit to the Fields, has purchased two of these houses and has kindly consented to give every information to intending purchasers."[46]

At Barberton some years later, one could see almost a replica of the same scenes, the same overall forms, the same roofs, the same wooden-posted verandas. All Barberton, it would seem, was of corrugated iron, from the all-important first stock exchange in the Transvaal with its underground pub for the convenience of the members (fig. 7.11) to the impressive agricultural hall that, in the Anglo-Boer war at the end of the century, served as a school, hospital, and recreation center for the concentration camp located there. Loyalty to the queen was shown in Herman Cohen's iron-sheathed Jubilee House of 1897, with its red, white, and blue stained-glass windows, and the British tradition was maintained

Figure 7.11. The Transvaal Share and Claim Exchange, Barberton, South Africa. Harris, *South Africa*, 1888. (Courtesy Africana Museum, Johannesburg.)

in the corrugated iron pavilion of Moodie's Cricket Club. From the market square and the old market house, to Clutha's store and hotel, from the Phoenix or the Granville or the Caledonian Hotel (a corrugated iron structure with an almost Oriental cast to its thatched roof), to the newly erected verandaed buildings mounting step by step up the rugged mountainside, there is everywhere a vista of corrugated iron.[47]

As they were at Kimberley, many of these wood and iron buildings in the Barberton district were locally made. Examination of the few remaining structures show the majority to be clearly of local origin, for their *in situ* nature is apparent. This is not surprising, for, even in the first year or two of Barberton's existence, stores (usually offshoots of Durban establishments) sprang up that stocked a wide range of building materials including, of course, galvanized corrugated iron of all lengths (of Gospel Oak and other well-known brands), building timbers (especially deal), and joinery components such as doors and windows, together with the necessary ironmongery.[48] In 1886 it was reported that "800 wagons were recently counted on the road between Barberton and Ladysmith [the railhead]. About 500 of these were loaded with building material."[49] Obviously much local building activity was taking place, although the same observer wryly commented, "We could easily do with

twice the quantity of goods." To make use of this material, locally based craftsmen—migrants from the larger towns—advertised their services as carpenters and builders, and soon there were even architects established in Barberton, and bids were frequently called for the erection of wood and iron buildings.[50] Although brick-making machines were available in 1886 and masonry contractors set up business, few buildings in those first hectic months were of conventional construction because of the speculative nature of gold prospecting. As a note on "The Condition of Barberton" pointed out, "the temporary nature of many buildings now being erected shows that many, at any rate, are even now by no means certain of its [the town's] permanency."[51]

But even if there was an ample level of local building activity in Barberton, there is still much to indicate that a high degree of dependency on the importation of prefabricated houses and other buildings existed in the early years. Some of this evidence is firsthand. A partially demolished house on President Street has its timber-framed walls screwed together rather than fixed by nails in the familiar in situ fashion, and its iron bears the Braby hallmark—Braby was the well-known English manufacturer of prefabs who advertised in the South African market.[52] Another, on Sheba Street, has a precision of manufacture and finesse of detailing that clearly bespeaks an origin of a well-run workshop. These inferences from the actual buildings are given substance by the documents. Some notices are general: "To arrive shortly: Two-roomed iron house, 26 X 12, 6 foot verandah in front, lined throughout, with doors and windows complete;" or "For sale, cheap, 1 iron shed gable roof, 18 X 40, 1 iron building with two rooms, 18 X 12, in complete order for putting up."[53] But others are more specific, and, almost without exception—there is a reference to wooden houses from Sweden[54]—point to an origin, not in Britain (although invariably the iron is British), but in the colony of Natal. We have already seen how, half a century previously, the colony of New South Wales had amassed sufficient technical skill to prefabricate all the wooden structures for the settlement of Port Essington in the Australian north. Now we have a similar story, at a more advanced technological level, in the settlement of the South African interior. All the documentary evidence shows a considerable dependency by Barberton on the manufacturing skills of Natal, where British components were utilized.

Let us consider some examples. The Royal Barberton Music Hall was a wood-framed, corrugated iron covered building measuring 60' X 40', was fronted by an imposing façade, and contained "all the usual accessories of a Music Hall."[55] This building was to be the famed "Royal Albert Hall" (fig. 7.12) where Cockney Lil reigned, grandly dispensing her favors under a sky-blue ceiling with painted stars, and angels looking

Figure 7.12. Royal Albert Hall, Barberton, South Africa, 1886. Photo courtesy Esme Lownds.

benignly down. It was erected in Barberton in 1886, next to Tattersalls, but it was actually manufactured in Maritzburg. While the manufacturer is not known, it may have been John Hardy, a builder and contractor of that city who advised "Gold Mining companies, storekeepers and others intending to build wood and iron stores and houses, [that] they should not fail to get a tender from John Hardy, the Popular Builder, who prepares buildings, numbered and packed for transport, at short notice."[56] Another example is the Barberton Club, whose stone foundations, in November 1886, stood ready, awaiting the completion of the ironclad, brick-lined, superstructure. "This building was ordered from Natal in May last, and only arrived a fortnight ago. The contractor has already nearly finished the erection, and the building will be ready for occupation in another month. The Club building will be 78 feet X 42 feet, and will contain handsome billiards, reading, club and two cards rooms, passage and bar, with a 9 foot wide verandah all round. The Walls are 13 foot high, and thereby coolness will be ensured. The casements and half-glass doors are all fitted with stained glass, which tends to modify the glare."[57] Elegance is judiciously married to concern for environmental proprieties demanded by a hostile climate. In the same issue of the *Gold Fields Times* in which this account occurs, we find an advertisement from Thomas Poynton, "the oldest established building firm in Durban," that notifies the Barberton public that "light strong and durable Wood and Iron Buildings are their speciality; in the satisfactory execution of which

136

they are unrivalled"; and, also, under the heading "Dwelling Houses and Stores Complete," the following announcement is published: "Having now supplied several of the above to residents on these fields, and each having given great satisfaction, we solicit the favour of further orders. Being turned out from the yard of John Nicol of Durban, should alone be a guarantee of good and reliable workmanship, which can be confirmed by personal inspection of many of the best wood and iron buildings in Barberton. Order at once, to secure early transport."

It is fitting, perhaps, that the Barberton agents for John Nicol were Savory and Raw. When T. W. Savory decided to venture from Durban to the new gold fields at Moodies prior to the establishment of Barberton proper, among the preparations he made "was the building of a store measuring about 30 by 20 feet, wooden walls and iron, made for us by a town builder, and this duly marked and numbered as with all other goods railed to Maritzburg, beyond which town the railway did not then extend, to be loaded on wagons for transport to the fields."[58]

To round off our survey of Natal firms supplying prefabricated corrugated iron buildings to the Barberton gold fields we must refer to Joseph Wright of the West End Steam Saw Mills, Durban, who offered "all classes of wood and iron houses" complete with free plans and estimates. Wright and Nicol both continued to advertise extensively for many years, indicating a well-founded industry rather than an opportunist, fly-by-night venture. Their later advertisements (dated 1889) appeared in the British-produced weekly *South Africa*,[59] and were directed, not to Barberton, but to those entrepreneurs and adventurers investing in the dramatic new gold fields of the Witwatersrand centered on Johannesburg. This was to be the fabled city of gold, but, like its predecessors, it was built more mundanely of galvanized corrugated iron.

The universality of this brash material, so harsh in the African sun, was further demonstrated when it came to Ferreira's Camp, the crude nucleus of the future Johannesburg, at first little more than a tent town. "Wood and iron buildings, in sections ready for erection, arrived very quickly and speedily were placed in position. In a little while Ferreira's Camp was the main centre of business activity."[60] According to a contemporary account, there were about 400 inhabitants; 24 iron buildings were soon standing, and many others were in the course of construction.[61] The rate of development was stimulated by the subdivision of the area into 600 building lots, with wide streets, and the establishment of a village that would bear the name of Johannesburg.[62] From this time onward the erection of buildings in the wood and iron mode became the established procedure. As early as August 1886, bids had been accepted for the construction of government buildings in corrugated iron,[63] and, early in 1877, permission was granted for the purchase and erection of a

Figure 7.13. Theatre Royal, Johannesburg, South Africa, c. 1887. (Courtesy Africana Museum, Johannesburg.)

temporary hospital of the same material.[64] During the next couple of years, until the recession of 1890, a thriving business in all manner of iron buildings—houses, banks, stores—is reported, and there is a spate of building, removing, selling, and renting of iron structures that range from modest cottages to "one of the handsomest villa residences . . . in the Goldfields [whose] outside walls are Gospel Oak Iron . . . lined with brick plastered," or, even more grandly, "that Beautiful and Palatial Residence," a house of iron (again, brick lined), on government block.[65]

Luscombe Searelle, an actor-manager who had already made his name as an entertainer in Australia, undertook an epic trek from Durban to Johannesburg, partly by train, and partly by wagon, over the rugged Drakensberg passes, and the swollen Vaal river, with a cast of temperamental performers; in addition to their costumes and other requirements, he transported the very theater in which they were to perform, the wood and iron Theatre Royal[66] (fig. 7.13). For Searelle this was a short-lived venture. By the end of 1888 a notice of sale proclaimed: "The Theatre Royal and adjoining Premises are built of the best Corrugated Iron, easily removed, or can be converted at a very small expense, into immense business premises . . ."[67], and, in 1890, he left the country and the theater passed into other hands. But this small, cramped fire hazard of a temporary theater fulfilled a valuable cultural role in early Johannesburg until more substantial masonry buildings were erected in the 1890s. Entertainment of another sort was provided in 1889, when the circus of

Frank Fillis became established in its permanent Johannesburg home—a polygonal, timber-framed, corrugated iron-covered structure of vast dimensions, with a floor space of over 10,000 square feet, a height adequate for the daredevil trapezists, a claimed capacity of 2,500 seats, and illumination by that new wonder, electric light. In Barberton in 1886, Fillis had housed his circus in a tent 1,000 feet in diameter, but in Johannesburg, he erected a veritable amphitheater of corrugated iron.[68]

By this time iron was not a novelty in Johannesburg, but the normal building material. Let us, as a case study, examine the market square—the very heart of the emerging town—in 1889 (fig. 7.14).[69] Here stood the government building, a solid, single-story, neo-French Baroque structure dominating the square, seemingly the most permanent of buildings, but, ironically, one of the first to be demolished to make way for the grandiose post office. Stretching away from this building, on either side of the square, were 48 building lots. By 1889 six remained vacant, eleven had small brick structures upon them, and the remaining thirty-one were covered by corrugated iron buildings: stores and shops, a bar and a hotel, an auction mart and a concert hall. On the square itself a segmental-roofed iron structure—the fire station—was soon erected.

Figure 7.14. The market square, Johannesburg, South Africa, 1889. (The shaded sites are occupied by corrugated iron buildings.) After De Waal, *The Market Square of Johannesburg.*

139

Figure 7.15. Park Station, Johannesburg, South Africa, 1886–87. (Courtesy Africana Museum, Johannesburg.)

North of the square, past a sea of corrugated iron one- and two-story buildings, was the railway station (fig. 7.15). This structure, like its predecessors, Zeederberg's stagecoach office and the first primitive Park Station, was also of iron, but it was much more ambitious.[70] Railways in the Transvaal were developed by the Dutch firm of Maarschalk and Company, which laid out the tracks and were responsible for the erection of the new station building. This was a large, cast-iron, steel-framed structure with rolled steel joists and a high, barrel-vaulted main hall, roofed—as were the lower elements and cantilever roofs—with corrugated iron. It was designed by the architect J. F. Klinkamer, and was originally erected in Amsterdam to house an exhibition in 1885. It was purchased in that year and transported to Johannesburg, where it was reerected in 1886–87. It is not known whether the cast iron is of Dutch origin, but the Birmingham firm of Skillingrove manufactured the steel beams.

Close to the station, on Tuin Plein, stood the municipal offices, a corrugated iron "temporary" building rushed up as an emergency measure to house the municipality when—or so the story has it—it was discovered that the town clerk had, by oversight, failed to renew the lease of the existing council premises.[71] Christened the "Tin Temple" by an ex-clergyman councillor, we are told, it remained in use for many years, first as accommodation for the municipality and then, beginning about 1904, as the home of the South African School of Mines (forerunner of the Witwatersrand University—until that school moved to its own campus in 1922).

By 1890 Johannesburg had grown from a mining camp to a well-established town that could boast of several fine two- or three-story brick structures, and even one grand building, Palace Buildings, whose elegant tower soared 90 feet above the bustling streets. In contrast to the other

mining towns, local brick, "a relatively cheap article of commerce,"[72] was in abundant supply. But the boom conditions, endemic in those early years of spectacular growth, also generated a chronic shortage of skilled building labor and a housing shortage of critical severity. Accommodation of any sort was hard to come by, and exorbitant rents could be charged for any semblance of shelter—as much, we are told, as "£30 per month for four-roomed tin shanty."[73] Consequently the building of corrugated iron houses continued at such a rate that, at the beginning of the twentieth century, wood and iron buildings constituted nearly half of the 30,000 more permanent dwellings on the Witwatersrand.[74]

Ready availability of the necessary building materials and components, ease of construction, and relative economy were all factors in the enduring popularity of the iron house; the material was never really admired for its aesthetic quality, being far too brutal and harsh for late-nineteenth-century taste. But there was another factor in its continued use, and that was its lack of "fixedness", where the land was often only held in leasehold,[75] and where an atmosphere of chance, change, and indeterminancy prevailed, the "portable" quality of the readily demountable iron house was, as we have seen, a redoubtable asset. So, when vast new residential land subdivisions took place (sometimes hundreds of

Figure 7.16. House in Gus Street, Jeppestown, Johannesburg, South Africa, late nineteenth century. (Courtesy Africana Museum, Johannesburg.)

building sites were auctioned at a time), the newly generated suburbs were filled with their due share of corrugated iron structures (fig. 7.16). Beyond the town, on the suburban fringes, in the gold fields themselves, the mining companies became the prime users of galvanized corrugated iron. It was used for the dramatic industrial structures, the giant storage sheds, the majestic battery houses; for the well-appointed villas of the mine managers; and for the neat rows of cottages, with their pretty gardens, as prim as an English village, for the white miners and their families.[76]

While some of these iron houses were pretentious in character and provided luxurious accommodation, generally they were of simpler, more modest, design. The structural framework, internal partitioning, roof trusses, and floor beams were of timber and the external cladding and roofing were of galvanized corrugated iron—hence the term "wood and iron," or the pejorative term, "tin shanty." Internal linings were of boarding, pressed metal, or brick, plastered and papered. Verandas with wooden posts, simply patterned railings, decorative brackets, and sun-screening trellis work (usually all of wood, although cast iron was sometimes used) fronted the house, or surrounded it on all sides. Sometimes the fenestration consisted of graceful, full-height French doors, usually shuttered, but it more frequently consisted of simple sliding sash windows shielded by a protective metal hood that pierced the corrugated-iron walling incisively, sometimes brutally. The roofs were hipped, and often a projection ended in a gable (ventilated, perhaps, with louvers), or there was a patent metal vent fixed at ridge level. Segmental or faceted bays projected from the iron walls to add a touch of elegance or richness. There was no suggestion of a modular construction, no apparent use of a panel system like the one Hemming had used nearly half a century before in Australia. In all, the detailing was direct, simple, effective, and, sometimes, almost naïve. Present-day observers, accustomed to the blunt and brutal architecture of the seventies, are not deterred by the lack of finesse in these old iron buildings, but find their simplicity charming, and their freshness attractive.

One of the most impressive iron buildings of early Johannesburg was the Hosken Brothers store, which was probably built in 1887. This was a vast, basilicalike structure of two stories, with a continuous clerestory ventilating the roof ridge.[77] William Hosken, a mining materials merchant, was the Johannesburg representative of Nobels, the famous dynamite manufacturers—explosives, naturally, were a vital commodity in the mining process. When President Kruger of the South African Republic granted a dynamite concession to a German friend, Lippert, the embittered Hosken agreed, reluctantly, to cooperate, and provided storage facilities for Lippert's explosives in his great iron warehouse. Eventually,

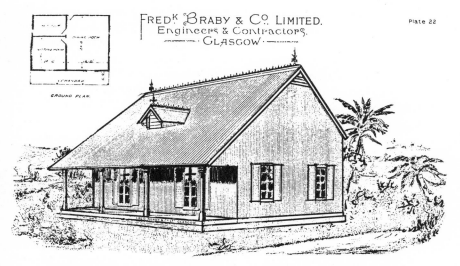

FRED^K BRABY & C^O. LIMITED.
Engineers & Contractors.
——— GLASGOW ———

Plate 22

GROUND PLAN.

DWELLING HOUSE lately shipped by us to South Africa for a Gold Mining Company. Containing 3 rooms, with projecting verandah, as shewn on annexed plan. Framed in best red pine timber, and covered externally with our best "Empress" Brand Galvanized and Corrugated-Iron Sheets. Lined and ceiled with tongued, grooved, and double v-ed boarding. Patent Inodorous Felt between outside sheeting and inside lining, to equalize temperature and deaden sound. Flooring of timber, on brick foundations. Ventilation provided by means of ornamental dormer, and louvres in ends of building. Windows arranged to open as casements, with timber louvred shutters on outside. W.-I. gutters and pipes, and ornamental finials and cresting.

Figure 7.17. Frederick Braby. House for a South African gold mining company, 1889. Frederick Braby & Co., *Illustrated Catalogue*, 1889. (Courtesy City of Liverpool Library.)

however, he broke with Lippert and denied to him the use of his dynamite magazine. A consignment of the volatile German explosives arrived and, because of storage difficulties, it was left for some days in the train, standing in the blazing sun at the Braamfontein railway siding. The result of this was Johannesburg's "Great Dynamite Explosion" of February 1896, a disaster that not only blew an enormous crater in the ground, but wreaked havoc with the surrounding buildings. However, instead of the normal rubble of a destroyed city, there was left lying, like windblown leaves, the fragile twisted wreckage of uncountable corrugated iron sheets.

Where did this vast quantity of iron buildings on the Witwatersrand originate? Of all of the major British firms manufacturing prefabs that we have examined in this study, only one appears to have links with the gold field market. This is Frederick Braby & Co., which not only advertised in the South African directories, but which also illustrated, in their 1889 catalogue, a "dwelling house (fig. 7.17) lately shipped by us to South Africa for a Gold Mining Company."[78] Morewood & Co., who had dealings with Kimberley,[79] do not appear to have traded in the Transvaal.

143

The few manufacturers of iron buildings who advertised in the South African directories at the turn of the century were British producers of "iron and wood buildings . . . specially constructed for Colonial use . . . marked for reerection . . . key plans provided," whose names are new to us, and who are not among the giants or the pioneers.[80] There are very few references in the daily newspapers, but the Johannesburg *Star* features one of the most comprehensive, from the London Iron Building Company of Battersea Park: "Iron Buildings, Roofing and Fencing: The Cheapest House in the Trade. Churches, Chapels, Mission Halls, Schools, Shooting Boxes, Bungalows, Cricket Pavilions, Boat Houses, Cottages, Concert Halls, Stables, Billiard Rooms, Granaries, Farm Buildings, . . . All Buildings are distinctly marked ready for re-erection, and key plans supplied." This catholic range of products is amazingly redolent of the Victorian era.[81]

In addition to these British sources of iron buildings, there was a Natal industry, at Durban and Maritzburg, concerned with the manufacture of wood and iron buildings for the hinterland. There were Wright and Nicol, as active on the Witwatersrand as they had been at Barberton. Together with these firms, we must draw attention to a firm of expanding importance in the South African building industry: Hunt, Leuchars and Hepburn, whose Durban joinery workshop, at the turn of the century, consisted of a two-story building of 20,000 square feet extent, equipped with the most up-to-date woodworking machinery, operated by 100 skilled workers. This firm produced a wide range of joinery products, and specialized in "wood-and-iron buildings for up-country, which are pre-erected at the works then taken down and afterwards packed for rail ready for re-erection."[82]

Even when all this has been said, we must come to the conclusion that, in Johannesburg, except for the first critical period, this great mass of iron building was less the product of external industry imported complete than it was the result of local construction utilizing both imported timber (for framing) and the ubiquitous imported corrugated iron sheet, which was held in vast stocks by builder's merchants.[83]

The sources of supply were firms such as the famous Gospel Oak firm of Wolverhampton; Baldwins, which produced the "Phoenix" brand; Lysaghts; Brabys; and George Adams & Co. of the Mars Iron Works at Wolverhampton, who advertised themselves as the "manufacturers of the 'Adam-Mars' brand of galvanized corrugated iron, the best known and most highly approved brand in the South African market."[84]

Eventually the catastrophic war between Boer and Briton brought about a caesura in the building activity on the gold-rich Witwatersrand, but out of the war came two incidents not altogether irrelevant to our history of prefabrication. The first is, in a sense, only peripheral to our

theme, but it is directly linked to the abundance of new and used corrugated iron in South Africa. By 1901 British tactics in dealing with guerilla warfare demanded the use of chains of strongly made blockhouses, each held by a garrison of about seven men. Altogether, about 8,000 of these blockhouses were erected; for a task of this magnitude to be completed with limited manpower, prefabrication was the obvious technique. Factories were started in Middelburg, Pretoria, Bloemfontein, and other centers where there were Royal Engineer camps; these factories manufactured octagonal (later circular) blockhouses with timber frames, double skins of corrugated iron (using confiscated local supplies where possible, later supplemented by importations), and a gable roof (later replaced by a more logical conical form). The cavity between the iron sheathing was filled in, *in situ*, by earth or stones. "In the work of manufacture all parts were standardized, so that they fitted together perfectly when the time came to assemble them, sometimes hundreds of miles from the workshops where they originated."[85]

The second vignette relates to the British army of occupation. From 1900 onward, it was necessary to house large garrisons of troops at strategic centers to maintain Britain's hold on the occupied territories. This necessitated a considerable investment in the construction of temporary barracks; in light of the experience of the Crimean War and the durability of the prefabricated barracks at the various British camps (Colonel Lugard, we are told, who built the Curragh Camp, "would have been somewhat astonished if he had known that some of the temporary huts he had built were still in use for the accommodation of troops 40 years after"),[86] it was decided once again to manufacture such hutments in Britain. A sum of two million pounds was requested for the housing of British troops in South Africa, and by 1905 approximately two and a half million pounds had been spent on these prefabricated cantonments[87] (to use the term, especially popular in India, that normally described residential military accommodation of a more substantial and durable nature than tents, in a camp of some permanency). Although the initial estimate had been largely for "wooden hutments," it is clear that a significant number of the buildings erected at the South African camps were of wood and iron. One of the most important groups was at the British military camp for the army of occupation at Middelburg, in the Transvaal. (This was the camp, incidentally, where Major Rice, who had invented the prefabricated blockhouse, was commanding officer, Royal Engineers.) This camp was reputed to cover some 200 acres and house some 5,000 troops during the period of intensive use from 1900 to 1905. It was an extraordinarily advanced camp, not only in its use of prefabricated structures, but also in its application of electricity from its own generators to the lighting of the entire area.[88]

145

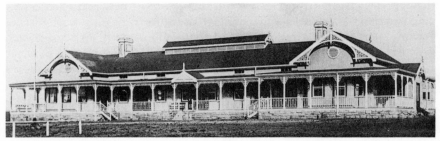

Figure 7.18. Officers' club, Middelburg Camp, Transvaal, South Africa, c. 1901. (Courtesy Africana Museum, Johannesburg.)

The Middelburg cantonments, unfortunately, no longer exist, but we can reconstruct something of their nature from early photographs.[89] There are extensive barracks or soldiers' cantonments; there is a large and impressive military hospital, and an officers' mess (fig. 7.18) no less ambitious, perhaps, than that which Hemming had erected at Aldershot a half century previously. Although there is some variation in the details of the trim (bargeboards, brackets, and balustrades), all these buildings are basically homogeneous in character. They are long, narrow buildings covered with lofty, gable-ended roofs; the wings are arranged in U-shape, T-shape, or other complex forms; the roofs are ventilated by louvered openings, often circular, in the gables, and by long lantern lights at the ridges; the external walls are of corrugated iron with tall, sliding sash windows, pairs of elegantly proportioned French doors, and occasional, shallow, faceted bays, all shielded by a low, shadow-inducing, all-embracing veranda. These buildings are so consistent in character, no matter their shape or function, that they were obviously designed to one standard, and probably made by one manufacturer. They are also remarkably similar to other military buildings located elsewhere in South Africa—notably, the British army cantonments in Barberton—of the same period. When the Barberton Camp was eventually closed down these prefabricated buildings were sold, disassembled, and reerected elsewhere; one actually became the town hall of Barberton, serving in this august capacity until it was destroyed by fire.[90]

At least part of the Middelburg Camp was reused in this way. The officers' mess, as we have already noted, was a capacious, well-built wood and iron structure, internally sheathed with boarding; one report[91] has it that it was first sent from Britain to India, and then transshipped to South Africa during the war. One of the Boer generals who had taken part in the early peace negotiations at Middelburg subsequently returned to the camp, in the years of peace and reconstruction, and in 1908 actually

bought the officers' mess for £300. It was transported by steam engine and truck to the farm Doornkloof at Irene, near Pretoria; there, in somewhat altered form, it was reerected (fig. 7.19) (which required a year and £1,000), and became the family home of South Africa's most famous statesman, General J. C. Smuts. It was an austere but well-loved house, "an ideal refuge for stoics." If it lacked elegance and conventional architectural beauty, it had the virtues, as Smuts's son later explained, of spaciousness and pliability; the house "was like a big meccano set, for it was easy to dismantle the internal walls and alter its shape at will."[92] This strange but sensible purchase evoked the following comment from Emily Hobhouse: "How funny about the house, taking one from the Cantonments. Oddly enough, I had meant to write to you about these buildings, because as I passed Middelburg I saw them and wondered about the waste, and was going to propose to you to found an industrial colony there. . . ."[93] And so, with Doornkloof, the story of the wood and iron prefab reaches its climax, and corrugated iron, that practical, flexible, austere, and most modest of materials, enters briefly into the pages of world history.

Yet this is not the entire story. Through the use of this unspectacular material—corrugated iron—the general texture of Johannesburg at the end of the nineteenth century became drab and mundane; set against the background of these utilitarian buildings, however, were some special jewels. Within a few short years of the founding of this city, large, new

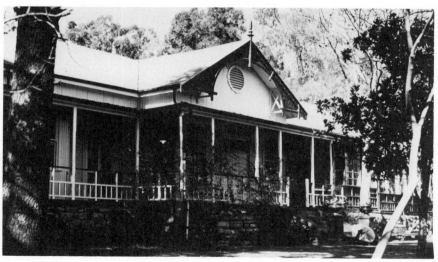

Figure 7.19. Smuts's home, Doornkloof, Irene, South Africa, 1908.

three- and four-story buildings arose—a bank, a department store, an office building, a shopping arcade, a grand hotel, a rooming house, a brothel, perhaps—and many of these were resplendent in a finery of slender cast-iron columns, lacelike balustrades, foliated brackets, richly decorated panels, lofty towers, and lanterns. This collection of rich cast-iron confectionery, like that to be found earlier in Australia, India, or the West Indies, was imported from Britain, and it represents another chapter of the history of prefabrication. If corrugated iron had degenerated from bold technological adventure into utilitarianism, it is perhaps because it had been replaced in importance by a material at once much older and yet, now, infinitely more acceptable to the tastes of designers and customers alike, a material much more malleable to High Victorian needs, even in the colonial world. We are reminded that, parallel with the development, extensive manufacture, and widespread exploitation of corrugated iron, there is another chapter in the history of prefabrication to unfold—the story of cast iron. It is to this that we turn briefly, in our final chapter.

CHAPTER 8

A CAST-IRON SOLUTION

Thus far in our account of its development, the term "iron prefab" has had the connotation of the corrugated iron building. We have been concerned with what were, essentially, relatively lightweight constructions: a mere sheathing of corrugated iron or, at most, a double-skinned panel upon a framework of wood, wrought iron, or cast iron. From the aspect of "portability" such systems are eminently sensible, and they endured, as we have seen, for half a century or more. Parallel with the development of the corrugated iron prefab, however, was the evolution of its heavier, more substantial, and architecturally more pretentious counterpart, cast iron. We are not concerned here with cast iron merely as a structural skeleton used in conjunction with other materials of a more traditional kind, as in the well-known iron-framed mills and warehouses of the nineteenth century. We are primarily interested in the use of cast-iron elements for the construction of building façades and, even more fundamentally, with the use of cast iron in total building systems. The use of cast-iron elements in partial or total systems has a long and interesting history. Let us now look at the textural background, and at some of the highlights.

A stroll through the tailored gardens of Wollaton Park in Nottingham is an enjoyable experience at all times. From the point of view of the history of nineteenth-century prefabrication, it is also an instructive experience. At the foot of the great pile of Wollaton Hall, adjoining the terrace, is the graceful Camellia House of 1823. This elegant structure has an interesting interior: cast-iron columns support tented glass roofs in copper sashes, with sheet metal barrel vaults over the walkways—in this it is an early forerunner of many distinguished iron hothouses produced in the first half of the nineteenth century. Externally, though, it breaks entirely new ground, for, in this structure in the classical idiom, we have, I believe, one of the earliest examples of a completely fabricated iron

Figure 8.1. Camellia House, Wollaton Park, Nottingham, England, 1823. Detail.

building.[1] Every structural and decorative element is of cast iron (fig. 8.1): the square pilasters between the large metal-framed windows, the entablature over, the parapet with its decorative urns against the skyline, the solid end wall capped by a traditional pediment, and the paneled door set within its molded architrave. The entire vocabulary of a neoclassical facade is here carried out completely in cast iron. Technically the building could have been made in nearby Derbyshire, where such renowned firms as the Britannia Iron Works, the Butterley Company, the Alfreton Iron Works, or Weatherhead, Glover & Co. had considerable experience in iron castings for substantial engineering and architectural works,[2] but it actually was manufactured much farther afield, at the Metallic Hot-house Manufactory of Jones and Clark of Birmingham.[3] With its components made under the controlled conditions of a foundry, transported to the site at Nottingham, and there reerected, in a real sense it is a pioneer prefabricated building, and perhaps one of the first in cast iron.

Much of the significant history of cast-iron prefabrication is American. It was in the United States that Bogardus carried out his first experiments and built his pioneer constructions; it was there that Badger & Co. developed their enormous business, constructing iron buildings for cities all over the country, as well as abroad. It was in American cities such as New York and St. Louis that iron buildings proliferated in the golden decades of cast iron, the 1850s and '60s, and it was in America that continuing construction took place, right up to the end of the century. The history of American cast iron in its various phases has been widely documented,[4] although, perhaps, it still awaits a definitive summation. It is beyond the scope of this book to retrace this history, but there is a need to give an account of the parallel, less widely known, perhaps less spectacular development of cast-iron buildings that took place in Britain, and to relate this development to our general theme— the production and exportation of industrially prefabricated buildings. The British contribution, although quantitatively smaller than the American, is of especial interest in three aspects: its pioneer role, in the early part of the century; the elegance of design and diversity of product, at mid-century; and the development of a cast-iron component industry, in the later years, carrying right through to the beginning of the twentieth century.

It was Turpin Bannister, in his precise account of the evolution of the cast-iron façade, who drew attention to British precedents to Bogardus[5]—most notably, the iron mill produced by Fairbairn and sent out in 1840 to Turkey. We have referred to this example in an earlier chapter, noting its catalytic role in the history of prefabricated iron structures. But we now see, with such buildings as the Camellia House, that there is a prehistory of cast-iron buildings extending back some decades before the time of Fairbairn and Bogardus. According to White, "the first prefabricated metal houses were probably built from cast-iron flanged panels which were bolted together in the vertical position, painted externally and lathed and plastered inside."[6] This is also the structural system of the cast-iron lighthouses pioneered in the 1840s by Alexander Gordon. It is a logical, if structurally somewhat naïve system, and it persisted, together with the lath and plaster interior, for at least a quarter of a century. Houses utilizing this method of construction were apparently built along the canals; one example, the lockkeeper's cottage on the Birmingham Canal at Tipton Green (fig. 8.2), stood in good condition for nearly a hundred years, until it was demolished in 1926.[7] It was at Tipton, incidentally, as we have seen earlier, that the Horseley Iron Works produced prefabricated iron bridges for the Oxford Canal, and built the "Aaron Manby," the first prefabricated iron seagoing vessel. It is

151

Figure 8.2. Lockkeeper's cottage, Tipton Green, Staffordshire, England, c. 1830. Richard Sheppard, *Cast Iron in Building* (London: George Allen & Unwin Ltd., 1945), reproduced in Gloag, *Victorian Taste*, p. 126.

reasonable to speculate that here was the origin of the lockkeeper's cottage.

From this time onward, the interest in iron houses grew. The demand for prefabricated dwellings existed, and iron was becoming a fashionable, almost symbolic, Victorian material. Prior to 1844 the techniques of producing galvanized corrugated iron were still costly, whereas cast iron was readily available, in forms underwritten by a considerable technical experience and production know-how. It was natural, therefore, at least up to the early 1840s, that Britain's interest in iron construction find its expression in the use of the cast material. The capacity of the British iron masters to produce first-class castings (which had, previously, resulted in the production of iron components only), now produced complete buildings in cast iron.

"Within two years past," a commentator noted in 1842, "several cottages and villas have been put up near London, which are exclusively cast-iron—walls, doors, steps, roofs, chimneys, sashes, &c."[8] The following year a correspondent for the *Mining Journal* drew attention to the fact that "buildings of cast iron are daily increasing at a prodigious rate in England, and it appears that houses are to be constructed of this material." The writer was apparently referring to a specific system of construction. "As the walls will be hollow, it will be easy to warm the buildings by a single stove placed in the kitchen. A three-story house, containing ten or twelve rooms, will not cost more than £1,000, regard being had to the manner in which it may be ornamented." The concept

here is clearly not so much of permanent housing, but of portability: "Houses of this description may be taken to pieces, and transported from one place to another, at an expense of not more than £25."[9]

These houses seem very close in nature, size, and cost to those ascribed to a Belgian manufacturer, a M. Rigaud of Brussels. In 1842 it was noted[10] that he had built a hollow-walled house of quite phenomenal size: it weighed nearly 800 tons, had 17 rooms, and was three stories in height. It is a pity we do not know more of these early buildings, because they are perhaps the first known multistory iron buildings other than Fairbairn's.

Many references point to iron prefabs made in Belgium. One account at this time refers to the large number of cast-iron houses being made in both England and Belgium as a response to the crisis created by the fire that devastated part of Hamburg;[11] later reports note the great number of cast-iron cottages, warehouses, and even churches and chapels sent out from Antwerp to California.[12] These notes refer to centers of production at Couillet, Verviers, and Seraing. It is interesting to note that the great iron works at Seraing, near Liege, were those of Cockerill & Co., which had been set up by the Englishman at the express invitation of the king of the Belgians.[13]

In the descriptions of these structures, the references to hollow cast-iron walls are ambiguous, and may relate to either of two different systems of construction. One technique is to use two cast-iron plates with an air space between them. W. Vose Pickett, who was a severe critic of the inappropriate use of iron in Slater's iron church, demonstrated such a system in a paper to the Society of Arts in 1846; his beautifully finished models, which showed his bolted and riveted all-iron houses as being directed largely to the export market, evoked great admiration.[14] An alternative method, first illustrated in the *Mechanics' Magazine* in 1844, utilized hollow cast-iron blocks keyed together and post-tensioned vertically by iron tie rods. This proposal was technically ingenious but architecturally unadventurous, for it resulted in the simulation of stone, having the appearance of a kind of cast-iron ashlar.[15]

But the techniques of casting could do much more than merely produce flat plates and simple blocks. After all, as the pragmatic Victorians noted, "the finest ornaments cost little more than plain castings."[16] When, in the 1840s, corrugated iron came to the fore as a utilitarian material *par excellence*, it replaced cast iron as the principal material for prefabricated structures where economy and lightness were the main criteria. But cast iron had potentialities for richness that the more humble corrugated iron could not fulfill. Ewing Matheson, London Manager of Handysides (the renowned manufacturers of cast-iron goods) and a theorist of the proper use of iron, saw the value of the material with

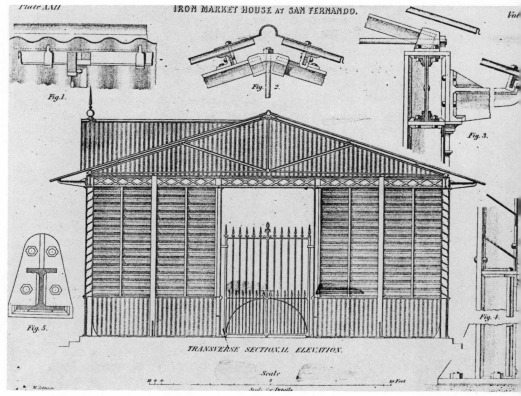

Figure 8.3. J. H. Porter. Market house, San Fernando, Trinidad, 1848. The *Practical Mechanic's Journal*, January 1849.

eclectic Victorian eyes, appreciating its decorative versatility; he said that it might "be made to any shape that plastic clay will take, or to any which can be carved in stone, marble, mahogany or oak. . . ."[17] By virtue of these qualities it was possible, as had been revealed in Cragg's Liverpool churches, to reproduce the intricacy of Gothic tracery and vaulting or, as had been demonstrated by the Camellia House, to shape the trabeated structures of the classical idiom.

Cast iron was strong, and it was versatile. Because of its strength multistory frame structures became possible. Such structures were aggregated of relatively small components—columns, caps, beams, moldings, spandrel panels, window frames—readily joined and united into a single façade capable of horizontal and vertical extension. These façades were essentially cellular and modular, these being the inherent qualities of industrialized building. In its more austere versions this type of build-

ing was close to the familiar patterns of twentieth-century architecture. However, because of its inherent versatility, cast iron was adaptable to a wide range of forms, which made it possible to express the basic skeletal façade in a variety of stylistic terms. It was as equally amenable to Venetian Gothic or Roman Baroque as it was to the undecorated pragmatism of the functional tradition. The real and presumed qualities of cast iron—its utility, economy, strength, durability, resistance to fire—coupled with its expressive versatility, made it irresistible to Victorian tastes on both sides of the Atlantic.

Building systems in cast iron such as those developed by Badger and Bogardus in America or the Scottish ironfounders sought to exploit these inherent qualities of the material. They were translated into industrial terms: sets of standardized components mass-produced in the factory, sturdy modular building elements, remarkably similar in principle, no matter how varied the eclectic mold in which they were cast. Simple repetitive units, readily transportable, easily assembled at the building site: the essential ingredients of a prefabricated system.

The mid-century climax of the development of modular skeletal structures and infill systems came with the building for the Great Exhibition of 1851. Three separate traditions led to the Crystal Palace. The first was the background of engineering, which first Barlow and then Fox and Henderson (through their extensive experience with large-scale repetitive structures, gained in the manufacture and erection of the giant iron and glass roofs for many of Britain's railway stations and naval dockyards) brought to the Hyde Park project. The second tradition, that of greenhouse building, was crystallized in Paxton's concern for lightweight modular wall and roofing systems done, generally, in timber, and in his development of industrial methods for producing the necessary elements, particularly the mullions, the sash bars and the patent guttering, by means of steam-driven machinery. The third source of the Crystal Palace lay beyond Paxton's and Fox's immediate areas of experience and activity, but perhaps it was the most important of all, for it provided the conceptual base for the whole operation. This was that continuous development of industrialized prefabrication, first in timber and then in iron, whose history we have been recounting here. If the essential feature of the Crystal Palace's design was, as Paxton claimed when presenting it to the public, that "all the roofing and upright sashes would be made by machinery, and fitted together and glazed with great rapidity, most of them being finished previous to being brought to the place, so that little else would be required on the spot than to fit the finished materials together,"[18] then he was reiterating, on a grand scale, perhaps, a philosophy of construction underwritten by all the early pioneers of prefabrication, both in theory and in practice. The Manning cottage and the

155

Camellia House are the distant ancestors of the Crystal Palace, and John Henderson Porter's handsome iron market house for San Fernando, Trinidad, is its more immediate progenitor (fig. 8.3).

The Crystal Palace is a turning point in the history of prefabrication, but its significance does not derive from any claim to be first in the field, for it is by no means the pioneer modular iron prefabricated structure. In addition to its intrinsic architectural quality, the purity of its form, and the poetry of its immense ethereal spaces, its value also lies in its dramatization of the possibilities of prefabrication, in its revelation of the potential of industrial processes speedily to create vast, precision-built, immaculately engineered architectural works—a potentiality that was only hinted at in the pioneer works that we discussed earlier.

While it would be superfluous to analyze this well-known building here, two points are relevant to our general discussion. First, it is worthwhile to note that the Crystal Palace's purity of form and apparent simplicity of structure conceal an incredible complexity of construction. The building is not, as is sometimes claimed, "made up of a limited number of components . . . all standardized in size and design."[19] What appear to be standardized columns are actually composite structures (fig. 8.4) with a set of alternative footings, bases, shafts, and connecting pieces that, in a variety of combinations and permutations, enable the columns to meet a wide range of demands deriving from various locations and load conditions. The column, then, is not a single precast building element, but an intricate subsystem in itself. Similarly, in the Hyde Park building, the external façade is not merely a series of mullions at 8-foot centers with standard infill panels, but the assembly of a truly vast number of different small elements, some of iron, others of wood, into a complex series of interrelated subunits capable of many permutations (fig. 8.5). The industrial process is here more directly linked to the production of the small elements—the casting of the many sections that unite to form a column, or the machine shaping of wooden moldings out of which a window or a wall panel is made—than it is to the assembly of these elements into the primary building units—the column and the infill panel. Our information is far from complete here, but a study of the details of construction of, for example, the facade, seems to indicate a considerable amount of hand assembly of the various elements—frames, louver blades, sills, mullions, boarded panels, battens, half-columns—that make up one façade unit. I do not know (and this is an interesting question for further research) whether this assembly of small elements into units of construction took place in the workshop or on the site, and a proper assessment of the prefabricated nature of the Crystal Palace depends upon the answer to this question. Certainly Paxton's original intention, as we have already seen, was that most of the work would be finished in the factory, leaving

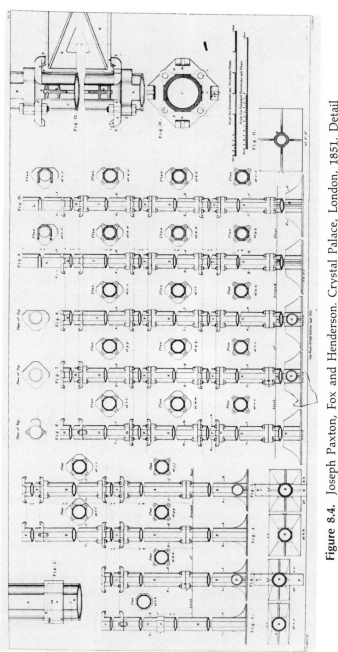

Figure 8.4. Joseph Paxton, Fox and Henderson. Crystal Palace, London, 1851. Detail of columns. Downes, *The Building Erected in Hyde Park*, pl. 8. (Courtesy Victoria and Albert Museum.)

Figure 8.5. Joseph Paxton, Fox and Henderson. Crystal Palace, London, 1851. Façade details. Downes, *The Building Erected in Hyde Park*, pl. 21. (Courtesy Victoria and Albert Museum.)

little to be done on the site other than the assembly of the main elements. But this was in terms of an initial concept far simpler than the actual building. In this respect the first proposals of Paxton for a truly modular structure with every mullion a structural column and with simple infill panels is closer to the later Sydenham Building than to the building for the Great Exhibition.

Arising out of the complexity of the Hyde Park building and the ambiguity that surrounds the question of the degree of site work involved is our second point. This is that the significance of the Crystal Palace lies not only in its reliance on industrial processes in the factory, but in its extension of the rationalization of building to the entire construction process, from factory to site. In that its components originate in the workshop and the factory, the Crystal Palace compares directly with its more naïve counterparts, the prefabricated structures destined for the colonial markets. But in its organizational concept, in its realization of the processes of building, in its handling of the flow of materials, components, and labor, in its production of systems and subsystems, and in its coordination of the entire vast enterprise as a planned sequence of events, the Great Exhibition building is unique for its time. Not only are the components factory produced, but industrialized processes are introduced into the site itself in sophisticated testing, assembly, and erection procedures that are dependent upon skilled manpower, hydraulic and mechanical devices, and the motivating power of four steam engines.[20] This is a far cry from those prefabricated structures we considered earlier, those buildings that were based on simple site techniques and a relatively unskilled local labor force. For Paxton, however, the process

was, ideally, a total process; we recall that when he later shipped prefabricated huts to the Crimea, he sent with them his own skilled erection crews, for he considered design, construction, and erection to be linked processes.

After the excitement and glamor of the Great Exhibition, the focus shifted from London to the north. In Scotland in the 1850s, we find a striking series of commercial buildings whose precisely fabricated cast-iron façades stand comparison with the best contemporary American work. Thanks to the pioneer research of Hitchcock and to later investigations,[21] such examples as Glasgow's Jamaica Street warehouse, the immaculately preserved Gardner's store (fig. 8.6), or its handsome near-neighbor, the Paisley Building, are well known indeed. They indicate the high level of design ability and industrial proficiency reached at that time by Scotland's engineers, its great ironfoundries, and its innumerable metal-working shops. This vast iron-working industry was largely geared to export; the skills of the iron building manufacturers were nurtured in a trade far more extensive in scope than the home market alone could generate. We delight in the elegance of the Glasgow iron buildings, but we must remember that they are the fruits of broad-based Scottish experience derived from the exportation on a vast scale of iron buildings for the urgent needs of emigration. I do not wish to imply that McConnel, the ironfounder who made Gardner's iron building, was himself engaged in the export trade. Although he may well have been, I have no evidence to support this view. But my contention is that he and the other builders of the Glasgow warehouses operated within an ambience of extensive activity by many other manufacturers in Glasgow and in Edinburgh, most of whose work was directed to overseas markets. Let us look in more detail at some examples of this Scottish industry.

In about 1856 Charles D. Young & Co. published a pamphlet of their work in wrought, cast, and corrugated iron entitled *Illustrations of Iron Structures for Home and Abroad*.[22] The corrugated iron structures we have considered elsewhere—the cottages, warehouses, military hospitals, and larger buildings such as the notorious Brompton Boilers—were listed there, but, in addition to these lightweight structures, there is an extensive range of cast-iron buildings of various types.

Included among these examples are illustrations of five houses manufactured by Young to the design of the engineers Bell and Miller.[23] These houses are described as iron dwelling houses with handsome cast-iron fronts. Except where the side walls are of corrugated iron, all external walls—especially of principal façades—are of cast iron. According to Young, "no other material affords greater scope for the display of architectural effect than cast-iron. The most elaborate mouldings or the finest tracery work can be executed in it with a success not attainable in any

Figure 8.6. R. McConnel, ironfounder; J. Baird, designer. Gardner's iron building, Glasgow, Scotland, c. 1855.

other. . . ." Moreover, Young stressed, the versatility of cast iron facilitated "in the case of Villas, and Detached Houses for warm climates, the indispensable adjunct of the Veranda . . . planned and constructed so as to harmonize strictly in all details, and give a unity of design to the whole structure."

In this spirit, houses are illustrated that are designed for use in South America, Australia, and other "warm countries."[24] They are architecturally ambitious structures, classical in feeling rather than in detail, Palladian in symmetry; the tall windows are arcuated, the walls paneled by molded pilaster strips; there are stringcourses, cornices, balustraded parapets; the overall character deriving from these elements and from the low, hipped roofs, the graceful arcades, and the projecting bays, is Italianate. These are not settlers' cottages, but large and imposing mansions, two, sometimes even three, stories in height (fig. 8.7).

Such houses as these, by Young and other manufacturers, were obviously considered to be "desirable gentlemen's residences." W. and P. McLellan, the well-known Scottish ironfounders, built such a mansion for Mr. Westgarth, the mayor of Melbourne; nearly 3,000 square feet in area and built of massive ½-inch and ¾-inch cast plates, it cost £2,000 prior to shipping.[25] Another house on this grander scale was "Tintern," a bow-fronted house of cast iron in Toorak, Melbourne, built before 1855 for I. Colclough. Tintern is reminiscent of Bell and Miller's designs, although its details are different; possibly—this is merely speculation—it is a product of Young's Edinburgh factory.[26]

One example in Young's catalogue[27] merits our especial attention for both its intrinsic architectural value and its fascinating history. It is a villa with gable-ended pitched roofs; there are richly decorated bargeboards and circular decorative insets, arcaded galleries and a projecting porch with rather unusual flat-topped arches, triple-arched projecting semicircular bays, and paired, octagonal chimneys (fig. 8.8). These details occur in various combinations in some of the other houses, and characterize the designs of Bell and Miller.

The caption relating to this design offers some significant information. The cottage is described as "a Country Villa, in a neat style of architecture, with Verandas to correspond." Then we are told: "The Villa, from which this is a drawing as actually erected, was made for the late Mr. Gray, Colonial Land Commissioner at Geelong.[28] The whole of the fittings and interior work of the house were executed in the most complete style. The windows and doors were of mahogany, the ceilings of *papier mache*; and the walls were lined and prepared for paper." This building is now known to be Corio Villa in Geelong, Victoria (fig. 8.9), one of the most admired and most widely publicized prefabricated iron structures of mid-nineteenth-century Australia. It appears in accounts

Figure 8.7. Charles D. Young. Two iron dwellings with cast-iron fronts, c. 1855. C. D. Young & Co., *Illustrations of Iron Structures for Home and Abroad*, designs 12, 13. (Courtesy Royal Institute of British Architects.)

and histories of Australian architecture by Boyd, Robertson, Saunders, and Freeland, and in White's history of prefabrication.[29] These accounts are generally dependent upon the basic study of Corio Villa made in 1949 by G. E. Drinnan, then a fourth-year architectural student at Melbourne University.[30] In his monograph, Drinnan gave an account of the somewhat enigmatic history of Corio Villa.

> Late in 1855 there was unloaded at the Cunningham pier (Geelong), a shipment of strange cast iron sections, classic vases, and roofing iron, a consignment from Glasgow with no particulars of sender or receiver.
>
> Apparently the "pieces" were shipped by some gentleman who had decided to settle in Geelong, and aware of the shortage of materials in the now flourishing community, he decided to export his own house from the newly set up prefabricating foundry in Glasgow, and erect it on his arrival. For six months this non-descript collection of building materials lay on the wharf unclaimed, and the port authorities began to make enquiries. These investigations proved fruitless, however, insomuch that the would-be immigrant could not be traced.

The foundry, Drinnan went on to suggest, had, for some reason, ceased to exist, and no plans for the erection of the house were forthcoming. In these circumstances, "nothing remained but for the port authorities to dispose of these relics which were cluttering up their wharf, and they were eventually sold to Mr. Alfred Douglas for a small sum. . . . The iron

sections were hauled to the top of the slope to a site over-looking the bay, where certain ingenious colonial craftsmen succeeded in solving the jig-saw puzzle without plans or directions.''

Because of this improvisation, the form the house took when it was actually built is not identical to the original prototype as published, but the constructive system, details of decoration, and architectural character, as well as the historic circumstances, all underline the fact that this is the work in Young's publication. The house as it was built is a handsome example of the ironmaster's craft, but the original design was even more elegant.

An examination of the text of the Young pamphlet clears up much of the mystery of Corio Villa. The death of the client, the "late" Mr. Gray, is obviously the reason for the failure to collect the consignment. But we are still left with one problem: what happened to the manufacturer, who

disappeared so inexplicably from the scene? Charles D. Young, whose company manufactured Corio Villa, was a member of an Edinburgh family of ironmongers whose recorded business history goes back to 1840. In the directories of that year,[31] James and William Young were listed as manufacturing ironmongers and wire workers, in High Street, Edinburgh. The first mention of Charles Young was in 1842, when the High Street firm changed its name to William and Charles Young; they continued in this fashion for the next four or five years. In 1847 the two brothers went different ways. Charles bought out his brother William for £4,000 and established the firm of C. D. Young & Co., with works in Edinburgh and offices in Glasgow, while William Young established the firm of Young, Peddie & Co.,[32] which continued in business until 1860, when William Young and Robert Peddie parted, to carry on separate

Figure 8.8. Charles D. Young. Iron cottage, Geelong, Australia, before 1856. C. D. Young & Co., *Illustrations of Iron Structures for Home and Abroad*, design 14. (Courtesy Royal Institute of British Architects.)

businesses.[33] After the breakup of William and Charles, our interest centers particularly on the firm of C. D. Young & Co. The business flourished. By 1851 branches had been set up in London and in Liverpool, and C. D. Young & Co. produced catalogues[34] that indicated an extensive range of products; there were utilitarian farm fences and rick stands, elaborate wrought- and cast-iron gates and railings, various arched, trussed, and suspension bridges for Britain and the West Indies, classical urns, vases, and fountains in cast iron, conservatories and hothouses, and iron houses and stores for exportation and home use. It is amply evident that, at the time of the making of Corio Villa, Young had behind him a business history and manufacturing experience of some 15 years. Against this background of accumulated know-how, the masterly technique evident in the casting of the components of Corio Villa becomes more readily understandable.

The pamphlet of 1856 fills out some of the details of this extensive experience. In the construction of iron buildings, claimed Young & Co.,

they have supplied of all classes and dimensions, from the humblest Cottage to Mansions of the greatest extent and most elegant design— from the small Store-room to extensive ranges of Warehouses—and from the temporary Meeting and School-house to Churches capable of accommodating two or three thousand persons, with Galleries and Spires, and in every style of architecture. Their experience has been no less considerable in erections of a public character—such as Arcades, Market-houses, Customs-houses, Sheds for Stations, as also in Military Barracks, and other accessary [sic] buildings; and in all these they have been largely employed by Home and Foreign Governments, as well as by Public Companies and Mercantile Firms in this country and abroad.

It is possible that these claims are inflated, for, after all, this is an advertising pamphlet. Nevertheless, they have a substantial basis of fact. Young's exports to California and Australia were of considerable proportions. He expanded his works and plant at St. Leonard's and at Cross-causeway, investing some £45,000 in these two ventures, and giving employment to nearly a thousand men. He supplied the ironware for important engineering structures, including the Chelsea and Westminster Bridges. Moreover, as we have already seen with the Brompton Boilers, we are able to point to specific buildings of note, actually manufactured by C. D. Young & Co. Another well-known work was the Dublin Crystal Palace for the Irish Industrial Exhibition of 1853. This iron and glass building, obviously descended from Paxton's famous prototype of 1851, was designed by Sir John Benson, while Young & Co. were the contractors for the iron columns and other cast-iron work.

The costly method of casting wall components, window and door frames, columns, arches, and balustrades, as seen in houses such as Corio Villa, are perhaps more appropriate on the scale of larger, multistory buildings of repetitive design. Young gave examples of such buildings in his 1856 pamphlet. One of these, a three-story shop and dwelling, was constructed for Miller and Dismorr of Melbourne, as early as 1851, and erected in Collins Street (fig. 8.10). It showed (or so Young claimed) "to what perfection the system had even then attained." In fact, the early date of this building is remarkable; the only known examples of multi-story cast-iron fronts of earlier date of which we have illustrations are those of Bogardus; among British manufacturers it must claim precedence, even over the Jamaica Street warehouse and other Glasgow iron fronts. It is a historic building, and it is a pity our knowledge of it is not more extensive.

This 1851 example for Melbourne is relatively small, but there are designs for buildings much more ambitious than this. One example illustrated is a three-story building of elaborate design, perhaps 120 feet in length (fig. 8.11). It is not a specific building, but an archetypal proposal

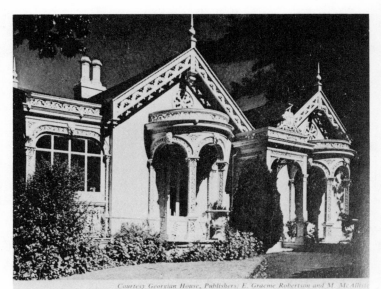

PLATE 1.2*a*
Corio Villa, Geelong, a prefabricated house of cast iron

PLATE 1.2*b*
Corio Villa. Detail of one of the bays

PLATE 1.2*c*
Corio Villa. Detail of cast-iron filigree
ornament on one of the columns

A.

Figure 8.9. Charles D. Young. Corio Villa, Geelong, Australia, before 1856. *A.* the house as seen in the 1940s; *B.* a view in the 1860s; *C.* assumed construction details. (Courtesy G. E. Drinnan.)

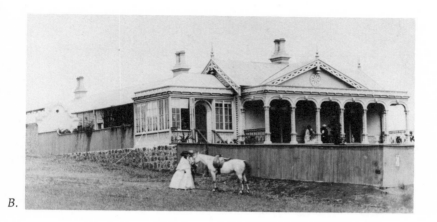

B.

LATH & PLASTER WALLS
STUD FRAMING

TIMBER ARCHITRAVE &
JAMB LININGS

a

MOULDED IRON
WALL SECTIONS

SLIDING SASHES

ARCHITRAVE

PLAN OF WALL AT WINDOW

METAL 'CEMENT'

DETAIL AT 'a'

600 mm × 300 mm
FLANGED PANELS

ASSUMED REAR SIDE OF WALLING

C. **'CORIO VILLA' DETAILS (assumed)**

Figure 8.10. Charles D. Young. Iron dwelling and shop, Melbourne, Australia, 1851. C. D. Young & Co., *Illustrations of Iron Structures for Home and Abroad*, design 15. (Courtesy Royal Institute of British Architects.)

Figure 8.11. Charles D. Young. Range of iron dwellings and shops, before 1856. C. D. Young & Co., *Illustrations of Iron Structures for Home and Abroad*, design 16. (Courtesy Royal Institute of British Architects.)

to illustrate the potentialities of the system of construction for prefabricated buildings. "They are susceptible of being carried out in ranges to any required extent, so as to form whole streets or squares, or may be put up simply as detached houses," Young explained, making a valid case for standardization and repetition. "The greater the extent of building to be erected," he said, "the less in proportion will be the expense of the first preparation of the work, and, consequently, also of the entire cost."

Another Scottish firm producing cast-iron buildings similar in size and character to those of Young at this time was the Glagow ironfoundry of Robertson and Lister.[35] We have already discussed the similarity between the cast-iron churches produced by these two firms. In our present context—the development of extensive prefabricated cast-iron systems for export—the work of Robertson and Lister achieves special significance. A contemporary account describes one such example just prior to its shipment to Melbourne in 1853:

> This erection is an extensive warehouse of three stories in height, comprising a saloon or show-room, with double plateglass display windows underneath, mess-rooms for the young men of the establishment above, and, in the upper story, eight bed chambers. The building is seventy feet in length. But the facade presented to the street is its prominent feature, being composed of cast semi-columns, standing on square pilaster pedestals, and sustaining superb projecting cornices. . . . Above, fluted columns, with a rich cornice and entablature, decorate the front of the upper story; the windows being circular headed and surrounded by architrave mouldings. The windows of the third story are likewise arched,

169

having square pilasters. A cast-iron balustrade on the top, finishes off the front.[36]

The exuberant classical detailing of this building evokes immediate comparison with the rich cast-iron fronts of Young.

In 1856, when Young wrote of the many virtues of iron construction, he not only stressed its decorative potential and its great strength and durability, but also, prophetically, drew attention to "the ease and comparatively small cost of removal and reconstruction elsewhere." The history of the Macquarie Street iron church and the long life of Corio Villa are testimony to Young's faith in the quality of his materials and his technique of construction. "The former are of the very best of their kind, and of strength carefully calculated to be equal to every contingency; and the latter is based upon the soundest scientific principles, having due regard to the varied circumstances of purpose, situation and climate."

Charles Denoon Young's faith in iron was enormous, and his enthusiasm was without bounds. From simple beginnings, working with his own hands and with no capital, he built a vast business whose products went all over the world. But enthusiasm and optimism were not enough. His management was weak, and his system of financial control was inadequate. He undertook major projects and, in the process of making a reputation, lost a fortune—he was owed £19,000 on the rebuilding of Westminster Bridge, lost £18,000 on Chelsea Bridge, and £14,000 on the Manchester Exhibition buildings; the bad debts on his Australian and American exports amounted to over £14,000. In 1858, owing over £100,000, his business was sequestrated in a bankruptcy of monumental proportions, scandalizing Edinburgh and Glasgow.[37] The story of C. D. Young & Co. is thus a story of great technical proficiency brought down by administrative incompetence. We can, perhaps, see the shadow of these characteristics in handsome Corio Villa—so beautifully fabricated, yet sent far away to Geelong without proper consignment papers or a plan for its assembly.

Scotland dominated the British cast-iron building industry, but there were, nevertheless, some significant firms in England. No complete list can be attempted; some firms, such as the Union Foundry of K. & T. Parkin of Liverpool, do not even appear in the relevant sections of the trade directories, and yet we know they made and exported large structures overseas;[38] others, well-known firms such as E. C. & J. Keay of Birmingham, are listed as "Iron and Church manufacturers," but we know little, as yet, of their work at this time, although some of their later buildings, such as the market building at Kimberley (fig. 8.12), still stand.[39] Some are better known today, such as Henry Grissell of the Regents Canal Ironworks, London, the "Iron Henry" whose masterpiece,

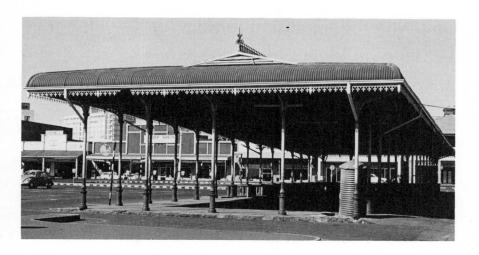

Figure 8.12. E. C. & J. Keay. Open-air market, Kimberley, South Africa, 1907. *Top,* general view; *Left,* detail of columns. Photo Alexander McGregor. (Courtesy Kimberley Public Library.)

the Sheerness Boat Store, is a well-documented classic of structural purity.[40] This latter building is a prefabricated structure in the same sense as the Glasgow warehouses or the Crystal Palace; Grissell was also responsible for prefabricated iron buildings for export, particularly cast-iron lighthouses, including one for the Falkland Islands, another for the Great Isaac Rock, near Bermuda, and a third for Russia, all in the mid-1850s.[41]

Such firms as Grissell or Cochrane—whose Woodside Iron Works near Dudley, Worcestershire, reputed to be "one of the largest establishments in the Kingdom,"[42] produced most of the cast-iron girders and columns for the Crystal Palace—were general ironfounders engaged only peripherally in the prefabrication of iron buildings. Others made this a focus of their activities. One such firm was the Britannia Iron Works of Derby—especially after it was taken over by a Scot, Andrew Handyside, in 1858.[43] During its heyday (from 1860 to 1880) this enterprising firm produced large numbers of ornate, precision-engineered, cast-iron structures, many of them "complete, with woodwork, glass, wall paper and with doors and windows as described, fitted in England, marked for erection and properly packed"[44] for customers as far afield as Bombay (fig. 8.13) or Rio de Janeiro.

In addition to special iron buildings for specific purposes, Handyside marketed a range of standard cast-iron structural and decorative elements (fig. 8.14). These prefabricated units could be combined to form complete iron structures, or they could be purchased and formed into subsystems of iron, often incorporated into buildings of more traditional materials such as brick or stone. Many manufacturers began to produce cast-iron elements and subsystems of this kind—staircases, multistory verandas, balustrades—and, beginning in the middle of the century, a component industry of some significance emerged that encouraged open-

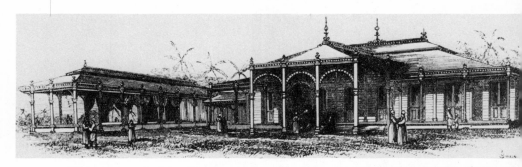

Figure 8.13. Andrew Handyside. Iron bungalow for Bombay, India. *Works in Iron,* 1868. (In *Journal of the Society of Architectural Historians,* May 1970, p. 170, fig. 1; copyright © 1970, Society of Architectural Historians.)

ended systems of iron construction whose loss of purity was, perhaps, offset by a gain in flexibility. Perhaps this quality was always inherent in cast-iron construction (as the improvised assembly of the components of Corio Villa wryly demonstrated), but now it was consciously exploited. Firms manufacturing a wide range of cast-iron building elements flourished, and their offerings to the building public were enshrined in effusively illustrated advertisements and trade catalogues.

The Milton Iron Works of McDowell Stevens and Co., for instance, had, by 1890, produced 21 editions of their illustrated catalogue. A typical example, a house in Mitcham, South Australia, shows the application of cast-iron columns, beams, spandrels, railings, rainwater goods, cornices, finials, lamps, vases, and even a cast-iron "keep off the grass" sign. Cottam and Hallen, another long-lived and active firm,[45] the manufacturers of the first iron lighthouses designed by Alexander Gordon, were also at that time (about 1840) advertising their cast-iron railings and verandas for the Indian market.[46] In the 1851 exhibition they showed their cast-iron stables,[47] staircases, railings, and gates; in later years they expanded this list of products to include windows and doors. Verandas, of course, involved such structural elements as columns, beams, brackets, rafters, and lengths of roofing iron. Although at times they listed themselves as "Builders of Portable Houses," their principal activity was the manufacture of cast-iron components.

Other manufacturers of components who advertised in the colonial directories, or whose imprints were frequently identified on their castings, were Falkirk Iron; James Allen Senior and Son; the Elmbank Foundry, of Glasgow; St. Pancras Ironworks, London; and Hill and Smith, of Brierley Hill.[48]

Perhaps the largest and most significant, as well as the most influential, of all the ironfounders engaged in the component industry was the Glasgow-based firm of Walter Macfarlane & Co.[49] The foundry was founded in 1850 by Walter Macfarlane—a worker with 20 years experience in gold, silver, and hammered iron—on Saracen Lane, Glasgow, from which the name Saracen Foundry, by which the firm was known for over a hundred years, presumably derived. In 1862 it moved to Washington Street and changed its designation from "Ironfounders and Smiths" to the more pretentious "Architectural ironfounders and sanitary engineers." From 1869 to 1870 the firm began a move to Possilpark, a suburb of Glasgow, where, by the following year, the firm was fully established. A London warehouse was opened, and the firm's own Saracen Wharf. Business flourished as a result of extensive advertising, mainly by catalogue, and through the extremely high quality of the castings. Before 1890 the plant occupied an area of 14 acres, with 10 acres of foundries and workshops covered by sawtooth roofs, showrooms covering ¾ of an

For prices see Appendix.

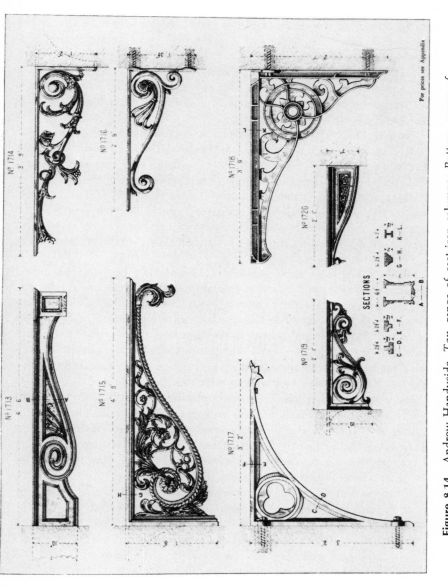

Figure 8.14. Andrew Handyside. *Top, range of cast-iron columns; Bottom, range of cast-iron brackets. Ornamental Ironwork Catalogue, 1874.* (In *Journal of the Society of Architectural Historians*, May 1970, p. 171, fig. 3; copyright © 1970, Society of Architectural Historians.)

acre, and an office wing, the "counting house," extending along a 260-foot frontage (fig. 8.15). At this period this vast establishment employed about 1,200 skilled workmen. A railway spur fed the works and ran right into the warehouses and foundries. Macfarlane's, now under the enlightened stewardship of Walter Macfarlane (the nephew), kept abreast of the times. Telephones were installed in 1894, and a few years later a telegraph address was published. By the end of the century Macfarlane's name was a byword from Trinidad to Johannesburg, wherever in the world development was taking place.

The Macfarlane catalogues are monumental achievements, worthy of extensive study. Before the turn of the century, they were running close to 2,000 pages; even the more modest sixth edition is in two volumes and extends to some 700 pages embracing 23 sections: pipes; gutters; ridging; terminals; railings; gates; panels and gratings; stairs (fig. 8.16) and balconies; seats; benches and tables; lavatory ranges; baths, pumps, etc.; fountains; urinals; trough water closets;[50] trough dry closets; dustbins; lamps; brackets; columns (fig. 8.17); enrichments; windows; and structures.

While the last section, structures, "embracing business premises, shop fronts, arcades, and every conceivable outdoor structure for recreation, shelter, rest, shade and ornament," was, to quote the catalogue, "an extensive branch of our trade," the emphasis was, without a doubt, on components. Where examples were shown, it was stressed that they were generalized and indicative, only suggestions that "our customers can themselves best supplement according to their own special requirements." While Macfarlane's was prepared to offer design advice and aid, its system was directed rather toward user-involvement, a kind of architectural self-help project. The whole process was aimed at this end. The range of buildings elements, carefully dimensioned and identified, were by intent "so accurately delineated in the illustrations as to facilitate their selection and combination by our customers themselves to suit almost every requirement." There was an explanatory preface to each of the 23 sections, containing explicit directions for measuring and ordering. This was possibly the first mail-order house in the prefabrication business.[51] And the efficient organization of the catalogue and ordering process was backed up, by necessity, with a commensurate merchandising system. As Macfarlane's catalogues claimed, "the vast variety of patterns and sizes and the large stock of goods kept on hand enabled us to give quick despatch."

A combination of factors led to Macfarlane's world-wide success; they became, as a Victorian commentator quaintly put it, "the source of supply of useful and artistic foundings for all parts of the civilised and, we might add, the un-civilised world."[52] These factors included the economies of scale of production, the precision and high quality of cast-

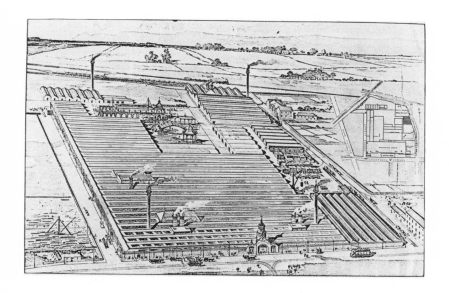

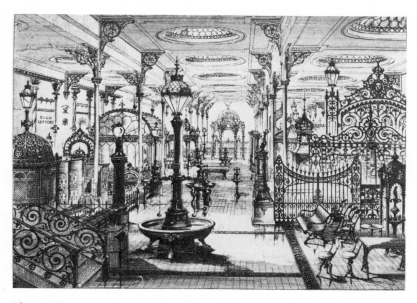

Figure 8.15. Saracen Foundry, Possilpark, Glasgow, Scotland, c. 1890. *Top*, aerial view; *Bottom*, showroom. *Macfarlane's Castings*, 6th ed.

SECTION VIII.—STAIRS.

FOR EVERY KIND OF INTERIOR AND EXTERIOR ACCESS AND COMMUNICATION.

The treatment of Stairs has become a matter of great moment in the designing and construction of buildings with the view of economising space, and also for admission of light and security from fire, for the attainment of which cast iron possesses advantages over every other material, while the light and graceful forms it admits of, render it peculiarly suitable for Balusters and Stair Railing.

Please insert in Specification "To be Macfarlane's Castings, from Saracen Foundry, Glasgow," to prevent an inferior article being supplied.

	pages	
Straight Stairs,	368—369	
Spiral Stairs,	370—371	
Balusters,	372—380	
Newel Posts,	see Section V,	173—226
Baluster Brackets,		281—288
Handrail Brackets,		330—339
		363—367

The illustrations of Balusters and Newel Posts are arranged in the order of their breadth.

DIRECTIONS FOR ORDERING.

State the No. and sizes, and if necessary, give a rough sketch with exact measurements, stating the nature of the fittings required, whether for wood, stone, brick, or iron, and we will furnish the working drawing for fixing up. The following examples show the simplest method of ordering.

Figure 8.16. Illustrations from Macfarlane's catalogue. *Top*, stairs; *Bottom*, spiral stairs. *Macfarlane's Castings*, 6th ed.

Figure 8.17. Illustrations from Macfarlane's catalogue. Columns. *Macfarlane's Castings*, 6th ed.

Figure 8.18. Illustrations from Macfarlane's catalogue. Building before and after decoration. *Macfarlane's Castings*, 6th ed.

ing, and the efficiency of the merchandising. There was understanding here of prefabrication as a process involving, not only production, but also distribution on a world-wide scale. In this, Macfarlane's contribution is a highly significant one. In addition to this comprehensive industrial and organizational process, there was one other factor. Macfarlane's knew their customers; not only did they allow for active customer-participation nearly a century before such concepts became explicit in architectural theory, but they had instinctive insight into their customers' aesthetic tastes. Cast iron, for Macfarlane, was not only a utilitarian material, "occupying little space, giving the maximum light, strength and durability," but, more importantly, it expressed "the most elegant picturesque forms and lacelike tracery, for which stone is too massive and wood too perishable." Well could Macfarlane's boast that their infinite range of cast-iron products had "become prominent objects not only in this country but over all the world, noted for their fresh iron-like features, sharp, clean and full of character."[53] Macfarlane's catalogue held up a mirror to the taste of the High Victorian world (fig. 8.18).

For a typical example of the effusive vigor of the Macfarlane style, let us consider a gallery in South Africa. The Arcade, Johannesburg (fig. 8.19), was a two-story covered shopping mall that graced the rough-and-ready mining camp that had sprung up in 1886 after the discovery of gold in the Transvaal. In a world of austerity and utility, this iron and glass wonderland of 1890 evoked echoes of a society more settled, and a town more urbane—an environment that represented an idealized concept of "back home" for the miners. It was built into a conventional masonry structure, but was nevertheless a complete unit "supplied, fitted complete with every part lettered and numbered, ready for erection according to marked plan, by Walter Macfarlane and Co."[54]

Despite a disaster en route—two-thirds of the glass was smashed in transit, necessitating that a replacement order be cabled for—the arcade proved a great success. Not only were the people of Johannesburg delighted with it, but "Messrs. Macfarlane and Company are reported to have stated that taken altogether it is the finest Arcade ever turned out of their works."[55]

The South African market was obviously important to Macfarlane's. They advertised in the directories, giving an extensive list of the components available,[56] and their catalogues were to be found in architects' offices throughout the country. I have seen their castings, which still adorn innumerable public buildings and private houses in such areas of South Africa as Cape Town, Paarl, Durban, and Pietermaritzburg. In the mining town of Kimberley (fig. 8.20) such diverse buildings as the prestigious De Beers' head office and the headquarters of the Kimberley regiment are enriched by Macfarlane's castings. On the Witwatersrand,

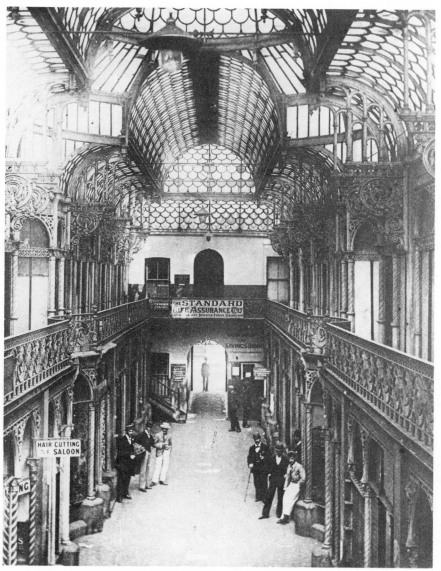

Figure 8.19. Macfarlane's. The Arcade, Johannesburg, South Africa, 1893. *Scenes and Life in the Transvaal*, c. 1895. (Courtesy Africana Museum, Johannesburg.)

Figure 8.20. Macfarlane's. Cast-iron stairs and gallery, library, Kimberley, South Africa, c. 1886. Photo Alexander McGregor. (Courtesy Kimberley Public Library.)

Figure 8.21. Marfarlane's. Aegis Building, Johannesburg, South Africa, c. 1894. *Album of Johannesburg*, Grocott and Sherry. (Courtesy African Museum, Johannesburg.)

the surviving work is less extensive, and only a small proportion of that originally carried out. The business in castings must have been on an extraordinarily large scale. Generally Macfarlane supplied complete subsystems such as the multistory iron verandas with their cast-iron columns, brackets, richly ornamented balustrades, and roof spandrels that graced many contemporary Johannesburg buildings (fig. 8.21) of the gold rush era.[57] The systems were extremely versatile, and were even used to provide the balustrading and stairs of such mail steamers as the *Balmoral Castle*.

A more exotic example, a large veranda-encircled two-story villa in Trinidad, with high basement, dormered roof, tower, and dome, is dominated by Macfarlane's contribution. The basic structure is masonry, but Macfarlane's have provided ornamental railings, stairs, verandas, canopy, roofwork, and tower. It is this iron outrigging that determined the architectural character of the building. Because of the universality of the system—at home equally in the West Indies, Africa, and Australia—Macfarlane cast iron and its derivatives really constituted an international style whose character and technological level derived entirely from the Glaswegian source. Macfarlane was not a pioneer of cast-iron archi-

tecture in the sense that Bogardus was, nor was he primarily concerned with total structures, as was Young, but his place in the history of prefabrication is assured, not only through his systematization of the manufacturing and merchandising process, but also for the influence that the exuberant Macfarlane house style exerted upon the architectural taste of the late nineteenth century, particularly in the colonial world.

The history of the British contribution to prefabrication in the nineteenth century reflects the expansionist phase of urbanization at home and colonialism abroad. The vital period of innovation in British prefabrication lay in the earlier years of Victoria's reign, but innovation continued significantly until the end of the century—the passing of Victoria, and the end of an era. During this era, in their modest workshops and in their large factories, British manufacturers of prefabricated buildings established the basic concepts of industrialized building: the concepts of standardization and modular coordination, of large-scale industrial production of repetitive elements, of sales promotion and marketing on an international scale, of integrated packaging and distribution systems, of rational site erection procedures, and of the differentiation of open and closed systems. These concepts were propounded and explored and principles were established during this pioneer phase. It was a preliminary stage, tentative, and often immature, but it was the essential basis of all future development.

Beginning in the twentieth century, prefabrication exploited new techniques and materials. In addition to timber and corrugated and cast iron, precast concrete emerged as a new system of building with enormous potential for prefabrication. As one firm that utilized both iron and concrete technologies for their prefabricated buildings put it, their patented cement slab construction process was definitely "the system of the future."[58] The goals of industrialized building underwent a change from the ad hoc solutions of intermittent crises to the possible solution of mass housing problems of the urban proletariat. These new techniques and new directions take us beyond the defined scope of our story, for, with them, we move beyond the pioneer stage of the history of prefabrication toward a stage of emerging maturity.

NOTES

CHAPTER 2

1. John Manning, *Swan River*, advertising pamphlet (London, c. 1830) British Museum.

2. An account of Manning's "Portable Cottage for the use of Emigrants and others" is to be found in John C. Loudon, *Encyclopaedia of Cottage, Farm, and Villa Architecture* (London: Longman, 1833), pp. 251–57. It is not quite clear which particular Manning was responsible for the design of the cottage. All advertisements after 1837 refer to H. Manning, presumably the Henry Manning who, from 1836 to 1872, was listed variously in the directories as a carpenter, builder, sashmaker, etc., at 251 High Holborn. Other Mannings listed at the same address were J.(John), 1821–30, 1832, and T.(Thomas) 1831, 1833–34. However, Loudon's "List of Contributors" refers to Mr. William Manning, carpenter and builder, of Holborn. The first pamphlet (see note 1 above) was signed "John Manning."

3. Robert Irving, "The Governor's Portable House" (Manuscript. Sydney, 1973).

4. Journal of P. G. King, 1786–90 (First Fleet manuscript. Mitchell Library, Sydney), p. 139. I owe this reference to. Mr. Irving.

5. John M. Freeland et al., *Rude Timber Buildings in Australia* (London: Thames & Hudson, 1969), p. 16.

6. Samuel Wyatt to Matthew Boulton, 10 December 1787. Birmingham Assay Office. Many sources refer to Jeffrey Wyatt (later Sir Jeffrey Wyatville) as the architect of the hospital and—sometimes—of Phillip's house. At the time of the construction of these prefabs, Jeffrey was a young assistant working with his uncle, Samuel Wyatt.

7. Samuel Wyatt to Matthew Boulton, April 1788, Birmingham Assay Office.

8. Morton Herman, *The Early Australian Architects and Their Work*, (Sydney: Angus and Robertson, 1954), p. 8.

9. Robert Irving, "The Portable Hospital, Sydney, 1790–1816" (Manuscript. Sydney, 1973).

10. Samuel Wyatt to Matthew Boulton, April 1788, Birmingham Assay Office.

11. Herman, *Early Australian Architects*, p. 23.

12. For details of the Sierra Leone settlement, see George Kubler, "The Machine for Living in Eighteenth-Century West Africa," *Journal of the Society of Architectural Historians*, III (April 1944), pp. 31–32. (Hereafter cited as *JSAH*.)

13. Ronald Lewcock, *Early-Nineteenth-Century Architecture in South Africa* (Cape Town: Balkema, 1963), p. 79. There are several references to early prefabrication in South Africa in this work.

14. Charles E. Peterson, "Early American Prefabrication," *Gazette des Beaux-Arts*, 6th ser., no. 33 (1948), pp. 37–46.

15. According to a letter from a colonist to the *Times* of London, 11 August 1820.

16. Lewcock, *Early-Nineteenth-Century Architecture*, p. 191.

17. Ibid. According to Lewcock these buildings were used as stores and houses for government employees and for Port Elizabeth's first school and church. Some were sent to Bathurst for the Drostdy staff, and one existed in Durban in 1826. A company of soldiers at the Kowie was housed in two of these buildings. Another of the prefabs served as temporary accommodation for the Cape Astronomer until the Royal Observatory was completed (c. 1825).

18. See, for example, the double-unit cottage and the adjoining house probably erected in 1840 by a Mr. Woods, an 1820 settler, in Havelock Street, Port Elizabeth. (Verbal communication to the author from the Port Elizabeth Historical Society.)

19. It is interesting to speculate whether these frames were mortised and tenoned in the traditional manner or simply fixed by nailing the elements together. If the latter were the case, these early colonial prefabs would be the forerunners of the American balloon-framed houses introduced in 1833 in Chicago. Cheap machine-made nails were, of course, already available by 1820; Reed's patent was probably established as early as 1807 (Sigfried Giedion, *Space, Time, and Architecture* [Cambridge: Harvard University Press, 1941]).

20. For a description of the house and specification, see "Portsmouth Prefabs, 1772 and 1849," *JSAH*, XXIII (1964), pp. 43–44.

21. See illustration and letter entitled "An Early Prefab" in *Country Life*, August 1970.

22. Herman, *Early Australian Architects*, pp. 116, 172.

23. Manning's lowest-priced house (possibly of one room containing 144 square feet) was £15; Thompson's small houses were priced at about £10 per room. Verge's estimate for the Busby house was £592 15s. 4d. (Herman, *Early Australian Architects*), p. 172.

24. The description of the Manning cottage given here comes partly from Loudon, *Encyclopaedia*, pp. 251–57, and partly from Manning's advertisements in the *South Australian Record* from 1837 onward.

25. For an account of this traditional system see T. Ritchie, "Plankwall Framing, a Modern Wall Construction with an Ancient History," *JSAH*, XXX (March 1971), pp. 66–70; see also Freeland, *Rude Timber Buildings*, pl. 15, for the Australian horizontal "slab" hut, which is comparable.

26. Charles E. Peterson, "Prefabs for the Prairies," *JSAH*, XI (1952), pp. 28–29. Peterson suggests that "the possibilities of piracy were not overlooked in the United States." His claim that John Hall's "Portable Cottage for the use of new settlers and Others" of 1840 derived directly from Manning is borne out by a comparison of the plans and text, which show that Hall copied literally from Manning, using identical details and phraseology of description. It is interesting to speculate, in the light of this unashamed plagiarism, whether there was any connection between this John Hall and the Captain J. G. Hall for whom Manning had once built a prefabricated cottage at Wargrave. (See Loudon, *Encyclopaedia*, p. 256, for a description of this cottage.)

27. These canvas houses were perhaps similar to the canvas houses sent out to Sierra Leone in 1792. (See note 12 above.)

28. Quoted in the *South Australian Record*, 8 November 1837.

29. Miss Halse, *An Account of John Barton Hack of Australia, c. 1840 ff* (Bedford, 1930). According to this source, one cottage was erected near the sea at Glenelg, the other near the present railway station of Adelaide.

30. Letter dated 1 May 1837, in the *South Australian Record*, 13 January 1838.

31. Quoted in Geoffrey Dutton, *Founder of a City* (London: Chapman and Hall, 1960), p. 218.

32. According to shipping notices in the *South Australian Record*, 8 November

1837. For a note on the importation of building material to Victoria, see John M. Freeland, *Melbourne Churches 1836–1851* (Melbourne: Melbourne University Press, 1963), p. 15.

33. Letter dated 22 March 1837, in the *South Australian Record*, 8 November 1837.

34. Manning claims to have sold Hindmarsh one of his cottages, which may be the house referred to. See advertisement in the *South Australian Record*, 1 January 1840.

35. This account of Hindmarsh's hut is given in Dutton, *Founder of a City*, p. 221.

36. Presumably Mr. Edward Stephens.

37. Letter in the *Commercial Gazette and India, China, and Australian Telegraph*, 24 October 1838. (Hereafter cited as the *Commercial Gazette*.)

38. Thomas Scown, a builder, wrote in the *Commercial Gazette*, 24 October 1838, that he had been offered many jobs in Adelaide, including houses and a church, but was compelled to refuse them because of the great shortage of building laborers.

39. Some useful insights into Australian prefabrication were provided by John Ballinger, "Prefabrication and Industrialization in Nineteenth-Century Australian Architecture" (Seminar paper. School of Architecture, University of Adelaide, 1964). I am particularly indebted to Ballinger for drawing my attention to the advertisements by Manning and Thompson in the *South Australian Record*, which are referred to in this book. The first advertisement of which I am aware appeared on 27 November 1837.

40. These prominent South Australians included Howard and Hack; Gouger, the colonial secretary; Strangways, the colonial secretary pro tem; Kingston, the former surveyor general, and Frome, his successor; Hindmarsh, the late governor; and Cooper, the chief justice. Hack, as we know, had brought two cottages; and Gouger, Strangways, and Kingston were reported to be so satisfied with the first that each ordered a second. It is not known whether all of these orders were actually fulfilled. There were, of course, other houses not referred to in the advertisement.

41. La Trobe's cottage is illustrated in Freeland, *Rude Timber Buildings*, pl. 65. I have not had the opportunity to see the house, which is now owned by the National Trust of Australia (Victoria).

42. See the *Builder* (1854), p. 476; (1856), p. 222.

43. Advertisement in the *South Australian Record*, January 1840.

44. For an account of his career see Ida Darlington, "Thompson Fecit," *Architectural Review* (September 1958), pp. 187–88.

45. J. B. Cleland, "Section-Built Manning Cottages," *Proceedings of the Royal Geographical Society of Australasia*, (SA Branch), LVII (December 1956). Cleland expressed the opinion that these early buildings were never actually erected, despite Thompson's claims. In view of the evidence of dishonesty submitted by Darlington, "Thompson Fecit," it is not unreasonable to presume that Thompson's advertising was, to say the least, an inflation of the truth.

46. Illustrated in an advertisement in the *South Australian Record*, 11 September 1838.

47. The roofing was probably of Croggon's Patent Asphalt Roofing Felt, which Thompson was known to have used on his churches (see the *Illustrated London News*, 7 September 1844, p. 156), and which was variously advertised as "portable" and "particularly applicable to warm climates."

48. The *South Australian Record*, 11 September 1838.

49. The *Colonial Gazette*, 6 April 1839.

50. The *Commercial Gazette*, from 15 April 1840 onward.

51. Max Lamshed and Jeannette McLeod, *Adelaide Sketchbook* (Adelaide: Rigby Ltd., 1967), p. 62.

52. Extract from The *Colonist*, 6 July 1837, printed in the *South Australian Record*, 8 November 1837.

53. Lamshed and McLeod, *Adelaide Sketchbook*, p. 62.

54. See in particular, G. E. Laikve, ed., "A Survey Report on the Meeting House of the Society of Friends, Pennington Terrace, North Adelaide" (Report. School of Architecture, University of Adelaide, 1963), for the basic history and measured drawings of this building. For their historical information, the contributors acknowledge their dependence upon Frank H. Goldney, *A short History of the Society of Friends and the Meeting House, etc.* (Adelaide, n.d.). There are also some relevant documents in the library of the Society of Friends, London, in the portfolios of correspondence, and in the minutes of the Meetings for Sufferings.

55. Samuel Darton to John Barton Hack, 16 October 1839 (photocopy of letter in Laikve, "Report on the Meeting House of the Society of Friends," p. 6A).

56. Report of the "Committee on African Instruction," read at the yearly meeting of Friends, 1825, and reported in the *Yorkshireman* 1 (1833), p. 204.

57. Letter from Samuel J. Levitt, clerk, to the Meeting for Sufferings, 11 January 1837 (Portfolio 8/30).

58. William Alexander, *Observation on the Construction and Fitting Up of Meeting Houses & c for Public Worship* (York, 1820).

59. Samuel Darton to John Barton Hack, 16 October 1839.

60. Letter from John Barton Hack to Gates, 27 April 1841 (Copy in portfolio 8/86).

61. The land was transferred to the trustees of the Friends in December 1840. Due to complicated circumstances, the final settlement of accounts did not take place until 1845 (Minutes, 20 August 1845).

62. The original bill for erection charges, including landing fees, cartage, deed of transfer, and what appears to be sale of land, amounts to £431.14.0. See Laikve, "Report on the Meeting House of the Society of Friends," p. 6C.

63. The *Colonial Gazette*, 16 March 1839.

64. According to recent excavations, the buildings were of a fair size; the hospital, $60' \times 26'$; the quartermaster's store, $43' \times 20'$; and the so-called store b, $40' \times 20'$. A short history of the expedition and the findings of the excavations is given in J. Allen, "The Technology of Colonial Expansion," *Industrial Archaeology* (May 1967), pp. 111–37.

65. Ibid.

66. The statistics were given in an article in the *Illustrated London News*, 6 July 1850, p. 16.

67. The *Builder*, 1846, p. 110.

68. Ibid.

69. The *Builder* (1854), p. 476; (1856), p. 222.

70. In Pigot's Directory, 1836.

71. Advertisement in the *London Monthly Overland Mail for All India*, 4 December, 1840.

72. The *Builder* (1854), p. 476; (1856), p. 222.

73. "Wooden Houses," The *Builder*, 1843, p. 70.

74. "Temporary Churches," The *Builder*, 1844, p. 471; and "Temporary Church at Kentish Town, St. Pancras," the *Illustrated London News*, 7 September 1844, p. 156.

75. "Iron Church for Jamaica," the *Illustrated London News*, 28 September 1844.

76. The *Port Phillip Herald*, 12 March 1844.

77. I owe this list of churches to Darlington. She also notes that Peter Thompson had proposed to Edwin Chadwick, in 1845, that he erect large prefabricated dwellings, each suitable for six families, in order to ease the housing problem. Thompson himself described some of these temporary churches in "To the Editor of the Ecclesiologist," in the *Ecclesiologist*, VIII (August 1847), pp. 63–64.

78. "Wooden Churches," the *Ecclesiologist*, IV (1845), pp. 148–49.

79. The *Builder*, 1843, p. 70.
80. The *Illustrated London News*, 7 September 1844, p. 156.
81. The *Builder*, 1843, p. 177.
82. See note 26 above.
83. Here the best source is Charles E. Peterson, "Prefabs in the California Gold Rush, 1849," *JSAH*, XXIV (1965).
84. See Peterson, "Prefabs for the Prairies," and Rita Robison, "Prefabs: an Old Technique," *Architectural and Engineering News*, (June 1967).
85. For a description of these houses and their history, see *Bulletin of the Historical Society of Port Elizabeth*, September 1965, pp. 9–11.
86. Loudon, *Encyclopaedia*, p. 256. The cottage built by Manning for Captain Hall in England was indeed thatched as suggested here.
87. This is evident on the interior, which approximated the original condition. The exterior of Nocton Farm was given a brick skin, and I was unable to ascertain what lay behind.
88. Advertisements in Victorian papers of the 1850s indicate an extensive trade in wooden houses, as well as wood-framed, zinc-lined houses, and corrugated iron structures.
89. Many houses are advertised as Singapore Houses. They ranged in size from two-room shacks, 22' × 11' (*Argus*, 3 January 1854), to four-room houses, 30' × 24' (*Gazette*, 16 January 1854). Asking price for a four-room Singapore house was £300 (*Gazette*, 26 January 1854). A cargo on the *Eugene* from New Zealand included four wooden houses "complete in every respect, and ready for erection" (*Gazette*, 1 April 1854).

CHAPTER 3

1. A. Raistrick, *Dynasty of Ironfounders—the Darbys of Coalbrookdale*, p. 207.
2. *Derbyshire Directory*, 1827–29, introduction, p. ix.
3. J. C. Groucott, "Skew Arches and Pre-Fabricated Cast Iron," *Industrial Archaeology*, August 1971, pp. 317–19.
4. According to the account by John Grantham, discussed in *Minutes of Proceedings of the Institution of Civil Engineers*, 1842, pp. 168–69.
5. "Iron Steam Vessels Built by Mssrs. Wm. Fairbairn and Co., of Millwall, London," The *Civil Engineer and Architect's Journal*, May 1841, p. 147.
6. The *Year Book of Facts in Science and Art*, London, 1840, p. 21–22.
7. For an account of many of these lighthouses see Turpin C. Bannister, "Bogardus Revisited. Part 2: The Iron Towers," *JSAH*, XVI (1957) pp. 11–19.
8. For further information on these buildings see: a) *Minutes of Proceedings of the Institution of Civil Engineers*, 1850, pp. 182–194; b) the *Illustrated London News*, 4 (1844), p. 260; Ibid., 10 (1847), p. 12; Ibid., December 1855, pp. 765–66; Ibid., June 1858, pp. 589–90; Ibid., June 1861, p. 584; c) The *Year Book of Facts in Science and Art*, 1854, pp. 73–74.
9. According to a note written to me by Edward Stoute, of the Barbados National Trust.
10. For the development of corrugated iron see H. W. Dickinson, "A Study of Galvanized and Corrugated Sheet Metal," *Transactions of the Newcomen Society*, (1943), pp. 27–36. There are useful notes in Charles E. Peterson, "Iron in Early American Roofs," *The Smithsonian Journal of History*, Fall 1968, III:3.
11. As described in the *Journal of the Franklin Institute*, 1833. (Cited by Peterson, Early American Roofs," p. 45.)
12. British Patent 5786/1829. Two years earlier, Elias Carter had taken out a patent for covering roofs with cast-iron plates (5552/1827).
13. This founding date is claimed in advertisements of the Patent Corrugated Iron Roofing Works, Morgan H. Davies proprietor, late Richard Walker, Son and

Successor to the Patentee. (See for instance the London Post Office Directory, 1879, p. 143.)

14. The assumption that Walker is the first patentee rests upon his own claims and advertisements dating from 1832 as noted in our text, and upon contemporary newspaper accounts—for example, the *Illustrated London News* of 14 July 1849, p. 20 ("Richard Walker, the original manufacturer and patentee") or the *Journal of the Franklin Institute*, 1833, as cited by Peterson, "Early American Roofs" ("Credit was given to 'a Mr. Walker [of Rotherhithe, we believe]' "). There is an account attributing the invention to Walker in Loudon, *Encyclopaedia*, pp. 206–11, which appears to me to be based upon Walker's advertisement of 1832 (see note 16).

15. The purchase of the patent is noted by William Evill in his "Description of the Iron Shed at the London Terminus of the Eastern Counties Railway," *Minutes of Proceedings of the Institution of Civil Engineers*, 1844, pp. 288–90.

16. Robson's London Directory, 1832, appendix, p. 79.

17. For Palmer's work at the docks see *Minutes of Proceedings of the Institution of Civil Engineers*, 1842, p. 59.

18. According to an advertisement in the *South Australian Record*, 12 September 1838. The felt was presumably Croggon's Patent Felt, also used by Thompson in other buildings.

19. Loudon (*Encyclopaedia*, p. 206), in dealing with sheet-iron roofs that he claimed had been in common usage in Russia since 1814, noted that they were given two protective coats of red or green paint—green being more durable than red.

20. See Peterson, "Early American Roofs," and "Galvanized Iron and Steel," *Encyclopedia Brittanica*, 14th ed., vol. 6, p. 471. See especially Dickinson, "Galvanized and Corrugated Sheet Metal, pp. 28–29.

21. British Patent 9055/1841.

22. British Patent 9720/1843.

23. In a cautionary note to emigrants to California and other parts of America, Morewood and Rogers claimed the rights to the exportation from Britain of galvanized iron, since they had not granted sanction or license to others to do so (The *Builder*, 24 March 1849, p. 143).

24. Illustrations of the work and products of Morewood and Rogers may be found in their *Catalogue, Galvanized Tinned Iron* (c. 1850). These products include tiles and corrugated sheets, gutters, and galvanized nails and screws.

25. In the mid-forties Morewood became financially dependent upon the Gospel Oak Ironworks of Staffordshire, from whom he obtained his "black" sheets. (See Dickinson, "Galvanized and Corrugated Sheet Metal," p. 32.) Gospel Oak was the property of G. & E. Walker, the family of ironfounders of Rotherham, whose business was established as early as 1741. It is not known whether Richard Walker was related in any way to this family, nor do we know if he was related to the Robert Walker of Glasgow who, in 1852, patented an ingeniously conceived portable house. (British Patent 784/1852.)

26. The claim is made on behalf of his father by John H. Porter in an undated publication, *Examples of Iron Building and Roofing* (London, probably 1850). John Porter senior is first noted as an iron fence-maker in 1832 in the post office directories. In 1842 he established the Grove Iron Works, Southwark. References to John Porter continue, with varying additional addresses, until 1849. In that year there is an additional entry in the name of one John Henderson Porter who established an "iron roofing works" at London Bridge. After 1850 there are no further references to John Porter senior.

27. British Patent 10,859/1845. Morewood and Rogers (*Galvanized Tinned Iron*) show applications of "galvanized tinned iron" for roofs, sheds, warehouses, and dwellings that use both the tile and the straight and curved corrugated-iron sheet. Apart from buildings for export, the catalogue indicates extensive use of this galvanized iron roofing in Britain, for many railways, the dockyards at Liverpool, and a large number of naval dockyards.

28. British Patent 10399/1845. A description of the process, together with a

diagram of the apparatus, appeared in the *Civil Engineer and Architect's Journal*, 8, 1845, opposite p. 264.

29. Robson's London Directory, 1832, appendix, p. 79.

30. According to Jane Loudon's biography of her husband, Loudon started to prepare the *Encyclopaedia* in 1832. (See John Gloag, *Mr. Loudon's England*, [Newcastle upon Tyne: Oriel Press, 1970], appendix.)

31. Letter to the *Times*, 11 August 1820.

CHAPTER 4

1. The first advertisement of which I am aware appeared in the *South Australian Record*, 27 November 1837. By a strange coincidence, this is the issue in which Manning first advertised.

2. There is a reference to this building in the records of the Society of Friends, London, portfolio 8/30, dated 11 January 1837. This building must have been shipped in 1836, since it had been converted to serve the purposes of the Quakers by January 1837.

3. The *South Australian Record*, 8 November 1837.

4. Letter from Thomas Gilbert to Mr. Trenow, 22 April 1837, reported in the *South Australian Record*, 8 November 1837.

5. Peterson, "Early American Roofs," p. 46.

6. Evill, "Description of the Iron Shed," pp. 288–90.

7. William Fairbairn, *Treatise on Mills and Millwork*, vol. 2 (London: Longmans, 1861); also see *Minutes of Proceedings of the Institution of Civil Engineers*, 1843, pp. 125–26.

8. William Pole, ed., *The Life of Sir William Fairbairn, Bart.*, (1877) (Newton Abbot: David & Charles Reprints, 1970), p. 172.

9. Fairbairn, *Mills and Millwork*, p. 116.

10. As reported in the *Builder*, 1843, p. 171.

11. The *Times*, 16 February 1843.

12. The *Builder*, 1844, p. 623. In 1845, according to the *Builder* (p. 236), Laycock built an iron house for a family in Nova Scotia.

13. The *Builder*, 1843, pp. 178–79.

14. The *Illustrated London News*, 28 September 1844.

15. The information on this firm comes from John H. Porter's catalogue, *Examples of Iron Building and Roofing*, London, c. 1850.

16. According to a note in the *Builder*, 1843, p. 511, the patent expired in April 1843.

17. Evill, "Description of the Iron Shed," pp. 288–90.

18. Carriage shed, Paddington, Great Western Railway, 32 feet wide by 230 feet long with galvanized corrugated iron roof and corrugated iron side walls painted with anticorrosive paint (1845); four similar sheds for London and South Western Railway, at Esher, Woking, Basingstoke, and Winchester stations (n.d.); temporary workshops for the Lynn and Ely Railways Co. (1846); warehouse, London and South Western Railway, Chertsey, with ten-foot cantilevers over tracks and roadway (1848); Windsor Station, Great Western Railway (n.d.); and goods station, London and North Western Railway, 181' × 200' × 30' high (1849).

19. See, for example, the large shed, 46' × 300' long with bowstring roof carried on cast-iron columns made for the Patent Fuel Company at Swansea (1847), and the works at Deptford produced for the same company; and the Western Gas Company's purifying houses at Kensal Green, a polygon 166 feet in diameter (1847).

20. Cattlesheds, stables, barns, and cartsheds covered with corrugated iron, at Riby, Lincolnshire (1846); cattlesheds, stables, barn and engine house at Testwood, near Southampton (1849).

21. Including a corrugated iron sugar factory at Barbados, 120 feet long by

40 feet wide by 17 feet high (1846), and a similar building at Georgetown, British Guiana, used also as a dwelling; Megass (cane-trash) sheds, in three bays, with a ventilated ridge, at Jamaica (1847); and an iron church roof with ventilated ridge, at Montpelier, Jamaica (1848).

22. In addition to the description in the catalogue, there is a detailed illustrated account of the San Fernando market in the *Practical Mechanic's Journal*, December 1848, p. 207, and January 1849, pp. 224–25, pl. 21, 22.

23. According to Porter, *Iron Building and Roofing*, his works were at Southwark, his office at 3a Mansion House Place, London. Tupper & Carr had offices at 3 Mansion House Place from 1845–56. The London Post Office Directory indicates that Porter was at Mansion House Place only in 1850.

24. John Henderson Porter, according to the directories of those cities, was in business in London from 1849–64, and in Birmingham from 1852–63. In the last entry, he is listed as "Porter & Co., Engineer." The firm manufactured frames, wrought-iron work, galvanized iron roofs and buildings, bridges, girders, fireproof floors, steam boilers, and tanks. J. H. Porter patented various designs for using corrugated iron structurally in beams, floors, etc. (British Patent 12091/1848, 12356/1848).

25. After 1858 the firm's name changed to Chas. Wm. Tupper & Co., of London and (from 1864) Birmingham. The last recorded entry in the London Post Office Directory is dated 1891. A catalogue from 1851 (in the Royal Institute of British Architects Library) claims that they had provided 13,000 louvres for the Crystal Palace, galvanized-iron plates for shipbuilding, and the iron roofs of Waterloo Station and the Portsmouth and Chatham docks.

26. The *Builder*, 1846, p. 190; see also the *Mechanics' Magazine*, April 1846, p. 272.

27. See Freeland, *Melbourne Churches*, p. 90.

28. According to David Saunders, *Historic Buildings of Victoria* (Melbourne: Jacaranda Press, 1966), p. 36.

29. According to an advertisement in the London Post Office Directory, 1850, p. 2082.

30. According to Evill, "Description of the Iron Shed," pp. 288–90.

31. From 1853 to 1858, John Walker operated from Ferry Road, Millwall, Poplar. The works and warehouses of Tupper and Carr were at Millwall (according to their catalogue of 1851); and, from 1854 to 1858, one of the several addresses of Morewood and Rogers was at Millwall, Poplar. This suggests the possibility of some relationship between Walker and one or both of these firms at a time when John and Richard Walker were presumably working independently of each other.

32. William Henry Griffiths from 1860–72; Morgan H. Davies from 1873–87; he was, perhaps, a relative of Edward Davies (a pioneer in the field of galvanizing).

33. Peterson, "Prefabs in the California Gold Rush," pp. 321–22.

34. Alfred Tylor, *Paris Universal Exhibition: Report on General Metal Works*, London, 1857, pp. 73–74.

35. American roofing contracts of Morewood & Rogers prior to 1850 include The Merchants Exchange, New York; Post Office, New York; Stores of the Atlantic Dock Company, New York; and Brooklyn City Hall.

36. In 1845 Naylor used Morewood & Rogers galvanized iron sheets for the window shutters of his warehouse at 9 Stone Street, New York. When he ran out of stock (we learn from a letter he later wrote to Morewood & Rogers on 8 August 1848, which they cited in *Galvanized Tinned Iron*, p. 29), he was forced to use ungalvanized iron—which implies a difficulty in obtaining supplies in New York at that time. He had earlier (1842) roofed a house on Staten Island for a Mr J. P. Nesmith, using Morewood's galvanized roofing (Ibid., p. 27).

37. This building was reported both in the *Builder*, 1849, p. 382, and in the *Illustrated London News*, 14 July 1849.

38. As reported in an article in *Loudon's Magazine* of 1838, (article 4, pp. 66–70). This roof is of serrated cast-iron plates.

39. See Porter, *Iron Building and Roofing*. In one example (a warehouse at the Cape 1846), the principle is extended so that the roof becomes semicircular and the walls are eliminated completely—the prototype of the Quonset hut.

40. The work of Charles D. Young & Co., of Edinburgh, is illustrated in a large brochure, *Illustrations of Iron Structures for Home and Abroad, Consisting of Stores, Dwelling-houses, Markets, Arcades, Railway Stations, and Roofing, &c. &c., Constructed of Wrought and Cast Iron and Corrugated Sheets, Manufactured by Charles D. Young & Co.* (Edinburgh, c. 1856) Royal Institute of British Architects Library.

41. See plate XXIII of the Badger catalogue, reproduced in *The Origins of Cast Iron Architecture in America* (New York: De Capo Press, 1970).

42. See, for instance, the photographs of Roger Fenton in H. and A. Gernsheim, *Roger Fenton: Photographer of the Crimean War* (London: Secker & Warburg, 1954), or the photographs of Robertson in the Victoria and Albert Museum.

43. G. M. de Waal, *The Market Square of Johannesburg: Catalogue of Buildings on or around the Square till about 1920* (Pamphlet. Johannesburg Public Library, 1971).

44. I have seen roofs of this kind covering farm buildings in Derbyshire, a warehouse in Port Adelaide, and the ruined sheds on Ammunition Hill, Jerusalem.

45. The *Civil Engineer and Architect's Journal*, October 1849, p. 319; the *Illustrated London News*, February 1849, p. 109.

46. I am indebted to Charles E. Peterson for this information, as my own enquiries have been unrewarded. The buildings referred to are illustrated in Peterson, "Prefabs in the California Gold Rush," p. 323, and idem, "Early American Roofs," p. 47.

47. For an illustration, see Leonardo Benevolo, *History of Modern Architecture* vol. 1 (Cambridge: M.I.T. Press, 1971), fig. 58.

48. John Grantham, *Iron as a Material for Ship-building* (Liverpool: Lace and Addinson, 1842). A typically versatile Victorian engineer, Grantham also published papers on dock design, city railway systems, and water supply. He is listed in the directories as a consulting civil engineer. His father was a pioneer in iron-shipbuilding who worked with Aaron Manby.

49. Advertisement in Liverpool Directory, c. 1850.

50. It is possible that these firms were linked; their products and testimonials bear a striking resemblance.

51. The *Year Book of Facts in Science and Art*, London, 1851, p. 47; for a detailed description of this building see the *Practical Mechanic's Journal*, II, 1849, pp. 142–43. We are also told of "a beautiful Gothic villa" made entirely of iron that had corrugated iron sheathing.

52. Bellhouse started manufacturing between 1841 and 1845. The first directory reference to E. T. Bellhouse was in 1845, and these references continued until 1892, despite the fact that Bellhouse had died 10 years previously. For information on Bellhouse see *Jubilee of the Manchester Association of Engineers*, c. 1905, p. 39, and the obituary in the *Manchester Guardian*, 15 October 1881.

53. A reference to Bellhouse's iron buildings in the *Practical Mechanic's Journal*, 1 March 1860, p. 316, refers to his use of Morewood's galvanized corrugated iron.

54. See, for example, the *Builder*, 1849, pp. 221, 343, 417; ibid., 1850, p. 129; and the *Mechanics' Magazine*, 1849, pp. 234–35, 440–42.

55. The *Mechanics' Magazine*, 1849, p. 441: a large warehouse, based upon a five-foot module, using 5'0" × 2'6" plates horizontally. Some of these warehouses were made in Liverpool and not at the main Manchester works.

56. *Algemeine Bauzeitung*, Vienna, 1850, pp. 184–85, illustration on p. 342.

57. C. D. Young & Co., *Illustrations of Iron Structures for Home and Abroad.*

58. According to the *Official Catalogue of the Great Exhibition*, London, 1851.

59. The *Illustrated London News*, September 1851.

60. The *Builder*, 1851, pp. 559–60; *Engineer and Machinist*, 1851, pp. 210–11; the *Year Book of Facts in Science and Art*, 1852, pp. 70–71.

61. British Patent 609/1853.

62. According to the report in the *Illustrated London News*, April 1850, p. 274.

63. A. F. Hattersley, *British Settlement of Natal* (Cambridge: At the University Press, 1950), p. 203.

64. Artist unknown. Located in the Local History Museum, Durban.

65. Mr. Brian Kearney, who generously made his researches on iron buildings in Natal available to me, suggested in a letter of 9 November 1971 that Lamport himself acquired Byrne's hotel and set it up as a store in Aliwal Street, Durban.

66. Advertisement in the *Natal Mercury*, either late June or early July 1856 (date obscured). The building contained the following materials: curved roof, about 1,008 superficial feet; angle iron, about 811 running feet; gutters and piping, about 50 running feet; sides, including large folding doors, windows, shutters, etc., about 985 superficial feet.

67. Hattersley, *British Settlement*, p. 205.

68. Morewood's patent galvanized iron products were advertised in the Natal market by 1859 (*Natal Mercury*, 16 June 1859), and Hugh Gillespie (with three hundred sheets of iron) and Lamport advertised frequently. The *Natal Almanac and Register*, 1864, gives the following values of galvanized iron imported to Natal: 1860: £3,478; 1862: £5,959; 1863: £10,780. The 1865 *Almanac* notes that, in 1863, iron houses to the value of £1,177 and wooden houses to the value of £144 were imported into Natal.

69. The *Builder*, 2 July 1853, p. 422.

70. From a report in the *Australian and New Zealand Gazette*, 1 January 1853. It was noted that 15,000–20,000 of a population of 70,000 people in South Australia had left to move to Victoria. The *Builder*, 9 September 1854, p. 476, drew attention to the growth of Melbourne, the high cost of labor, and the inordinately high ground rents.

71. In the *Australian and New Zealand Gazette*.

72. It is interesting to note that his California warehouse of 1849 cost £600 or 10 shillings per square foot. According to E. Graeme Robertson, "The Australian Verandah," *Architectural Review*, (April 1960), p. 240, small iron cottages produced by Walker's rival, Hemming of Bristol, "were landed at the cost of £25 each, and sold at from £60 to £75."

73. According to a note from Brian Kearney to me, Russell, in his book *Old Durban*, had stated: "The quality of the iron of that period was excellent, and the corrugation of large size;" and John M. Freeland, *Architecture in Australia* (Melbourne: Cheshire, 1868), p. 114, says of Corio Villa (1855) that "the original broad corrugated roofing iron . . . [is] still completely serviceable."

74. I am indebted to Professor John M. Freeland for the information that the following iron houses still exist: House reerected at Swan Hill Folk Museum, Victoria; House at Tintern Avenue, Toorak, Victoria, c. 1855–56; House at 40 Moor Street, Fitzroy, Victoria (by Bellhouse); House previously at 62 Curzon Street, North Melbourne (now moved to Moe, Victoria). See also various houses in Freeland, *Architecture in Australia*, pp. 113–14.

75. Information in a letter to me from Freeland, 31 August 1971.

76. Advertisement in the *Australian and New Zealand Gazette*, May 1853, p. 446.

77. The *Builder*, 2 July 1853, p. 422.

78. According to the report in the *Builder*, 2 July 1853, p. 422. In one advertisement in the *Gazette* (May 1853), Walker claimed, "upwards of four acres of land [were] kept constantly covered with various iron buildings."

79. According to an advertisement in the *Builder*, September 1855.

80. Advertisement in the *Builder*, February 1855.

81. Advertisement in London Post Office Directory, 1887, p. 143.

82. *M'Phun's Australian News*, May 1853, p. 9.

83. C. D. Young & Co., *Illustrations of Iron Structures for Home and Abroad*, p. 7.

84. Sources of information on Hemming include Matthews's, Wright's and Kelly's directories, various unidentified clippings in the Braikenridge Collection in the Bristol Central Library; and an undated catalogue (c. 1853?) in the library of Melbourne University. I am grateful to Mr. G. Watkins and Dr. Graeme Robertson for their assistance in obtaining this material.

85. Also listed at Coronation Road from 1854–59 is H. Hemmings, Australian House Manufactory. There was also a Frederick Hemming Portable House Builder at Birkenhead about 1855. I have not traced a connection between these firms.

86. The last reference I have been able to trace is at 24 Moorgate Street and Tredegar Street, Old Ford, in Kelly's Building Trade Directory, 1870.

87. According to an unidentified cutting in the Bristol Library (Braikenridge Collection).

88. Mrs. Chisholm, the wife of an Indian army officer and representative of the Family Colonization Society, was famous for her assistance to migrants; she eased the journey of thousands of travelers and worked indefatigably to improve the housing conditions of the settlers (see *M'Phun's Australian News*, May 1853, p. 4).

89. These newspaper clippings, unidentified as to source and date, are held in the Braikenridge Collection in the Bristol Library.

90. "The Avon Clift Iron Works," c. 1855 (Braikenridge Collection).

91. *Statistics of the Colony of Victoria*, an annual return presented to the Parliament of Victoria.

92. See, for instance, the advertisements in the Melbourne *Argus* throughout 1853, and particularly the *Argus* of 30 August 1854.

93. Ports of Melbourne and Geelong, *Accounts relating to Trade and Customs for the Year 1855*, p. 9.

94. *Argus*, 15 July 1854.

95. See advertisements in the Melbourne *Argus* and the Ballarat *Star* during 1855 and 1856.

96. Geoffrey Blainey, *Johns and Waygood Ltd. 1856–1956* (Melbourne: Caulfield & Co., n.d.), pp. 5–6.

97. Ballarat *Star*, 6 September 1856.

98. Five hundred carpenters and joiners, one-third of the work force, were unemployed, and many others were on subsistence wages, according to a letter from Melbourne (January 1858) reprinted in the *Building News*, 19 March 1858, p. 306.

99. Many manufacturers from Laycock (1843) onwards attempted to cope with the heat by advocating cavity walls, ventilated cavities, insulated infill, timber linings, etc. The solutions were generally inadequate, but there is ample evidence that the problem was clearly recognized. Porter (*Iron Building and Roofing*, p. 8), for instance, draws attention to the difference between an "iron shell," which is uninsulated, and an "iron house," and comes to the conclusion that the problem is economic rather than technical. "An iron building suitable for a dwelling is, comparatively, a costly affair."

100. Reported in the *Year Book of Facts in Science and Art*, 1855, p. 56.

101. The *Practical Mechanic's Journal*, 1860, p. 316.

102. The *Practical Mechanic's Journal*, 1854, pp. 77–78.

103. Dr. José Garcia-Bryce, in a letter to Malcolm Higgs (12 October 1970, which Dr. Garcia-Bryce kindly made available to me), and Dr. José Garcia-Bryce, in a letter to me (13 October 1973).

104. The information in this section derives from Dr. Garcia-Bryce, and from Monserrat Palmer Trias, *50 Años de Arquitectura Metalica en Chile, 1863–1913* (Instituto de Historia de la Arquitectura: Universidad de Chile, 1970).

105. For details of Bellhouse's South American buildings, see the *Civil Engineer and Architect's Journal*, 1856 and the *Practical Mechanic's Journal*, 1860, p. 316.

106. According to Winslow Ames, *Prince Albert and Victorian Taste* (London: Chapman and Hall, 1967).

107. The *Builder*, 10 May 1856, p. 262.

108. Henry-Russell Hitchcock, *Architecture: Nineteenth and Twentieth Cen-*

turies, (Baltimore: Pelican Books, 1958), p. 128, writes, "Although we can today appreciate some of the practical virtues of this edifice as a Museum of Science and Art, it must be admitted that it was inferior even to the general contemporary turn of prefabricated structures to which it belongs technically." Skempton, "The Sheerness Boat Store," *Journal of the Royal Institute of British Architects,* June 1961, p. 324, dismisses it as "little more than a large, temporary, triple shed with mezzanine galleries."

109. The *Builder,* 1843, p. 170.

110. See the *Illustrated London News,* August 1854, pp. 183–84, for the Metropolitan Cattle Market, and for the Price Candleworks see the *Illustrated London News,* December 1854, pp. 553–54.

111. *Building News,* April 1857, p. 412.

112. The *Builder,* February 1855.

CHAPTER 5

1. Melvin Kranzberg and C. W. Pursell, *Technology in Western Civilization* (New York: Oxford University Press, 1967).

2. *Tradition* V, no. 28, 1968, p. 30.

3. *Report of the Commission of Enquiry into the Supplies of the British Army in the Crimea,* first report (June 1855), second report (January 1856), p. 33.

4. I have not traced early records of the firm, but apparently by 1854 it was well established in Gloucester. At the time of the takeover of 1866 (see note 9 below), Eassie and Co., were described as "manufacturers of railway plant, and general builders and contractors." In the building trades directories they are variously described as "Builders of Portable Houses" (Wyman's 1868), "Iron Church and House Builders," and "Builders of Portable Houses: Wood" (Post Office Directory, 1870). In the Gloucester Directories from 1867–76, they are listed as "Timber Merchants."

5. The *Illustrated London News,* 6 January 1855, p. 14.

6. For a history of Price, Walker and Co., from its origins in 1736 until its bicentennial, see "Two Hundred Years in the Timber Trade," *Timber Trades Journal,* 2 May 1936. Richard Potter, one of the instigators of the Crimea hut project, was a partner in the firm.

7. The *Illustrated London News,* 6 January 1855, p. 14.

8. A. Forbes, *History of the Army Ordnance Services,* vol. 1 (London: Medici Society, 1929), p. 263.

9. In 1866, when Eassie and Co., became a limited liability company, Charles Walker of Price, Walker and Co., became chairman. Another director was Isaac Slater, manager of the Gloucester Wagon Company of which Potter was chairman. (Newspaper clippings, 1886, on file in Gloucester Library.) This firm, in the 1886 directory, was listed as "Iron Church and House Builders."

10. The *Commission of Enquiry* (1855–56), pp. 35–36.

11. The *Illustrated London News,* 6 January 1855, p. 41.

12. *Commission of Enquiry* (1855–56), p. 33.

13. Ibid., p. 36.

14. Ibid., pp. 289–92.

15. See memo. Lord Hardinge, 22 May 1854 (in H. N. Cole, *The Story of Aldershot,* (Aldershot, Gale & Polden, 1951), p. 30).

16. The *Illustrated London News,* 11 August 1855, p. 179.

17. British Official Records, War Office, 55/1934.

18. See, for example, the patents of Langman (311/1855), Isaac (336/1855), and Bellhouse (626/1855).

19. The *Illustrated London News,* 1 September 1855, p. 250.

20. According to George F. Chadwick, *The Works of Sir Joseph Paxton,* (London: Architectural Press, 1961), pp. 248–49.

21. Ibid.

22. *Report of a Board of Officers . . . on Different Principles and Methods of Hutting Troops*, War Department, London, July 1856.

23. Letter from Dr. Smith to Dr. Hall, 24 December 1855 (Item 322, Muniments Room, Royal Army Medical Corps Library).

24. E. A. Parkes, *Report on the Formation and General Management of Renkioi Hospital, Turkey* (London, 1857), p. 4.

25. See, for instance, the *Illustrated Times*, 1 December 1855, p. 412, and at least ten items in the *Times* between September and December 1855.

26. Parkes, *Renkioi Hospital, Turkey*, pp. 3–20.

27. Appendix no. 1: Memorandum by Isambard Kingdom Brunel: "Hospital Buildings for The East" (March 1855) in Parkes, *Renkioi Hospital, Turkey*.

28. The Melbourne *Argus*, 3 January 1854.

29. As reported in the *Practical Mechanic's Journal*, 1853, p. 69, the patent was taken out on 5 November 1852.

30. British Official Records, War Office, 28/174, July, August, 1855.

31. Photographs in Victoria and Albert Museum, N1256, N1257.

32. British Official Records, War Office, 45/270.

33. The *Builder*, 13:1855 (17 February 1855).

34. The *Illustrated London News*, 6 January 1855, p. 7.

35. The *Times*, 27 July 1855.

36. *General Report on the Commission Appointed for Improving the Sanitary Conditions of Barracks and Hospitals*, London, 1861, p. 29.

37. According to information given to me by G. Watkins of Bath University.

38. British Official Records, War Office, 45/270, 7 November 1854.

39. C. D. Young & Co., *Illustrations of Iron Structures for Home and Abroad*, p. 5.

40. The *Illustrated London News*, 13 October 1855, p. 453.

41. The contractor for the North Camp in 1855, and for the hotel opposite the cavalry barracks, is referred to by Cole (*The Story of Aldershot*, pp. 63–64) as a Mr. Hemmings.

42. The *Illustrated London News*, 29 September 1855, p. 397.

43. *How Britain Goes to War: a Digest and an Analysis of Evidence taken by the Royal Commission on the War in South Africa*, London, 1903, p. 171, item 11104.

CHAPTER 6

1. Freeland, *Melbourne Churches*, p. 147.

2. The *Illustrated London News*, 28 September 1844.

3. I am indebted to Professor Freeland for drawing my attention to this information in J. C. Symon, *The Life of Daniel James Draper* (Melbourne, 1870), pp. 157–59.

4. Ibid.

5. Unidentified cutting, "The Avon Clift Iron Works", in the Bristol Library (Braikenridge Collection).

6. These descriptions derive from contemporary lithographs and engravings; from a note in the *Illustrated London News*, 30 April 1853; and from the ticket of admission to the inaugural service (Braikenridge Collection).

7. E. Graeme Robertson, *Victorian Heritage: Ornamental Cast Iron in Architecture* (Melbourne: Georgian House, 1960), p. 45 ff.

8. According to an account in E. Graeme Robertson, *Sydney Lace: Ornamental Cast Iron in Architecture in Sydney* (Melbourne: Georgian House, 1962).

9. According to an 1892 comment cited by Robertson, *Victorian Heritage*, p. 49.

10. From notes appended to the plans of the iron church in *Instrumenta Ecclesiastica*, second series, 1856.

11. George L. Hersey, *High Victorian Gothic* (Baltimore, The Johns Hopkins University Press, 1972), p. 179.

12. W. Vose Pickett, "Iron Architecture," *Ecclesiologist*, (August 1856), pp. 280–81.

13. For a fully illustrated account of this proposal see Stefan Muthesius, "The 'Iron Problem' in the 1850s," *Architectural History*, XIII, 1970, pp. 58–63.

14. The *Civil Engineer and Architect's Journal*, XVII, 1854, p. 278.

15. C. D. Young & Co., *Illustrations of Iron Structures for Home and Abroad*, plate 11, fig. 17. (Erroneously called fig. 19 in Young's text.)

16. Information on the iron church of Macquarie Street comes from the *Empire*, 8 September 1853, p. 2715; J. Cambell Robinson, *The Free Presbyterian Church of Australia* (Melbourne: Hamer, 1947), p. 98; undated newspaper clipping, Small Pictures File; an advertisement in *Parkes Correspondence*, vol. 22, p. 110; and Mitchell Library document 314; all of which are in the Mitchell Library, Sydney.

17. Robinson gives Glasgow as the origin of the church, most other sources refer to Scotland; only the advertisement (Parkes) says: "imported direct from England." The date given in most accounts for the erection is 1855, but Mitchell Library/314 says 1857.

18. The use of cast iron for the main façade and corrugated iron for the sides can also be found in such houses by Young as Coria Villa, which we discuss in chapter 8.

19. Cole, *The Story of Aldershot*, p. 57.

20. According to an advertisement in the *Builder*, 27 February 1857.

21. See descriptive account in the *Builder*, 27 October 1855, p. 508.

22. Proceedings of the Metropolitan Board of Works, referred to in *Building News*, 27 February 1857, p. 221.

23. *Building News*, 22 May 1857, p. 539.

24. The *Civil Engineer and Architect's Journal*, XX, 1857, p. 236.

25. *Building News*, 15 January 1858, p. 57.

26. Principal sources of information on Morton are from J. M. Swift, *The Story of Garston and Its Church* (1937), pp. 185–88; Francis Morton & Co., *Catalogue 8/b*, 1873; *Building News*, 14 February 1888, p. 198; and various directories.

27. In the *Liverpool Daily Courier*, 26 April 1867. An illustration of the interior appeared in an advertisement in Wyman's directory (1868), trade appendix.

28. See letter of 17 June 1867, from P. C. Sandberg to Francis Morton, published in Francis Morton & Co., *Catalogue*, 1873.

29. Frederick Braby opened business in London in 1839 as an engineer, general contractor, and iron-building constructor. He established the "Eclipse Iron and Galvanizing Works" in Glasgow, and, eventually, additional establishments at London, Deptford, and Liverpool. They are listed in the various directories as "Iron Church and House Builders" and "Builders of Portable Houses" among many others. In 1889, after 50 years, Frederick Braby & Co.'s Iron Buildings and Roofing Department published an informative *Illustrated Catalogue*. (For an account of the firm see Stratten and Stratten, *Glasgow and its Environs* (London, 1891).

30. For an account of the Kimberley church, see following chapter 7. For an account of the Barberton church, see the illustration in W. D. Curror, *Golden Memories of Barberton* (5th ed., 1972), p. 31.

31. *Building News*, 12 March 1888, p. 415.

CHAPTER 7

1. The *Builder*, 1843, pp. 170–71.

2. Clipping dated 23 October 1852, in the Bristol Library (Braikenridge Collection).

3. "Glasgow Iron Ball in Messrs. Robertson and Lister's Iron Houses," *M'Phun's Australian News*, May 1853, p. 9.

4. The *Civil Engineer and Architect's Journal*, 1854, p. 185.

5. See the report in *Building News*, January 1888, p. 128.

6. "Corrugated Iron Roofs," *Building News*, August 1889, p. 284.

7. See statistics in *Encyclopaedia Britannica*, 14th ed., vol. 6, p. 471.

8. I am grateful to Mrs. Natalie Goodall, the present owner of the house, for many details of the history and construction of this iron structure. Because there was no storage space on land, the house was apparently assembled as the pieces came out of the hold of the ship, and therefore does not reflect the original plan. (Letter to me, 20 September 1971.)

9. Francis Morton & Co., *Catalogue*, 1873; Frederick Braby & Co., *Illustrated Catalogue*.

10. The catalogue of one of Morton's contemporaries, Crompton and Fawkes, also illustrates a wide range of "portable colonial cottages," single, paired, and in rows, in addition to a wide range of farm, industrial, and church buildings—according to a descriptive account in *Building News*, March 1886, p. 415.

11. James Henderson, a Melbourne architect and engineer, designed this two-story dwelling, which was manufactured by Goldie and Inglis, ironfounders of Glasgow. Details of its elegant structural system were given in the *Civil Engineer and Architect's Journal*, 1853, p. 456.

12. British Patent 784/1852. Also described in the *Practical Mechanic's Journal*, 1853, p. 162.

13. The foundation system was derived from the concept of a fencing post with a spiral gaining screw; the fibrous panels of the double-skinned external wall were (according to the account in the *Mechanics' Magazine*, September 1860, p. 198) Bielefeld's fibrous slabs.

14. For an informative account of Lascelles' work see A. E. J. Morris, "A Century of Concrete System Building," *Building*, 13 June 1975, pp. 107–9.

15. See, for example, the advertisement in the *Standard and Transvaal Mining Chronicle* (2 September 1890), which claimed that their product was "fast taking the place of iron, wood, felt, etc. for all building purposes . . . 2 tons will cover as much space as 5 tons of iron. It will last as long as iron, is very easily worked, does not sweat inside, is a non-conductor of heat, and is cheaper. A sheet will sustain the weight of as many men as can stand upon it." The company produced a catalogue of 12 designs of "portable buildings of every kind, light, durable and climate proof."

16. In 1889 there were two through trains every weekday from Durban via Pietermaritzburg to the railhead at Ladysmith, 189 miles from Johannesburg. Goods were then transshipped by ox wagon, the total journey to Johannesburg taking 15 days, to Barberton 22 days. By 1889 goods from Cape Town and Port Elizabeth were railed as far as Kimberley, a journey requiring 48 hours. From Kimberley to Johannesburg, the ox wagon took over. Passengers traveling by train and coach could get from Durban to Johannesburg in 72 hours, from Cape Town to Johannesburg in 85 hours, and from Durban to Barberton in 119 hours. The Cape Town-Pretoria railway line (with an 8-mile branch spur from Elandsfontein to Johannesburg) was completed in 1893, the Durban-Johannesburg line in 1895.

17. E. J. L., "Kimberley as it is", the *Diggers News and Witwatersrand Advertiser*, 21 May 1889.

18. R. W. Murray, *The Diamond Fields Keepsake for 1873* (Cape Town: Saul Solomon and Co., 1873), pp. 24, 29.

19. According to J. T. McNish, *Graves and Guineas* (Cape Town: G. Struik, 1969), p. 131.

20. The *Diamond News and Vaal Advertiser*, 19 November 1870.

21. J. L. Babe, *South African Diamond Fields*, 1872.

22. The *Diamond News and Vaal Advertiser*, 28 February 1872.

23. The *Diamond Fields Advertiser*, 1 May 1878.

24. See the illustrations in Anthony Hocking, *Old Kimberley* (Cape Town: Purnell, 1974), pp. 5, 14. There were newspaper advertisements about such buildings;

a typical example would be "A. A. Rothschild . . . is daily expecting a roomy wooden store with iron roof, 24 feet long and 16 feet wide, which will be for sale on arrival." (The *Diamond News and Vaal Advertiser*, 31 December 1870.)

25. The *Diamond News and Vaal Advertiser*, 22 November 1873.

26. Ibid.

27. Murray, *Diamond Fields Keepsake*, p. 20.

28. The *Diamond News and Griqualand West Gazette*, 1 November 1873.

29. "A rapid sketch of the . . . diamond fields," supplement, the *Diamond News and Vaal Advertiser*, 3 June 1871.

30. An editorial in the *Diamond News and Vaal Advertiser* (3 December 1870) dealing with the havoc caused by torrential rain says, "Two or three hours more of the same weather would have swept away every habitation on the Fields, with the exception of some half-a-dozen wood and iron houses." Murray, *Diamond Fields Keepsake*, p. 24, notes among these Jardine's Royal Arch Hotel, "which is frequented by pleasure seekers and invalids"; Berlyn's general stores; and a few cottages.

31. This church is the St. Martini Lutheran Church that was built for the German Lutheran Church of Kimberley and consecrated 31 October 1875. The building remained in use until 1963, when it was dismantled and taken to the Open Mine Museum. While the manufacturer is not known, the iron sheets are marked "Shelter: G/S," with the insignia of a tent. (I am most grateful to the city librarian of Kimberley for this and other relevant information on Kimberley.)

32. "To this day (1889), nine-tenths of the private dwellings are of corrugated iron," wrote E. J. L. in "Kimberley as it is."

33. Isaac Sonneberg and Company advertised sheet zinc, corrugated iron, sheet iron, deals, and yellowwood planks (the *Diamond News and Vaal Advertiser*, 5 November 1870); A. C. Stewart & Company of Port Elizabeth advertised galvanized iron of all lengths, Gospel Oak brand (ibid., 12 November 1870).

34. Ibid., 2 March 1872, and various issues of the *Diamond Fields Advertiser*, April—June 1878. Once again, Gospel Oak iron in 6-, 8- and 9-foot lengths is advertised.

35. The *Diamond News and Vaal Advertiser*, 16 December 1871.

36. See, for instance, the *Diamond Fields Advertiser* (6 April 1878) advertisement of a house, built of iron and brick lined "under the supervision of the well-known Builder and Architect, George McColl Esq." The Harris ballroom was also architect-designed; the plans are still in existence.

37. The *Diamond Fields Advertiser*, 29 January 1876.

38. Ibid., 4 January 1876. Other examples of such portability are a 30′ × 14′ iron house "removed for convenience of sale" (the *Diamond News and Vaal Advertiser*, 22 November 1873), and the 60′ × 20′ "South African Bar," an iron building that could "be removed to any part of the camp." (Ibid., 4 December 1873).

39. The *Diamond News and Vaal Advertiser*, 14 January 1871.

40. Ibid., 20 January 1872.

41. Ibid., 6 January 1872.

42. Ibid., 2 March 1872.

43. Ibid., 16 December 1871, 6 March 1872, 27 March 1872.

44. A Murell-manufactured building was advertised in the *Diamond News and Vaal Advertiser*, 9 March 1872, "A commodious wood and iron store 30 × 20, with fixtures, counters and partition, lined with felt."

45. The *Diamond News and Griqualand West Gazette*, 13 November 1873.

46. The *Diamond News and Vaal Advertiser*. These advertisements continued from January 1871 until July 1871.

47. For most helpful information on Barberton I am indebted to Esme Lownds, who generously shared her extensive knowledge of the history of that town with me.

48. There were many advertisements for building materials in the *Gold Fields Times*, the *Representative*, and the *Barberton Herald and Transvaal Mining Mail* of 1886–87. Merchants included B. Gallewski; A. Dunn & Co. of Durban; P. Hen-

wood & Son, who had branches throughout South Africa; and Poynton and Larsen, agents for Poynton's of Durban.

49. The *Gold Fields Times,* 7 December 1886.

50. According to many advertisements in the Barberton papers.

51. The *Gold Fields Times,* 30 November 1886.

52. See, for instance, the entry "F. Braby, iron house and church builder," in the "List of Manufacturers of English Goods for Export to South Africa," in the General Directory of South Africa in 1888 and again in 1890.

53. The *Representative,* 5 March 1887; the *Barberton Herald and Transvaal Mining Mail,* 5 April 1887.

54. See the following in the *Barberton Herald and Transvaal Mining Mail* of 5 October 1886: "J. E. Oliver, Builder and Carpenter, just arrived from Cape Town . . . is also prepared to supply on shortest notice Swedish Wood Houses complete, one, two, three, four, or eight-roomed houses."

55. The *Gold Fields Times,* 14 December 1886.

56. The *Barberton Herald and Transvaal Mining Mail,* 19 October 1886.

57. The *Gold Fields Times,* 30 November 1886.

58. T. W. Savory, *Diary,* transcribed by Mrs. Esme Lownds (1884).

59. *South Africa: A Weekly Journal for All Interested in South African Affairs* (European edition). Nicol advertised in this journal for about six months and Wright advertised for ten months commencing January 1889. Both referred to themselves as builders, contractors, and importers; both had steam sawmills; and both sold joinery components such as windows and doors. Nicol constructed wood and iron buildings on short notice from rough sketches.

60. James Gray, *Payable Gold* (Johannesburg: C.N.A., 1937), p. 118.

61. A letter from C. P. Ross to Cape Town cited by John R. Shorten, *The Johannesburg Saga* (Johannesburg City Council, c. 1966), p. 67.

62. On 24 September 1886 the state secretary of the South African Republic asked the surveyor-general to call for bids for the job of surveying 600 stands (building lots), a main street 75 feet wide, and other streets 70 feet wide, on the farm Randjeslaagte, which had been established as a township in October 1886. (According to E. L. and James Gray, *A History of the Discovery of the Witwatersrand Goldfields* [Johannesburg: Sholto Douglas & Co., 1940].)

63. Bid made by G. Pierneef "to build a new iron office with two windows and two doors including a wooden floor and two ventilators," 30' × 12' × 10' high, costing £98 plus an additional £43 for a ceiling of wood. (James Gray, *Payable Gold,* p. 140).

64. According to Gray (ibid., p. 156), Von Brandis purchased a 20' × 16' × 10-foot-high galvanized-iron building, which had already been erected, for £85. He now needed an additional £20 for a wooden floor.

65. The extent of this trade in iron buildings may be assessed from the advertisements in the newspapers of the period: The *Eastern Star,* the *Johannesburg Star,* the *Diggers News and Witwatersrand Advertiser,* and the *Standard and Transvaal Mining Chronicle.* The two houses cited come from the *Eastern Star,* 5 September 1888 and 17 April 1889.

66. See G. A. Leyds, *A History of Johannesburg* (Nasionale Boekhandel Beperk, 1964), p. 225.

67. The *Eastern Star,* 23 November 1888.

68. Fillis's amphitheater was designed by R. Taylor and erected by W. J. Symons at a reputed cost of £12,000. Although it was claimed that it could hold 2,500 spectators, at the opening ceremony on 7 September 1889, it was filled to capacity by 1,650 people. In 1890 the amphitheater was renovated and a wooden floor was installed; as the largest hall in South Africa it provided facilities for banquets, balls, soirees, lectures, and skating. (See the *Diggers News and Witwatersrand Advertiser,* 29 August 1889 and 3 September 1889, and the *Standard and Transvaal Mining Chronicle,* 20 February 1890.)

69. de Waal, *The Market Square of Johannesburg.*

70. I owe this account to R. Dohmeier, who undertook research on this building in a paper prepared for me at the University of the Witwatersrand, 1975. The station building still stands, but on a new site and as the railway museum—its third role.

71. For an account of the "Tin Temple" see Allister MacMillan, *The Golden City* (London: Collingridge, 1933).

72. See the article "The Rise of Johannesburg," in *South Africa: A Weekly Journal for All Interested in South African Affairs*, 12 October 1889. "For one brick house in Kimberley," the author says, "there are fifty in Johannesburg." Nevertheless, "wages in the building trade are very high, a day labourer being paid 20s. to 25s. a day."

73. Ibid.

74. According to the *Census of the Transvaal Colony and Swaziland* (1906), in 1904 there were the following numbers of dwellings:

Material	Barberton	Witwatersrand
Brick and stone	353	16,417
Wood and iron, lath and plaster	661	15,372
Wattle and daub, mud, sod	6,532	1,194
Tents, wagons, canvas roofs	171	1,181

75. "Preferent rights" (leasehold rights) to building sites were sold when Johannesburg was subdivided; at first rights were in effect for only five years; later after protests, this was increased to 99 years. This must have initially inhibited the erection of more permanent buildings. In Pilgrims Rest in the Eastern Transvaal, the fact that the mining company owned the residential land and that consequently there was no security of tenure is one of the principal explanations offered for that town's unique, all-iron, character. Many good examples of corrugated-iron buildings, including the quaint Royal Hotel, are still to be seen there, and restoration work continues. (The bar of the hotel, a late-nineteenth-century construction, was originally a Catholic mission church in Lourenco Marques. It was originally brought from Mozambique to nearby Pilgrims Rest to serve as a billiard room; later it became the bar of the Royal Hotel.)

76. A large number of these iron houses are still in existence, and I have examined extant examples that are in excellent condition at Consolidated Main Reef, Crown Mines, and Simmer and Jack Mines.

77. This account derives from Denis Godfrey, "Romantic Story of an Old Shed" (the *Johannesburg Star*, 16 May 1975).

78. See Frederick Braby & Co., *Illustrated Catalogue*, 1889, pl. 22: "Dwelling house lately shipped by us to South Africa for a Gold Mining Company."

79. *Diamond News and Vaal Advertiser*, 28 January 1871.

80. F. Smith & Co. of Stratford; Mitson and Harrison of London; Hill and Smith, the Brierley Hill Iron Works, Staffordshire; Cross and Cross, Union Works, Walsall. For iron building manufacturers exporting to South Africa see advertisements in Burton, *Cape Colony for the Settler* (Jutas, 1903); and Longland's *Transvaal and Rhodesian Directory*, 1903. For dealers in corrugated iron, see such directories as the Johannesburg and District Directory, 1890; and the *Free State Annual*, 1893.

81. The *Johannesburg Star*, 25 October 1890. This firm also advertised in the General Directory of South Africa for 1890. Frederick Braby & Co. advertised in the 1888 and 1890 issues of this directory.

82. *Encyclopaedia of the Transvaal*, 1906. I am indebted to Lynn Markowitz for drawing my attention to this information. The firm, which originated in Durban in the 1850s, not only manufactured, but also imported, large quantities of galvanized-iron products, building timbers, and cement.

83. I do not have figures for the Transvaal, but the total value of galvanized-iron imports to Natal increased from £3,478 in 1860 to £39,371 in 1875—a time when the annual value of imported houses never exceeded £1,000 (*Natal Blue Books*).

84. Longland's *Transvaal and Rhodesia Directory*, 1903, p. 11.

85. L. S. Amery, ed., *The Times History of the War in South Africa*, vol. 5 (London, 1907), pp. 396–97; Charles M. Watson, ed., *History of the Corps of Royal Engineers*, vol. 3 (Chatham: Institution of Royal Engineers, reprinted 1954), pp. 125–26. The blockhouses were invented by Major S. Rice, Royal Engineers.

86. Watson, *Royal Engineers*, p. 155.

87. Ibid., pp. 169, 170.

88. According to a letter from Mr. Rudolf Glass to the director of the National War Museum, Johannesburg, 2 February 1973.

89. According to photographs in the Africana Museum, Johannesburg.

90. According to information from Esme Lownds.

91. Verbal report from the director of the National War Museum, Johannesburg.

92. Jan Christian Smuts, *Jan Christian Smuts* (London: Cassell & Co. 1952), p. 271. Further information comes from *Standard Encyclopaedia of Southern Africa*, vol. 4, p. 69.

93. Keith Hancock and Van Der Poel, eds., *Selection from the Smuts Papers*, Vol. 2 (Cambridge: at the University Press, 1966), document 416 (Christmas Eve, 1908).

CHAPTER 8

1. Except for the rear wall, which is the brick retaining wall to the terrace, the entire building is fabricated of metal and glass.

2. For the history of the Britannia Iron Works see Malcolm Higgs, "The Exported Iron Buildings of Andrew Handyside and Co. of Derby," *JSAH*, XXIV (May 1970), pp. 175–80; for the remaining Derby foundries see the introductory notes (pp. ix–x) to the *Derbyshire Directory*, 1827–29.

3. Attention was first drawn to the historical importance of the Camellia House by me, in a paper called "The Enigma of the Camellia House at Wollaton Hall," (Monograph, 1973, privately circulated). I argued, from internal evidence only, that Jones and Clark were the likely manufacturers. This has now been confirmed independently by John Hix (*The Glass House* [London: Phaidon Press, 1974]), who has had access to the order books of this firm. Hix gives a valuable account of the role played by the manufacturers of conservatories in the development of prefabrication. The vexed question of the identity of the designer of the Camellia House is still unsettled. If, as Hix suggests, Jeffrey Wyatville was responsible for the conservatory at Kew (formerly at Buckingham Palace), then my supposition that he also designed the Camellia House is strengthened. At the time of its construction, he was active at Wollaton Hall, designing many additions there. We must, however, consider the possibility that the exterior of the Camellia House at Wollaton Hall was manufactured independently of the interior. The interior of the conservatory of the Grange, Hampshire, is almost identical to that of the Camellia House (and was also manufactured by Jones and Clark), but the exterior of the Grange's conservatory is a conventional masonry structure.

4. For an authoritative chronology of the cast-iron front, see Turpin C. Bannister, "Bogardus Revisited. Part 1," *JSAH*, XV (1956); for an early note on the St. Louis examples see Giedion, *Space, Time, and Architecture*; for basic material, the best source is W. Knight Sturges, Introduction to *The Origins of Cast Iron Architecture in America* (New York: Da Capo Press, 1970). Bannister gives an excellent bibliography, but does not deal with post-Bogardus cast-iron buildings; for this, see Cervin Robinson, "Late Cast Iron," *Forum* (September 1971), pp. 46–49.

5. Bannister, "Bogardus Revisited. Part 1."

6. R. B. White, *Prefabrication: a History of Its Development in Great Britain* (London: Her Majesty's Stationery Office, 1965).

7. According to D. Harrison, J. M. Albery, and M. W. Whiting, *A Survey of Prefabrication* (London: Ministry of Works, 1945).

8. The *Year Book of Facts in Science and Art*, 1842, p. 59.

9. Ibid., 1843, p. 40.

10. Ibid., 1842, p. 58.

11. Ibid., 1843, p. 40.

12. See, for instance, the *Builder*, 1849, p. 487; and the *Illustrated London News*, 15 September 1849, p. 178.

13. Tylor, *Paris Universal Exhibition*, p. 6.

14. The *Year Book of Facts in Science and Art*, 1846, pp. 110–11.

15. The *Mechanics' Magazine*, 1844, pp. 226–27. Such proposals continued for many years. There was, for instance, the fully worked out scheme for a pseudoashlar construction in cast iron by Chaplin, the Glasgow engineer and iron house builder, reported in the *Practical Mechanic's Journal* ten years later (1854, p. 68). Although these houses are made completely of iron, they are not dissimilar in appearance to the iron veneer used by John Haviland in his Pottsville Bank of 1830.

16. The *Year Book of Facts in Science and Art*, 1842, p. 52.

17. Ewing Matheson, *Work in Iron* (London: Spon, 1877). (Cited in John Gloag, *Victorian Taste* [Newton Abbot: David and Charles, 1972]).

18. The *Illustrated London News*, 6 July 1850, p. 13.

19. Chadwick, *The Works of Sir Joseph Paxton*, p. 115. Notwithstanding this oversimplification, Chadwick's insight into the significance of the Crystal Palace is perceptive and sound.

20. For details of the construction of the Crystal Palace, perhaps the best source is the account in *Minutes of Proceedings of the Institution of Civil Engineers*, vol. 10, 1850–51, pp. 127–91, and especially "The Execution of the Works," pp. 156–64. Also valuable is Charles Downes, *The Building Erected in Hyde Park for the Great Exhibition, 1851* (1852; reprint ed., London: Victoria and Albert Museum, 1971).

21. For an authoritative account of these buildings to which Hitchcock first drew attention in "Early Cast Iron Facades," *Architectural Review*, January 1951, see A. H. Gomme and D. W. Walker, *The Architecture of Glasgow* (London: Lund Humphries, 1968), pp. 114 ff.

22. The full title is given in n. 40 to chapter 4.

23. R. Bruce Bell was a civil engineer and Daniel Miller was a coppersmith and brassfounder. They set up practice as Bell and Miller, civil and mechanical engineers, in Glasgow in 1852, and the firm remained in existence until the end of the century. Young refers to them as "Engineers and Architects," but they are listed in the Glasgow Directory only as "Civil Engineers."

24. One such house, originally intended for use in Australia, was eventually erected in the vicinity of Glasgow, where it was considered "one of the finest suburban houses in the district" (C. D. Young & Co., *Illustrations of Iron Structures for Home and Abroad*, p. 3).

25. The house is described in the *Year Book of Facts in Science and Art*, 1855, pp. 54–57. McLellan's were ironfounders who, despite a considerable general trade, listed themselves in the various directories (Kelly's Building Trades Directory, 1870, 1886) as "Builders of Portable Houses," and "Iron Church and House Builders."

26. For a note on "Tintern" see Saunders, *Historic Buildings of Victoria*, p. 144.

27. C. D. Young & Co., *Illustrations of Iron Structures for Home and Abroad*, pl. IX, fig. 14.

28. Gray, presumably, was William Nairn Gray, Commissioner of Crown Lands for the district of Portland Bay, who died in June 1854.

29. Robin Boyd, *Australia's Home* (Melbourne: Melbourne University Press, 1952); Robertson, *Victorian Heritage*; Saunders, *Historic Buildings of Victoria*; Freeland, *Architecture in Australia*; White, *Prefabrication*.

30. I am grateful to Mr. Drinnan for letting me have a copy of his original

report, and for supplying me with much additional information about Corio Villa. Recent investigations carried out at Corio Villa and reported to me by Mr. Drinnan show the construction to be of flanged, cast-iron plates laid ashlar-style (that is, with staggered vertical joints), the external joints filled in so carefully that even today they are hardly discernible. This investigation seems to bear out my earlier supposition that the "plates were possibly caulked externally with iron cement." (See Gilbert Herbert, "A Cast-Iron Solution," Architectural Review, CLIII: 916, June 1973, p. 373.)

31. Information from the Edinburgh and Glasgow Post Office directories; there are references to the history of Young's business in the Scotsman, 30 June 1858 and 28 July 1858 and the Glasgow Herald, 28 July 1858 and 30 July 1858.

32. According to a report in M'Phun's Australian News, (May 1853), Young, Peddie & Co. were active in the manufacture of galvanized corrugated iron houses and warehouses for export to South America and Australia.

33. William D. Young & Co. continued in business in Edinburgh from 1861 to 1875; Robert Peddie and Co. was established there from 1861 to 1891.

34. These included a Compendium of C. D. Young & Co.'s Larger Catalogue of Iron and Wire Works, 1850; and his Address to Landed Proprietors, Agriculturists, etc., 1851.

35. Robertson and Lister first appear in the 1848 Glasgow directory as smiths, engineers, millwrights and ironroof contractors. From 1853 until 1862, they also style themselves "iron house builders."

36. The Civil Engineer and Architect's Journal, XVI, 1853, p. 339.

37. Not only was the sequestration reported in the Scotsman under the sensational heading "Extensive Bankruptcy," (30 June 1858), but the same paper ran a long editorial on the subject after the official hearing (28 July 1858).

38. An example of Parkin's work is the Mercado del Puerto de Montevideo, made at the Union Foundry in Liverpool in the 1860s. An account may be seen in Ricardo Alvarez Lenzi, "El Mercado Central," Revista de la Facultad de Arqitectura: Universidad de la Republica (Uruguay, October 1964), pp. 111–12.

39. They are listed as "Iron House and Church Manufacturers" in Kelly's Building Trades Directory, 1886. Keay's ornate iron market-pavilion with its cast-iron columns and corrugated iron roof on a steel frame, which he made for the Kimberley Council in 1907 at a Free on Board cost of £705 and an ultimate cost of £1665 16s., is still standing (see Municipal Council Minutes, 1907).

40. The finest account is Eric de Mare and A. W. Skempton, "The Sheerness Boat Store 1858–1860," Journal of the Royal Institute of British Architects, June 1961, pp. 318–24.

41. For these lighthouses by Grissell see the Year Book of Facts in Science and Art, 1854, pp. 73–74; the Illustrated London News, December 1855, pp. 765–66, June 1858, pp. 589–90.

42. Special issue of the Year Book of Facts in Science and Art 1851, dealing with the great exhibition.

43. A detailed description of Andrew Handyside's work is given by Higgs, "Exported Iron Buildings."

44. Andrew Handyside, Works in Iron (1868), pp. 44–45, cited by Higgs, "Exported Iron Buildings," p. 177.

45. Cottam and Hallen, variously referred to at later stages as Cottam & Co. or Cottam and Cottam (which were perhaps different or related firms), were established in 1818. They appear in the directories as ironfounders and, occasionally, as builders of portable houses, at least until 1886.

46. Advertisement in the London Monthly Overland Mail for All India, 4 October 1840.

47. Stables are probably some of the earliest examples of cast-iron subsystems. As early as 1837 stall systems involving columns, trussed arches, floor plates, and partition panels suggest—in range of components, methods of combination, and architectural character—the more ambitious cast-iron work of the second half of

the century. As an example, see Trumans Brewery Stabling, illustrated and described in the *Civil Engineer and Architect's Journal*, December 1837, p. 47.

48. South African usage of these ironmasters' imprints are referred to by Helen Aron et al., *Parktown 1892–1972* (Johannesburg: Studio Thirty-five, 1972). An extant veranda cast by the Elmbank Foundry that is still in excellent condition may be seen in Marshall Street, Johannesburg.

49. Our information on Walter Macfarlane and Co. comes from: Stratten and Stratten, *Glasgow and its Environs*, pp. 98–99; A. McLean, ed., *Handbook on Industrial Glasgow* (Glasgow: British Association for the Advancement of Science, 1901), p. 85; Walter Macfarlane, *Illustrated Catalogue of Macfarlane's Castings*, 6th ed., n.d.; idem, *Macfarlane's Examples of Architectural Ironwork*, n.d.; and Glasgow Post Office Directory.

50. These sanitary units, which are early examples of prefabricated modular installations, were highly praised by the army. See *General Report on the Commission Appointed for Improving the Sanitary Conditions of Barracks and Hospitals*, London, 1861, pp. 89–92.

51. In America, the great mail-order house of Sears Roebuck developed a "Modern Homes" department between 1895 and 1900, and produced its first catalogue of precut houses in 1908. (See B. Emmet, *Catalogue and Counters* (Chicago: University of Chicago Press, p. 226). According to Alfred Bruce and Harold Sandbank, *A History of Prefabrication* (Raritan, New Jersey: The John B. Pierce Foundation, p. 57), some 110,000 of these houses were sold in 40 years.

52. Stratten and Stratten, *Glasgow and its Environs*, p. 98.

53. Macfarlane, *Illustrated Catalogue*.

54. Macfarlane, *Macfarlane's Examples*, example no. 330.

55. The *Star*, 4 October 1890, supplement.

56. See, for example, the *Argus Annual and South African Directory*, p. 285.

57. The ironwork on the following buildings was identified and related to examples in the Macfarlane catalogue by G. M. de Waal, "Die Karakter van die Argitektuur in die Binnestad van Johannesburg tot 1920" (Master's Thesis, Rand Afrikaans University, n.d.): Aegis Building (1893); Thorne and Stuttafords (1893); Heath's Hotel (1894); Escourt Building (c. 1895); Jeppe Arcade (1896); Silesia Building (1896); Goch Buildings (c. 1896); and Pollak Buildings (c. 1896). In addition to these central city buildings, suburban buildings were also graced with Macfarlanes's castings, as we see in the elegant ironwork of Hazeldene Hall and Parktown Convent, both of which were built in Parktown at the beginning of this century. These latter buildings are illustrated in Aron, et al., *Parktown 1892–1972*, plates 2, 5.

58. Advertisement of Calway & Co. of Gloucester, in Burton, *Cape Colony for the Settler* (1903). They claimed that unskilled labor could swiftly erect their bungalows, farm houses, cottages, and portable buildings.

GLOSSARY

Architrave The trim around a door or window; the lowest part of an entablature

Balustrade A protective railing consisting, in traditional architecture, of a row of small columns supporting a coping

Bargeboard The board covering the projecting timbers of a gable roof

Bearer A horizontal supporting member, usually carrying another structural element

Board-and-batten siding An external covering of alternate wide and narrow boards

Boarded The covering of a building surface, internal or external, by lengths of sawn timber, usually not less than four inches wide

Bowstring truss A roof truss whose top member is segmental in form

Cladding Nonstructural surface covering of a framed wall or panel

Demountable Capable of being taken down, disassembled

Draught lobby An entrance porch or hall protecting the interior of a building against wind

Druggeting A lining of coarse cloth, usually wool

Entablature In classical architecture, the horizontal member, usually consisting of architrave, frieze, and cornice, carried above the column capitals

Feather-edged boarding Tapered or beveled boards laid horizontally, the thick edge of one board overlapping the thin edge of the board below

GLOSSARY

Flèche A slender spire, at roof level, used decoratively or, sometimes, as a roof ventilator

Floor plate A horizontal timber member carrying and distributing the weight of the floor joists

Gable The triangular end wall of a building, following the line of the pitched roof

Hipped roof A roof of approximately pyramidal form, with intersecting inclined planes

Hot-dip galvanizing Coating iron or steel with zinc by immersing the metal in the molten zinc

Infilling Panel, nonloadbearing walls fitted between columns or stanchions

Joinery Woodwork of a finer or more intricate kind than carpentry, relating to the finishes of buildings or the making of components such as doors or windows

Lean-to A single-slope roof, the upper end of whose rafters are usually supported by the wall of an adjacent structure

Marine glue An adhesive substance used in woodworking, composed of rubber, shellac, and pitch (or naptha)

Match-boarded Closely fitted boards with veed, beaded, or rebated edges, usually with tongue-and-groove joints

Monitor A continuous raised portion of a roof, which admits light or ventilation through vertical windows

Muntin A slender vertical bar separating and supporting panes of glass or other panels in windows or other framed elements

"One-off" houses Individual, custom-built houses as opposed to repetitive, standardized, or serialized housing

Pediment In classical architecture, the triangular face to the end of the gabled roof; sometimes, the triangular or segmental decorative head to a window

Pisé (Also pisé de terre) Construction of earth, rammed, while plastic, between shuttering

Plank-wall construction A wall made of boarding laid horizontally between slotted posts

Post-tensioned A constructive element containing cables or rods that

210

are stressed subsequent to the inclusion of the element in the building

Rainwater goods Auxiliary elements to a roof for the disposal of rainwater, including gutters, spouts, and rainwater downpipes

Raking balustrade A balustrade set at an angle to follow the line of the roof or stairs

Raking parapet A protective railing or low wall set at an angle to follow the roof line

Rolled sections Structural iron or steel sections, including I- or H-shaped beams, channels, angles, and T- or Z-sections

Screw-pile foundation A cylindrical column, pointed and with a spiral thread, which bores its way into the earth when revolved

Sheathing See "Cladding"

Spandrel beam A beam between columns supporting a story-height element such as a window and spandrel panel

Spandrel panel In framed or skeleton construction, the solid panel below the window

Springing The line or level from which an arch or arch-type roof truss commences

Stringcourse A continuous horizontal projection or band on the external face of the building, usually at floor or window-sill level

Stud The upright member in a timber framed wall; sheathing is fixed to it

Tongue-and-groove boarding Closely fitted or matched boards; a projecting tongue on one board fits into a corresponding recess on the adjacent board

Trabeated Of column-and-beam or post-and-lintel construction

Tracery A decorative, lacelike pattern of intersecting lines, usually the divisions of a window

Triangulated truss A roof structure whose elements are arranged to form triangles, thus minimizing deformation

GLOSSARY

"Vitreous cloth" A flexible translucent synthetic material intended as a glass substitute

Wall plate A horizontal timber member carrying the roof trusses or joists and distributing their weight; where "wall" plate is written, the term refers to a similar member in a framed structure where, literally, there is no wall

Weatherboarding External covering to a timber building; the boards are designed to overlap to prevent the penetration of rain or wind

SELECTED BIBLIOGRAPHY

A. NINETEENTH-CENTURY NEWSPAPERS, PERIODICALS, AND ANNUALS

Algemeine Bauzeitung (Vienna)

Argus (Melbourne)

Australian and New Zealand Gazette

Barberton Herald and Transvaal Mining Mail

Builder: "Wooden Houses," 1843, p. 70; "The Iron Palace of King Eyambo," 1843, pp. 170–71; "Emigration," 21 May 1843, pp. 177–78; "Portable Cottages," 6 May 1853, pp. 178–80; "Temporary Churches," 1844, p. 471; "Iron Houses," 1844, p. 623; "Architecture and Building in South Australia," 1846, pp. 110–11; "Large Public Market-House for Honduras. Entirely Constructed of Iron," 18 April 1846, p. 190; "California and the Gold Diggings," 1849, VII:314; "Iron Houses," 1849, VII:327, p. 221; "More Iron Houses," 1849, VII:343, p. 417; "Iron Houses Abroad," 1849, p. 487; "An Iron Ball-room for Prince Albert," 6 September 1851, pp. 559–60; "Iron House for Chagres, made by Walker," 2 July 1853, p. 422; "An Iron Custom-house for Payta, in Peru," 4 March 1854, p. 114; "Portable Shops and Stores for Melbourne," 8 April 1854, pp. 182–83; "Progress of Melbourne," 9 September 1854, p. 476; "Huts for the Crimea," 15 September 1855, p. 443; "St. Paul's Temporary (Iron) Church, Kensington," 27 October 1855, p. 508; "Houses in Melbourne," 19 April 1856; "The New Museum on the Kensington Gore Estate," 10 May 1856, p. 263.

Building News: "Portable Iron Buildings," 12 March 1886, p. 415; "Messrs. Francis Morton and Co. (Limited)," 14 December 1888, p. 798; "Corrugated Iron Roofs," 30 August 1889, p. 284.

Civil Engineer and Architect's Journal: "The New Stabling," December 1837, p. 47; "Iron Steam Vessels built by Messrs. Wm. Fairbairn and Co., of Millwall, London," May 1841, pp. 147–48; "Iron Ship Building," August 1842, p. 254; "Iron Buildings for California," October 1849, p. 319; "The Employment of Iron in Architecture," November 1851, p. 609; "Iron Buildings for the Colonies," 1853, p. 339; "Dwelling-house and Office," 1853, p. 456; "Iron Custom-house and Store for Peru," 1854, p. 185, pl. 20; "Iron Churches for Australia," 1854, p. 278; "Demerits of Iron Houses," 1855, p. 176; "Buenos Ayres Gas Works," 1856, p. 170.

Colonial Gazette

Commercial Gazette and India, China, and Australian Telegraph

Country Life

Diamond Fields Advertiser (Kimberley)

SELECTED BIBLIOGRAPHY

Diamond News and Griqualand West Gazette (Kimberley)

Diamond News and Vaal Advertiser (Kimberley)

Diggers News and Witwatersrand Advertiser (Johannesburg)

Eastern Star (Johannesburg)

Ecclesiologist: "Wooden Churches," July 1845, pp. 148–50; "To the Editor of the Ecclesiologist" (a letter from Peter Thompson), VIII, August 1847, pp. 63–64; W. Vose Pickett, "Iron Architecture," August 1856, pp. 280–81.

Empire

Engineer and Machinist: "Iron Structure for Balmoral," 1851, p. 210.

Gazette (Melbourne)

Gold Fields Times (Barberton)

Illustrated London News: "Cast Iron Lighthouse for the West Indies," 20 April 1844; "Temporary Church at Kentish Town, St. Pancras," 7 September 1844, p. 156; "Iron Church for Jamaica," 28 September 1844; "Iron Warehouse for California," 17 February 1849, p. 109; "Iron Store-house for Jamaica," 14 July 1849, p. 20; "Iron Hotel for Port Natal," 20 April 1850, p. 274; "The Tide of Emigration to the United States and to the British Colonies," 6 July 1850, pp. 16–17; "Cast-Iron House by Bellhouse and Co.," 20 September 1851; "Portable Iron Church for the Diocese of Melbourne, S. Australia," 30 April 1853, p. 324; "Portable Barracks for the Crimea," 9 December 1854, p. 575; "Huts for the French Army," 16 December 1854, p. 630; "Wooden Barracks for the French Army in the Crimea," 6 January 1855, pp. 13–14; "Shipment of Huts and Clothing from Trieste," 13 January 1855, p. 32; "The New Castle Hospital," 25 July 1855, p. 112; "The Royal Aldershott Club-house," 29 September 1855, p. 397; "Camp Cooking at Aldershott," 13 October 1855, p. 453.

Illustrated Times

Liverpool Daily Courier

London Monthly Overland Mail for All India

Loudon's Magazine

Manchester Guardian: "The Late Mr. E. T. Bellhouse," 15 October 1881.

Mechanics' Magazine: "Iron Buildings," 1844, p. 226; "Iron Houses," December 1844, p. 400; "Iron Market-house," April 1846, p. 272; "Iron Ware-houses for San Francisco," September 1849, pp. 234–35; "The House Export Trade," November 1849, pp. 440–42; "The Lighthouse Tower, Gibb's Hill, Bermuda," August 1852, pp. 129–34; "Iron Lighthouses," November 1852, pp. 405–6; "Calvert and Light's Portable Buildings," September 1860, pp. 198–99.

M'Phun's Australian News: "Iron Houses for Australia," May 1853, p. 4; "Glasgow Iron Ball in Messrs. Robertson and Lister's Iron Houses," May 1855, p. 9.

Natal Mercury (Durban)

Port Philip Herald (Melbourne)

Practical Mechanic's Journal: "Iron Market-house at San Fernando, Trinidad," I:9, December 1848, p. 207, I:10, January 1849, pp. 224–25, pl. 21, 22; "Iron Houses," II, 1849, pp. 142–43; "Iron-house Building in Glasgow," III, April 1850, pp. 83–84; "Iron Warehouses and Dwellings," V:60, 1853, p. 294; "Portable Houses," VI:68, 1853, pp. 162–63; "Iron Custom-house for Peru," VII, 1854, p. 45; "Cast-Iron Houses," VII:75, 1854, pp. 68–69; "Iron Custom-house at Payta, Peru," VII:76, 1854, pp. 77–78, pl. 154; "Iron Buildings," p. 316, pl. 253.

Representative (Barberton)

Scotsman

South Africa: A Weekly Journal for All Interested in South African Affairs

South Australian Record

Standard and Transvaal Mining Chronicle

Star (Ballarat)

Star (Johannesburg)

Sydney Morning Herald

Times (London)

Year Book of Facts in Science and Art: "Exportation of Iron Steam-boats," 1840,

pp. 21–22; "Iron Houses," 1842, p. 58; "Cast-Iron Church," 1842, p. 59; "Cast-Iron Buildings," 1843, p. 40; "Metal Houses," 1846, pp. 110–11; "Iron House Export Trade," 1850, pp. 88–90; "Building for the Great Exhibition of 1851," 1851, pp. 5–15; "Iron House-Building," 1851, pp. 46–47; "The Great Exhibition Building," extra vol. 1851, pp. 28–97; "Details of Iron Ballroom," 1852, pp. 70–71; "Cast-Iron Lighthouse for the Falkland Islands," 1854, pp. 73–74; "Iron Buildings," 1854, pp. 74–75; "Zinc Houses," 1854, p. 75; "Paper Houses," 1854, pp. 141–142; "Metropolitan Cattle Market, Copenhagen Fields," 1855, pp. 12–13; "Iron House Building," 1855, pp. 54–57; "Manchester Art Treasures Exhibition Building," 1858, pp. 13–15; "Lighthouse for Russia," 1859, pp. 42–43.
Yorkshireman

B. GENERAL REFERENCES

Album of Johannesburg, Grocott and Sherry, 1898.
Burton, *Cape Colony for the Settler*, 1903.
Catalogues and Trade Literature:
 Braby, Frederick & Co., Iron Buildings and Roofing Department. *Illustrated Catalogue*, Glasgow.
 Hemming, Samuel. *Hemming's Patent Improved Portable Houses*, Bristol, c. 1850.
 MacFarlane, Walter. *Illustrated Catalogue of Macfarlane's Castings*, 6th ed., Glasgow, n.d.; *Macfarlane's Examples of Architectural Ironwork*, Glasgow, n.d.
 Manning, John. *Swan River* (Advertising pamphlet), London, 1830. British Museum.
 Morewood and Rogers. *Catalogue, Galvanized Tinned Iron*, c. 1850.
 Morton, Francis & Co., Iron Buildings, Roofing and Galvanized Iron Department. *Catalogue, 8/b*, 1873.
 Porter, John H. *Examples of Iron Building and Roofing*, London, c. 1850.
 Tupper and Carr. *Catalogue*, 1851.
 Young, C. D. & Co. *Address to Landed Proprietors, Agriculturists, etc.*, 1851; *Compendium of C. D. Young & Co.'s Larger Catalogue of Iron and Wire Works*, 1850; *Illustrations of Iron Structures for Home and Abroad, Consisting of Stores, Dwelling-houses, Markets, Arcades, Railway Stations, and Roofing, &c. &c., Constructed of Wrought and Cast Iron and Corrugated Sheets, Manufactured by Charles D. Young & Co.*, Edinburgh, c. 1856.
Directories: Argus Annual and South African Directory; Birmingham Directory; Derbyshire Directory; Edinburgh and Leith Post Office Directory; General Directory of South Africa; Glasgow Post Office Directory; Gloucester Directory; Johannesburg and District Directory; Kelly's Directory; Kelly's Building Trade Directory; Liverpool Directory; London & Provincial Builder's Directory; London Post Office Directory; Longland's Transvaal and Rhodesia Directory; Manchester Directory; Marchant & Co. Builders & Building Trade Directory; Matthew's Bristol Directory; Natal Almanac and Register; Pigot's Directory; Robson's London Directory; Wright's Directory; Wyman's Architects, Engineers, and Building Trades Directory.
Encyclopaedia of the Transvaal, 1906.
Free State Annual, 1893.
Handbook on Industries of Glasgow, British Association for the Advancement of Science, 1901.
Minutes of Proceedings of the Institution of Civil Engineers, 1840–55.
Official Reports:
 Accounts Relating to Trade and Customs for the Year 1855 (Melbourne and Geelong).

SELECTED BIBLIOGRAPHY

Census of the Transvaal Colony and Swaziland, 1906.
General Report on the Commission Appointed for Improving the Sanitary Conditions of Barracks and Hospitals, London, 1861.
How Britain Goes to War: A Digest and Analysis of Evidence Taken by the Royal Commission on the War in South Africa, London, 1903.
Natal Blue Books.
Official Catalogue of the Great Exhibition, London, 1851.
Report of a Board of Officers . . . on Different Principles and Methods of Hutting Troops, War Department, London, 1856.
Report of the Commission of Enquiry into the Supplies of the British Army in the Crimea, London, June 1855, January 1856.
Statistics of the Colony of Victoria.
Scenes and Life in the Transvaal, c. 1905.

C. BOOKS AND ARTICLES

Alexander, W. *Observation on the Construction and Fitting Up of Meeting Houses &c for Public Worship*, York, 1820.
Allen, J. "The Technology of Colonial Expansion," *Industrial Archaeology*, May 1967, pp. 111–37.
Amery, L. S., ed. *The Times History of the War in South Africa*, Vol. 5, London, 1907.
Ames, Winslow. *Prince Albert and Victorian Taste*, London, Chapman and Hall, 1967.
Aron, Helen, Benjamin, Arnold, Chipkin, Clive, and Zar, Shirley. *Parktown 1892–1972*, Johannesburg, Studio Thirty-five, 1972.
Ballinger, John. "Prefabrication and Industrialization in Nineteenth-Century Australian Architecture," seminar paper, School of Architecture, University of Adelaide, 1964.
Bannister, Turpin C. "Bogardus Revisited," *Journal of the Society of Architectural Historians*. Part 1, December 1956, pp. 12–22; Part 2, XVI, March 1957, pp. 11–19.
Benevolo, Leonardo. *History of Modern Architecture*, Cambridge, M.I.T. Press, 1971.
Blainey, Geoffrey. *Johns and Waygood Ltd., 1856–1956*, Melbourne, Caulfield and Co., n.d.
Boyd, Robin. *Australia's Home*, Melbourne, Melbourne University Press, 1952.
Bruce, Alfred, and Sandbank, Harold. *A History of Prefabrication*, Raritan, New Jersey, The John B. Pierce Foundation, 1943.
Butt, J. *The Industrial Archaeology of Scotland*, Newton Abbey, David and Charles, 1976.
Chadwick, George F. *The Works of Sir Joseph Paxton*, London, Architectural Press, 1961.
Cleland, J. B. "Section-Built Manning Cottages," *Proceedings of the Royal Geographical Society of Australasia (S. A. Branch)*, LVII, December 1956, pp. 51–52.
Cole, H. N. *The Story of Aldershot*, Aldershot, Gale & Polden, 1951.
Cubitt, William. "On the Construction of the Building for the Exhibition of the Works of Industry of all Nations in 1851," *Minutes of Proceedings of the Institution of Civil Engineers*, X, 1850–51, pp. 127–91.
Curror, W. D. *Golden Memories of Barberton*, 5th ed., 1972.
Darlington, Ida. "Thompson Fecit," *Architectural Review*, September 1958, pp. 187–88.
de Mare, Eric, and Skempton, A. W. "The Sheerness Boat-Store 1858–1860," *Journal of the Royal Institute of British Architects*, June 1961, pp. 318–24.
De Waal, G. M. "Die Karakter van die Argitektuur in die Binnestad van Johannesburg tot 1920." Master's thesis, Rand Afrikaans University, n.d.
———. *The Market Square of Johannesburg: Catalogue of Buildings on or around the Square till about 1920*. Pamphlet, Johannesburg Public Library, 1971.

Dickinson, H. W. "A Study of Galvanized and Corrugated Sheet Metal," *Transactions of the Newcomen Society*, 1943, pp. 27–36.

Downes, Charles. *The Building Erected in Hyde Park for the Great Exhibition, 1851,* London, 1852 (reprint ed., Victoria and Albert Museum, 1971).

Drinnan, Geoffrey E. "Corio Villa," undergraduate thesis, Melbourne University, 1949.

Dutton, Geoffrey. *Founder of a City,* Chapman and Hall, 1960.

Emmet, B. *Catalogue and Counters,* Chicago, University of Chicago Press, 1950.

Evill, William. "Description of the Iron Shed at the London Terminus of the Eastern Counties Railway," *Minutes of Proceedings of the Institution of Civil Engineers,* 1844, pp. 288–90.

Fairbairn, William. *Treatise on Mills and Millwork,* London, Longmans (2 vols.), 1861–65.

Forbes, A. *History of the Army Ordnance Services,* Vol. 1, London, Medici Society, 1929.

Freeland, John M. *Architecture in Australia,* Melbourne, Cheshire, 1968.

———. *Melbourne Churches, 1836–51,* Melbourne, Melbourne University Press, 1963.

Freeland, John M., Cox, Philip, and Stacey, Wesley. *Rude Timber Buildings in Australia,* London, Thames & Hudson, 1969.

Gernsheim, H., and Gernsheim, A. *Roger Fenton: Photographer of the Crimean War,* London, Secker & Warburg, 1954.

Giedion, Sigfried. *Space, Time, and Architecture,* Cambridge, Harvard University Press, 1941.

Gloag, John. *Victorian Taste,* Newton Abbot, David and Charles, 1972.

———. *Mr. Loudon's England,* Newcastle upon Tyne, Oriel Press, 1970.

Godfrey, Denis. "Romantic Story of an Old Shed," *Star* (Johannesburg), 16 May 1975.

Goldney, Frank H. *A Short History of the Society of Friends and the Meeting House, etc.,* Adelaide, n.d.

Gomme, A. H., and Walker, D. W. *The Architecture of Glasgow,* London, Lund Humphries, 1968.

Grantham, John. *Iron as a Material for Ship-building,* Liverpool, Lace and Addinson, 1842. (Also referred to in *Minutes of Proceedings of the Institution of Civil Engineers,* 1842, pp. 180–81).

Gray, E. L., and Gray, James. *A History of the Discovery of the Witwatersrand Goldfields,* Johannesburg, Sholto Douglas & Co., 1940.

Gray, James. *Payable Gold,* Johannesburg, C.N.A., 1937.

Griffiths, S. *Guide to the Iron Trade of Great Britain,* London, 1873.

Groucott, J. C. "Skew Arches and Prefabricated Cast-Iron," *Industrial Archaeology,* August 1971, pp. 317–19.

Halse, Miss. *An Account of John Barton Hack of Australia, c. 1840 ff,* Bedford, 1930.

Hamilton, S. B. "The Use of Cast Iron in Building," *Transactions of the Newcomen Society,* Vol. 21, 1940–41, pp. 139–55.

Hancock, Keith, and Van Der Poel, eds. *Selection from the Smuts Papers,* Vol. 2, Cambridge, At the University Press, 1966.

Harrison, Michael. "A Century of Prefabrication," The *Builder,* 21 June 1963, pp. 1241–42.

Harrison, D., Albery, J. M., and Whiting, M. W. *A Survey of Prefabrication,* London, Ministry of Works, 1945.

Hattersley, A. F. *British Settlement of Natal,* Cambridge, At the University Press, 1950.

Herbert, Gilbert. "Corrugated Iron and Prefabrication," *Centre for Urban and Regional Studies Working Paper* 3, Technion, June 1971 (reissued in revised form 1972).

———. "The Portable Colonial Cottage," *Journal of the Society of Architectural Historians,* XXXI:4, December 1972, pp. 261–72.

——. "Prefabricated Structures for the Crimean War," *CURS Working Paper* 16, Technion, December 1972.

——. "A Cast-Iron Solution," *Architectural Review*, CLIII: 916, June 1973, pp. 367–73.

——. "The Temporary Church for Home and Abroad," *CURS Working Paper* 26, June 1973.

——. "The Enigma of the Camellia House at Wollaton Hall," Monograph, 1974.

Herman, Morton. *The Early Australian Architects and Their Work*, Sydney, Angus and Robertson, 1954.

Hersey, George L. *High Victorian Gothic*, Baltimore, The Johns Hopkins University Press, 1972.

Higgs, Malcolm. "The Exported Iron Buildings of Andrew Handyside & Co. of Derby," *Journal of the Society of Architectural Historians*, XXIV, May 1970, pp. 175–80.

Hitchcock, Henry-Russell. "Early Cast Iron Facades," *Architectural Review*, February 1951, pp. 113–16.

——. *Architecture: Nineteenth and Twentieth Centuries*, Baltimore, Pelican Books, 1958.

——. *Early Victorian Architecture in Britain*, New York, Da Capo Press, 1972.

Hix, John. *The Glass House*, London, Phaidon Press, 1974.

Hocking, Anthony. *Old Kimberley*, Cape Town, Purnell, 1974.

Irving, Robert. "The Portable Hospital, Sydney, 1790–1816," Manuscript, Sydney, 1973.

——. "The Governor's Portable House," Manuscript, Sydney, 1973.

Kubler, George. "The Machine for Living in Eighteenth-Century West Africa," *Journal of the Society of Architectural Historians*, III, April 1944, pp. 30–33.

Kranzberg, Melvin, and Pursell, C. W. *Technology in Western Civilization*, New York, Oxford University Press, 1967.

Laikve, G. E., ed. "A Survey Report on the Meeting House of the Society of Friends, Pennington Terrace, North Adelaide," Report. School of Architecture, University of Adelaide, 1963.

Lamshed, Max, and McLeod, Jeannette. *Adelaide Sketchbook*, Adelaide, Rigby Ltd., 1967.

Lenzi, Ricardo Alvarez, "El Mercado Central," *Revista de la Facultad de Arquitectura: Universidad de la Republica*, Uruguay, October 1964, pp. 111–12.

Lewcock, Ronald. *Early-Nineteenth-Century Architecture in South Africa*, Cape Town, Balkema, 1963.

Leyds, G. A. *A History of Johannesburg*, Nasionale Boekhandel Beperk, 1964.

Loudon, John C. *Encyclopaedia of Cottage, Farm, and Villa Architecture*, London, Longman, 1833.

MacMillan, Allister. *The Golden City*, London, Collingridge, 1933.

Manning, William. "A Portable Cottage for the Use of Emigrants and Others," in J. C. Loudon, *Encyclopaedia of Cottage, Farm, and Villa Architecture*, London, Longman, 1833, pp. 251–57.

Matheson, Ewing. *Work in Iron*, London, Spon, 1877.

Murray, R. W. *The Diamond Fields Keepsake for 1873*, Cape Town, Saul Solomon and Co., 1873.

Muthesius, Stefan. "The 'Iron Problem' in the 1850s," *Architectural History*, XIII, 1970, pp. 58–63.

"Nocton Farm," *Looking Back: Bulletin of the Historical Society of Port Elizabeth*, September 1965, pp. 9–11.

Parkes, E. A. *Report on the Formation and General Management of Renkioi Hospital, Turkey* (with an appendix by Isambard Kingdom Brunel: "Hospital Buildings for the East"), London, 1857.

Peterson, Charles E. "Early American Prefabrication," *Gazette des Beaux-Arts*, 6th ser., no. 33, 1948, pp. 37–46.

———. "Prefabs for the Prairies," *Journal of the Society of Architectural Historians,* XI, 1952, pp. 28–29.

———. "Prefabs in the California Gold Rush, 1849," *Journal of the Society of Architectural Historians,* December 1965, pp. 318–24.

———. "Iron in Early American Roofs," *The Smithsonian Journal of History,* Fall 1968, III:3, pp. 41–76.

———. "Pioneer Prefabs in Honolulu," *The Hawaiian Journal of History,* V, 1971, pp. 24–38.

Pole, William. *The Life of Sir William Fairbairn, Bart.,* (1877), Newton Abbot, David and Charles Reprints, 1970.

"Portsmouth Prefabs, 1772 and 1849," *Journal of the Society of Architectural Historians,* XXIII, 1964, pp. 43–44.

Ritchie, T. "Plankwall Framing, a Modern Wall Construction with an Ancient History," *Journal of the Society of Architectural Historians,* XXX, March 1971, pp. 66–70.

Robertson, E. Graeme. "The Australian Verandah," *Architectural Review,* April 1960, pp. 239–44.

———. *Victorian Heritage: Ornamental Cast Iron in Architecture,* Melbourne, Georgian House, 1960.

———. *Sydney Lace: Ornamental Cast Iron in Architecture in Sydney,* Melbourne, Georgian House, 1962.

Robinson, Cervin. "Late Cast Iron," *Forum,* September 1971, p. 47.

Robinson, J. Cambell. *The Free Presbyterian Church of Australia,* Melbourne, Hamer, 1947.

Robison, Rita. "Prefabs: an Old Technique," *Architectual and Engineering News,* June 1967.

Saunders, David, ed. *Historic Buildings of Victoria,* Melbourne, Jacaranda Press, 1966.

Savory, T. W. *Diary.* Transcribed by Esme Lownds. 1884.

Shorten, John R. *The Johannesburg Saga,* Johannesburg City Council, c. 1966.

Smuts, Jan Christian. *Jan Christian Smuts,* London, Cassell & Co., 1952.

Stratten and Stratten. *Glasgow and its Environs,* London, 1891.

Sturges, W. Knight. "Introduction," *The Origins of Cast Iron Architecture in America,* New York, Da Capo Press, 1970.

Swift, J. M. *The Story of Garston and Its Church,* 1937.

Trias, Monserrat Palmer. *50 Años de Arquitectura Metalica en Chile, 1863–1913,* Instituto de Historia de la Arquitectura, Universidad de Chile, 1970.

"Two Hundred Years in the Timber Trade," *Timber Trades Journal,* 2 May 1936.

Tylor, Alfred. *Paris Universal Exhibition: Report on General Metal Works,* London, 1857.

Watson, Charles M., ed. *History of the Corps of Royal Engineers,* Vol. 3, Chatham, Institution of Royal Engineers, reprinted 1954.

White, R. B. *Prefabrication: A History of Its Development in Great Britain,* London, Her Majesty's Stationery Office, 1965.

INDEX

Pages listed in *italic* type contain illustrations.

INDEX